Stories from the Camera

Stories from the Camera

reflections on the photograph

edited by michele m. penhall
preface by kymberly pinder

thomas barrow
geoffrey batchen
van deren coke
sarah greenough
christopher kaltenbach
beaumont newhall
robert parkeharrison
eugenia parry
meridel rubenstein
richard rudisill
april m. watson
carla williams
joel-peter witkin

© 2015 by the University of New Mexico Press
All rights reserved.
Published 2015
Printed in China
20 19 18 17 16 15
1 2 3 4 5 6

Library of Congress
Cataloging-in-Publication Data

Stories from the camera : reflections on the
photograph / edited by Michele M. Penhall ;
preface by Kymberly Pinder ; contributions by
Thomas Barrow, Geoffrey Batchen, Van Deren
Coke, Sara Greenough, Christopher Kaltenbach,
Beaumont Newhall, Robert ParkeHarrison,
Eugenia Parry, Meridel Rubenstein, Richard
Rudisill, April M. Watson, Carla Williams, and
Joel-Peter Witkin.
 pages cm
 Includes bibliographical references and index.
 ISBN 978-0-8263-5589-8 (cloth : alk. paper) —
 ISBN 978-0-8263-5590-4 (electronic)
 1. Photography—History. 2. Photographs—
History. 3. Photographic criticism. I. Penhall,
Michele M.
 TR15.S87 2015
 770—dc23
 2015009316

All images are courtesy of the University of New
Mexico Art Museum, unless otherwise noted.

Cover illustrations: (front) Photographer
unknown, Untitled; *Émile Zola photographing
a doll*, Verneuil-sur-Seine, ca. 1897
(back) Mark Klett, *Kem Brown in
Her Garden, Gimlet, Idaho, 9/6/81*
Designed by Lisa Tremaine
Composed in Chapparal and Futura

Contents

David Octavius Hill
(Scottish, 1802–1870)
Robert Adamson
(Scottish, 1821–1848)
Untitled, 1846
Calotype negative, 5½ × 7⅞ in.
Gift of Van Deren Coke
76.93

Preface

When I first learned about the University of New Mexico Art Museum's phenomenal collection of photography, I wondered, as most non–New Mexicans do, why in the middle of the desert? Then I finally came here and fully understood. The landscape can make you feel as if you are on the edge of the earth, while the confluence of so many cultures and histories offers centuries of stories to tell. This place is a haven for that endless quest for truth's doppelgänger, which the photographer both embraces and rejects. Having spent many years looking at, studying, nurturing, and building this collection, first as a student and then as its curator, Michele Penhall has assembled here a volume that successfully surveys an unparalleled legacy of looking. As she details in her introduction, the Photography Program at the University of New Mexico has drawn stellar faculty and students alike, many of whom, so greatly influenced by the collection, gave work and brought other great artists here. There was a symbiotic relationship among the landscape, the program, and the museum. Herein historians and artists alike reflect on the importance of this collection and the impact it has had on their lives and on the history of photography. It began as a study collection for the university's students, and the central role it has maintained as an open and free resource at a public institution cannot be overstated. Many artists and collectors have donated their photographs to the University of New Mexico Art Museum for that very reason—access. Generosity has fueled the growth of the collection and the care of these works. Active directors, dedicated curators, and devoted archivists have built the collection, advocating for over ten thousand photographs that represent a wide range of historical and contemporary techniques. Now the most comprehensive catalog of this work will enable an even larger audience to appreciate this gem in the desert.

KYMBERLY PINDER
Dean, College of Fine Arts
University of New Mexico

Robert ParkeHarrison
(American, b. 1968)
Rain Machine, 1993
Gelatin silver print on canvas, 30¾ × 22 in.
Edition 2/2
Gift of Dana Asbury and Richard Levy
© Robert ParkeHarrison
2000.32

Acknowledgments

This book, the first dedicated to the University of New Mexico Art Museum's entire photography collection, follows upon the 2012 exhibition *Reconsidering the Photographic Masterpiece*. That project, under former director E. Luanne McKinnon, surveyed the collection's extensive holdings from a particular curator's perspective. The intention was twofold: to present important recent acquisitions and to demonstrate that the museum's photography collection is "a tool that might contribute to a fuller understanding of the medium's achievements and potentials," to borrow the wise words of John Szarkowski.

I am indebted to many individuals who gave freely of their time and provided encouragement, editorial guidance, administrative and financial support, and boundless enthusiasm for this project. Colleagues, friends, and loved ones in this endeavor include Durwood Ball, Thomas Barrow, Geoffrey Batchen, Angela Berkson, David Bram, James Enyeart, Miguel Gandert, Ray Graham III, Betty Hahn, Nancy Johnson, Kristina Kachele, Christopher Kaltenbach, Wayne R. Lazorik, E. Luanne McKinnon, Robert Morton, John Mulvany, Sara Otto-Diniz, Eugenia Parry, Edward Ranney, Leilani Ringkvist, Ann Tanenbaum, Nancy Treviso, Katherine Ware, and especially my husband, Christopher C. Mead.

My thanks to University of New Mexico Art Museum staff—Steven Hurley, Stephen Lockwood, Angelina Skoneiczka, Sherri Sorensen, Bonnie Verardo—who assisted in countless ways toward the success of this project. Many thanks also to Margot Geist, Geistlight Photography, for her expert work in photographing many of the images and objects included in this volume.

Thank you to Mariah Carrillo, Erik Parker, and Christian Waguespack, dedicated and unflagging interns and graduate students who worked tirelessly to assist me in locating and organizing information and images as well as with untold other necessary details.

I am grateful to the artists who graciously waived reproduction fees and provided images for the cause—thank you.

My heartfelt thanks and gratitude go to the staff of the University of New Mexico Press, particularly John Byram and Lisa Tremaine, as well as Maya Allen-Gallegos, James Ayers, Delia Barnas, Felicia Cedillos, Trish Kanavy, Marie Landau,

ACKNOWLEDGMENTS

Joy Margheim, Lauren Consuelo Tussing, and Katherine White, all of whom have helped realize this book, making it the very best that it could be.

Partial funding for this book was generously provided by The FUNd at the Albuquerque Community Foundation, Sheilah Garcia, Elizabeth Wills, and a Beaumont Newhall Publication Assistance Grant from the New Mexico Council on Photography.

All efforts have been made to trace copyright owners and photographers whose works appear in this volume. While many individuals have made contributions to this book, unintentional errors and omissions are mine alone. Unless otherwise noted, all works belong to the University of New Mexico Art Museum and are reproduced here with permission.

MMP

Introduction
About a Collection

A great picture is something that awakens a very different reaction from each person who looks at it. Because not everybody is going to look at any picture and be drawn to it. . . . But the picture that creates an individual response is a great picture no matter who made it, and anybody might make it. Of course, there are so many people who feel that everything in photography is an accident. Well, anyone who cares for photography knows this is not true. The miracle of photography is that the very thing which makes it great is something that nobody can explain.

—Hugh Edwards, curator, Art Institute of Chicago, 1956–1979

first saw the photograph *Kem Brown in Her Garden* as a graduate student in 1988 in the University of New Mexico Art Museum's print study room, a place where students gathered to see, firsthand, original photographs and prints selected to augment the more formal classroom slide lectures.[1] I was as dazzled by its fidelity and color as I was curious about the woman who tended the immense, verdant garden, alone except for the company of a calico cat. It seemed like an ordinary circumstance and yet at the same time I felt I had interrupted a prescient moment in a larger unfolding story. There was an absolute stillness to the picture save for Kem Brown's

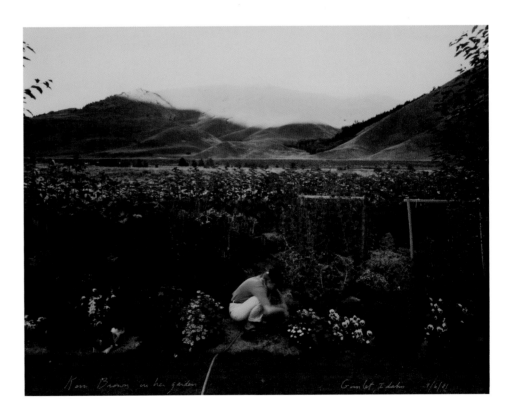

Mark Klett
(American, b. 1952)
*Kem Brown in Her Garden, Gimlet,
 Idaho, 9/6/81*
Dye transfer print, 20 × 16 in.
Purchased through the Julius L.
 Rolshoven Memorial Fund
© Mark Klett
85.9

Kenneth E. Nelson
(American, b. 1956)
F. Van Deren Coke, ca. mid-1970s
Daguerreotype, 4⅞ × 3⅞ in.
Promised gift of the Estate of F. Van Deren
 Coke and Joan Coke
©1977 Kenneth E. Nelson
T2011.26.2

fluttering hands that disrupted the calm like so many anxious children and animals seen in photography's earliest pictures.

The privilege and experience of looking at original works of art cannot be overstated. No matter which reproduction technology is currently in vogue, no matter how crystalline a new process or device promises to be, nothing replaces that experience of beholding the work itself. The size and scale of a work, the particular characteristics and nuances of canvas, paper, or metal, and sometimes even the faint scent of an object, are conveyed only in person. It can be exhilarating to see works up close, unglazed, and in a more intimate setting than a public museum or gallery space. For studio artists learning their craft or art historians just beginning to study a new discipline, the immediacy of considering works of art firsthand is seductive. Mark Klett's image of Kem Brown in her garden has remained with me for such a long time because of my experience with the actual photograph those many years ago.

In 1961 administrative control of what was then a small art gallery that focused on modest exhibitions was transferred from the UNM Department of Art (as it was called until 1983) to Clinton Adams, the dean of the College of Fine Arts.[2] With this shift it was decided to establish a teaching collection and to present larger, more significant exhibitions for the university and the greater community. The initial building phase of the new Fine Arts Center, which included an art gallery with expansive exhibition spaces, was completed and the center opened in September 1963. Van Deren Coke was appointed the founding director, and the first exhibition opened the following month, in October.[3] The name changed from University Art Gallery to University Art Museum in 1965–1966 in part "to give potential donors a feeling of reassurance in regard to the treatment and preservation of their gifts."[4] Donations of art began in earnest—over one hundred objects—following the museum's first exhibition, and these gifts were consolidated with art given to the university prior to the establishment of the University Art Gallery. Thus, a collection was formed.

From the beginning, the museum was closely aligned with the Department of Art and Art History; it was an effective symbiotic relationship that at times helped the museum's administration and also proved paramount in building the museum's collection. Their histories are closely linked, as witnessed throughout this book. Department faculty held positions in the museum and museum staff held faculty positions in the department. Many students of photography—both studio and art history—served as volunteers and interns for the museum. Examples of this reciprocal relationship include the following: Van Deren Coke was concurrently the director of the Art Museum and chairman of the Art Department from 1963 to 1966, and museum director again from 1971 to 1979. Robert Ellis was hired as both assistant director of the museum and Art Department faculty in 1964. He was the museum's director from 1968 to 1971, at which point he left the museum to teach full time in the Art Department.[5] Thomas Barrow was an associate professor in the department, teaching one class a semester, while he served as the associate director of the museum from 1973 to 1976. In 1985 Peter Walch resigned his tenured faculty position in the Department of Art and Art History, where he had taught since 1971, to become the museum's longest-serving director, a position he held until 2001.

Learning about art from original works was the premise for creating a study collection and one of the primary reasons for establishing a museum. Clinton Adams and Van Deren Coke recognized that within the cultural and economic climate of the 1960s, works on paper—nineteenth-century photographic objects, twentieth-century photography, prints that spanned the history of graphic arts and drawings—were both accessible and affordable for a university art museum, and these primary works of art were ideally suited to build a study collection. Photography at this time had not yet captured the attention of the art world and was still considered secondary to painting and sculpture. Consequently, it was easier to acquire significant works even on a state university budget. Elizabeth Anne McCauley reaffirmed this abiding mission in 1980 in the preface to the *Catalog of 20th Century Photographs*: "His [Coke's] primary goal was to create a repository where students exploring

photography and its history could come to see original prints by the greatest practitioners since Niépce and Daguerre."[6] The collection thus served the pedagogical needs of the Art Department, since it was available to both the faculty, in support of studio and art history classes, and to all interested students. It also was an important foundation for developing and curating exhibitions from the permanent collection.[7] (For many years, graduates in studio art were required to donate some of their works to the museum, a practice that helped build the collection in its early years.)

One of several important early gifts to the museum was a large collection—over five hundred objects—of nineteenth-century daguerreotypes, ambrotypes, tintypes, and vernacular photographic objects from Mrs. Theodore Labhard of San Francisco. This came about in part due to the efforts of Richard Rudisill, who was on the faculty in the department from the spring of 1968 through May 1970. Rudisill had just completed his dissertation, soon published as *Mirror Image: The Influence of the Daguerreotype on American Society*, in American studies at the University of Minnesota.[8] At a time when the study of photography's history was barely a codified discipline in the larger art history continuum, this exhaustive study about American culture and the daguerreotype's impact during a very specific period—1840 to 1860—was a significant addition to photography's nascent discourse. Through his research on this project, and as he noted in his acknowledgments, Rudisill met and worked with Mrs. Labhard and used examples from her collection throughout his book. Following her death in 1968, much of the collection was acquired by the Art Department, specifically by Rudisill and Coke, in 1969 or early 1970.[9] This collection, which resides in the UNM Art Museum, forms a significant part of the museum's early nineteenth-century photographic holdings and includes works by such important early camera artists as Albert Sands Southworth, Josiah Johnson Hawes, and John Plumbe. Another early gift to the collection was a cache of approximately 180 photographs by Carl Van Vechten. These were donated to the university in 1955, stored at the Raymond Jonson Gallery, the only suitable place on campus at the time, and eventually transferred to the UNM Art Museum in 1970.[10]

During the 1960s photographic education across the United States was in its adolescence.[11] The Department of Art and Art History began to offer an MFA in studio art in 1965 and was just one of a small group of institutions that conferred the terminal degree with a concentration in studio photography. The PhD program in art history started in the fall of 1969. Sometime between 1969 and 1970 Rudisill began to teach regular courses in the history of photography, a subject in which he was very familiar. Prior to this, the history of photography was informally presented in some studio courses but nothing formal had ever been taught.[12] With a growing collection of original works, history of photography classes were often held in the museum so that faculty could teach from actual photographs.[13] It is to Rudisill's credit that he initiated a curriculum in the discipline even though his term was short-lived. He was the first historian of photography in the UNM Department of Art and Art History, the first in a succession of distinguished scholars who taught photography's history to generations of young artists and emerging curators and academics. The UNM Art

LES BONS BOURGEOIS.

N.º 49.

Position réputée la plus commode pour avoir un joli portrait au Daguerréotype.

Honoré Daumier
(French, 1808–1879)
"Les bons bourgeois," from *Le Charivari*,
 1847
Color lithograph, 13 × 9½ in.
Gift of Joan and Van Deren Coke
97.47.31

Museum's photography collection was critical to the continued success of this peda-
gogy. This remains as true today as it was in the 1960s.

For reasons that are unclear, Richard Rudisill was dismissed in the spring of
1971 before his contract ended.[14] It is a curious coincidence that Rudisill's separa-
tion from the university is listed on the same page of the university's annual report
for fiscal year 1970–1971 as the appointment of Beaumont Newhall, who began
teaching in August 1971.[15] Newhall had just retired from the George Eastman
House in Rochester, New York, where he had been the director since 1958. His repu-
tation at this time was immense and certainly eclipsed that of the much younger
Rudisill. By 1971 Newhall had numerous publications, including his seminal work,
The History of Photography, and a résumé that included many years at the Museum of
Modern Art, first as a librarian and then as the museum's first curator of photogra-
phy.[16] The opportunity to have such a luminary as Beaumont Newhall could not be
passed up. He remained on the faculty until 1984, the year he received a MacArthur
grant.

By all accounts, Newhall was a gifted, very generous teacher, irrevocably commit-
ted to his discipline. His generosity of spirit extended well beyond the classroom. As
noted by Thomas Barrow in this volume, Newhall gave a portion of his MacArthur

Photographer unknown
Fireman of Torrent Company #2,
 ca. 1856
Ambrotype, 3⅛ × 3³⁄₁₆ in.
Purchased through the UNM Alumni Fund
X0.297.2.135

Foundation award to the museum, specifically for photography acquisitions. With these funds the museum acquired over one hundred works, which make up the museum's Beaumont Newhall Collection and include images by Ansel Adams, Diane Arbus, Anna Atkins, Eugène Atget, Henri Cartier-Bresson, Peter Henry Emerson, Walker Evans, Lewis Hine, Tina Modotti, and Charles Nègre. These works were selected specifically "to reflect Professor Newhall's particular areas of scholarship and to enrich the Museum's already strong collection of photography."[17] Newhall also curated numerous exhibitions for the museum, most notably a one-hundred-print retrospective in 1973 of Eliot Porter's photographs.

In 1986, two years after Newhall's departure, Eugenia Parry was hired to teach the history of photography. Her dynamic lectures and holistic approach to understanding a specific culture or particular artist moved the discipline in new directions, beyond the linear, technology-driven, and theoretical methodologies prevalent in so much of the literature. Parry was, and continues to be, concerned with the deep context of an artist's life and how these circumstances affect his or her practice, from nineteenth-century French photographers such as Gustave Le Gray or Henri Le Secq to modern artists such as Ralph Eugene Meatyard, Lisette Model, or Adam Fuss.[18] This approach is clearly articulated in the chapters she wrote for this current project. She left the University of New Mexico in 1994 to pursue writing full time.

Geoffrey Batchen began teaching at the University of New Mexico in August 1996. The following year his groundbreaking work *Burning with Desire: The Conception of Photography* was published. *Burning with Desire* brings together the myriad accounts of the successes and failures of the earliest attempts at photography and all of the players—the well-known and not so well-known figures—who struggled to conceive of, invent, and define photography. As different as Parry's approach was

from that of her predecessors, so was Batchen's style from that of Parry. One of Batchen's significant contributions to the discourse is his insistence on inclusiveness. He embraces nearly all genres of photography, especially those pictures and photographers not usually part of the academic conversation. It was while Batchen lived in Albuquerque that he became interested in vernacular photography, a field to which he brought renewed and serious respect and one that is now considered mainstream. This attention includes awareness and appreciation of the photograph's "objectness"—the object or thing that contains the image—and not just the image itself.[19] His essay here recounts his discovery of and growing interest in these previously neglected photographic objects. Batchen taught at the university until May 2002.

As Beaumont Newhall had, Eugenia Parry and Geoffrey Batchen also made vigorous use of the UNM Art Museum's photography collection during their respective tenures. Students were required to visit the print room and to write papers on specific works chosen by each professor. These were critical exercises in observation and perception, an integral part of their pedagogy. At this time, before the proliferation of online images and ever-decreasing attention spans among students, these experiences with original works had lasting effects upon the individuals who took up the challenge of working with primary images. This is one reason the writers included here were chosen.

Stories from the Camera is a book about pictures and the stories they have inspired. It brings together a particular group of distinguished scholars and artists—former UNM faculty and alumni—all of whom have a particular connection to the University of New Mexico Art Museum and the Department of Art and Art History. Through their own professional and artistic practices, they represent different generations of aesthetic voices and intellectual directions. These individuals were invited to select and write about pictures from the collection that were significant to them or particularly relevant to their personal work.[20] Collectively, these essays represent a unique history of photography. These are their stories.

This book, in which masterworks commingle with less familiar but no less masterful works, is the first in many decades to consider the museum's photography holdings in their entirety and from the perspective of successive generations of artists and scholars. Thanks to the perceptive guidance of the museum's first director, Van Deren Coke, along with the efforts of many subsequent erudite directors as well as curators and benefactors, the collection has swelled to include iconic works by most of the prominent names in photography's canon and also photographs by less recognized, more obscure, and often unnamed artists.[21] The museum's primary mission has remained constant and steadfast throughout the decades, and it continues to serve faculty, students, scholars, and the community at large. Although the finite selection of pictures seen here—from some of the very first gifts to more recent acquisitions—represents only a small part of a much larger corpus, it attempts to reflect the great breadth of this significant and inspiring collection.[22]

Notes

The epigraph comes from Danny Lyon, *Memories of Myself: Essays by Danny Lyon* (New York: Phaidon Press, 2009), 112. Hugh Edwards (1903–1986) began working at the Art Institute of Chicago in 1929. In 1932 he was transferred to the Department of Prints and Drawings and later he was the founding curator of the institute's photography department. He was also, for a time, a practicing photographer. See the obituary by Kenan Heise's, "Hugh Edwards, Friend to Photography," *Chicago Tribune*, August 27, 1986.

1. In the museum's early years, there were resources from the university's central administration dedicated for acquisitions. These eventually disappeared and other funds—often, but not always, named for a benefactor—were established to acquire work. Unless otherwise noted, all works were purchased by the UNM Art Museum and named funds are listed in the credit information for each image. Also included in the credits is the year when the object formally came into the collection (indicated by the first two or four digits of the accession number).

2. Much of the information here was obtained from the university's annual reports. My thanks to Erik Parker for his assistance in tracking down so much of this information.

3. The first exhibition, *Taos and Santa Fe: The Artist's Environment, 1882–1942*, opened October 10 and closed November 27, 1963. It was organized in conjunction with the Amon Carter Museum of Western Art. It included 109 works from 61 artists and was accompanied by a fully illustrated, clothbound book with an essay by Van Deren Coke, published by the University of New Mexico Press.

4. Van Deren Coke, *Report of the University Art Museum, July 1, 1965–June 30, 1966*, 517.

5. Robert Ellis also served as director of the Harwood Museum in Taos from 1990 to 2001.

6. Elizabeth Anne McCauley, ed., *Catalog of 20th Century Photographs* (Albuquerque: University of New Mexico Art Museum, 1980), preface. McCauley at this time was the assistant director of the museum.

7. For another detailed historical account of the Department of Art and the Art Museum and their reciprocal relationship, see also Keith F. Davis, "Photography at the University of New Mexico," *Artspace: Southwestern Contemporary Arts Quarterly* 1.4 (Summer 1977): 12–39.

8. The University of New Mexico Press published this work in 1971.

9. In addition to being recorded in the university's annual report, this purchase is also confirmed in "Museum Will Show Photos," *New Mexico Lobo*, September 24, 1969, 3. My thanks to Mariah Carrillo for tracking down this article. The article refers to an exhibition of some of this work. I was unable to confirm the dates and scope of the exhibition in the museum's files. The annual report also mentions that Rudisill was primarily responsible for securing this acquisition.

10. A letter from Peter Walch to Kristin Pelletier in the UNM Art Museum files explains the circumstances of this acquisition.

11. For a full account of programs in the United States and Great Britain, see W. G. Gaskins, "Photography and Photographic Education in the USA," *Image* 14.5–6 (December 1971): 8–13.

12. This information was obtained from Department of Art and Art History faculty files; a phone conversation with Wayne Lazorik, November 5, 2013; and UNM annual reports. An

annual report lists Rudisill's primary interest as "the history of photography" (*Annual Report of the University, 1967–1968*, 614). My thanks to Nancy Treviso for allowing me access to the faculty information.

13. Installation photographs of early museum exhibitions show that the North Gallery, a separate exhibition space added in 1978 and renamed the Van Deren Coke Gallery in 1985 "in support of photography and print classes," was used as an ad hoc print room before the first dedicated print and photography study facility was completed. Prints and photographs were then stored in wooden cabinets and brought out for discussion when classes came in. The current facility, formerly the Fine Arts Library, was completed in 2010 as part of newly acquired and renovated gallery, storage, office, and preparatory spaces. Then director E. Luanne McKinnon was successful in having the new space named the Beaumont Newhall Study Room, in honor of Newhall's contribution to the museum.

14. According to documents in Rudisill's faculty file, his probationary period was scheduled to end June 30, 1972. It was the general policy then that he would have received tenure upon successful completion of this probationary period.

15. See *Annual Report of the University, 1970–1971*, 909.

16. Newhall's book was originally published as a catalog for the exhibition *Photography 1839–1937* at the Museum of Modern Art in 1937. The following year it was reprinted as *Photography: A Short Critical History*. In 1949 Newhall rewrote the entire book and titled it *The History of Photography*. See Beaumont Newhall, *The History of Photography: From 1839 to the Present Day*, rev. and enlarged ed. (New York: Museum of Modern Art, 1978).

17. Peter Walch, former director, letter dated August 11, 1987, UNM Art Museum files.

18. See the contributors' bibliographies in this volume for a list of Parry's major works. See also an interview in which Parry discusses her approach: "Eugenia Parry Dishes to Susie Kalil," *Spot* (Houston Center for Photography), Fall 2011, 18–25.

19. Batchen curated *Photography's Objects*, an exhibition at the UNM Art Museum, August 26–October 31, 1997, that presented many of these vernacular works from the museum's permanent collection. He also consulted on *Foto-Escultura: A Mexican Photographic Tradition*, an exhibition at the UNM Art Museum curated by Monica Garza, April 14–June 14, 1998. This project focused on Mexican portraits, often hand-colored, that were affixed to a carved wooden base. They were frequently embellished with paint and jewelry. These dimensional sculptures are roughly dated between 1920 and 1970. The UNM Art Museum acquired two of these works in 1996 on the recommendation of Geoffrey Batchen.

20. Contributions from Richard Rudisill (1932–2011), Beaumont Newhall (1908–1993), and Van Deren Coke (1921–2004) were taken from earlier sources and also reflect upon works in the collection. They are included here because their work represents important and formative contributions to the establishment of photography as a discipline. Each man holds a significant place within the larger narrative of the museum and the university. Richard Rudisill initiated and taught the first courses on the history of photography in the Department of Art and Art History, beginning in 1968, long before it became mainstream. Beaumont Newhall taught in the department from 1971 to 1984. Van Deren Coke was the first director of the UNM Art Museum and a leading figure in the discipline as a curator, museum director, and teacher.

21. Van Deren Coke, the founding director of the museum, was a very generous donor from its earliest years. With his first wife, Eleanor, and later with Joan, his gifts to the

collection exceed over 1,600 works. The Frank Van Deren Coke Estate resides at the UNM Art Museum, and the museum holds the copyright on all of Coke's personal photography, correspondence, and published writings.

22. Many important recent acquisitions have been included in this volume. The first two or four digits of the accession number for each work indicate the year in which the object was acquired by the museum. Currently photographic works in the collection number over 10,000 and there are 1,400 photographers listed in appendix 1.

Climate of Need

The daguerreotype exerted profound influences on American society between 1840 and 1860, the effects of which have never been examined. In its early period of use the photographic medium affected life in the United States in three essential ways. Initially the new medium directly encouraged cultural nationalism. Its pictures were clear affective images reflecting and reiterating many impulses toward the definition of an "American" character. At another level of consciousness, the invention of photography helped Americans adjust themselves intuitively to the transition from an agrarian to a technological society in that these images were produced with a reliable mechanical tool. Important as are both of these functions, however, it is at the level of the spirit that we must seek for the most essential operation of the daguerreotype in American life. It both reflected and activated national faith in spiritual insight and truth obtained from perceiving the works of God in nature.

Surviving daguerreotypes provide the next thing to immediate views of America as it was in the decades before 1860. They contain a directness of experience which gives us fresh information and new insights into the quality of the time. Used

Photographer unknown
Untitled, ca. 1850
Hand-colored daguerreotype,
 3⅝ × 2¾ in.
Purchased through the UNM Alumni Fund
XO.297.1.2

Photographer unknown
Untitled, ca. 1850
Daguerreotype, 2½ × 2 in.
Purchased through the UNM Alumni Fund
XO.297.1.31

in parallel with written statements, these pictures allow us to approach nearer to American life before the Civil War than we can by any other means.

While it is true that public response was mainly to pictures, it is also true that pictures were made by decisions and choices of picture makers. The daguerreotype provided a means for deliberate report of, definition of, and response to things which were significant in the lives and feelings of Americans. It provided affective symbols in a form of direct experience otherwise unattainable—words, memories, and other pictorial processes having proved inadequate by comparison. Applications of the medium were deliberate whether they were made for conscious production of art or commercially in answer to public demand. The daguerreotype process was too slow to produce many snapshots or involuntary pictures. A daguerreotype represented mutually conscious participation between photographer and subject in the presence of the camera. Simultaneously, however, the motive for producing a daguerreotype was often quite subconscious because the impulses of the operator or the patron were culturally motivated. Decisions on presentation and subject matter made by daguerreotypists desiring to produce artistic pictures are significant because they reflect responses made to life by sensitive interpreters. Thus, they reveal value judgments, emotional responses, and interpretations of the facts of a given period in the way any body of art indicates the temper of the age. In this instance, the idea of art must take into account the deliberateness of intention on the part of the cameraman. His deliberate intentions caused him to be concerned with technique and aesthetics—as defined or applicable under the nature of his particular medium—in order to produce a chosen result. [John Adams] Whipple's concern to produce a picture of the moon which was both truthful and beautiful within the capability of his medium is a case in point.

It must be recognized at the same time that the process of daguerreotypy was mainly commercial in everyday application. Its major use was to make portraits. Photographers generally did not make completely independent choices of either subject matter or treatment, however much they might try to influence their clients. The average customer in a daguerreotypist's gallery was primarily concerned with a "good likeness" in direct visual terms without concerns for principles of style or aesthetics. If a pictorial rendering looked right in terms of accurate recognition of facts and was clearly enough presented to activate suitable feelings, the picture was good.

Choices of subject matter and presentation made for non-artistic reasons in answer to customer demand are also important because individual impulses to acquire pictures were often motivated by the climate of the age. People often responded to attitudes and events, traditions, styles, or whims without being aware of the sources of their impulses. Yet remaining pictures made under these circumstances mirror the sources of these impulses when both pictures and picture makers are considered within the context of their time.

Richard Rudisill (1932–2011) received his PhD in American studies in 1967 from the University of Minnesota, where he did groundbreaking work on the daguerreotype and American society. He received the McKnight Humanities Foundation Award in American History in 1967 for his dissertation, which was published by the University of New Mexico Press in 1971 as *Mirror Image: The Influence of the Daguerreotype on American Society*. The book was selected by *Choice* magazine as one of the "outstanding academic books of 1971." Rudisill went on to curate numerous exhibitions and to publish many articles on the history of photography. He taught at the University of New Mexico from 1968 to 1971, where he initiated regular courses in the history of photography. After leaving the university he held numerous positions, including that of photographic historian at the Photo Archive of the Museum of New Mexico in Santa Fe, a post he retained for thirty years.

Note

Reprinted from Richard Rudisill, *Mirror Image: The Influence of the Daguerreotype on American Society* (Albuquerque: University of New Mexico Press, 1971), 4–5, 119–20.

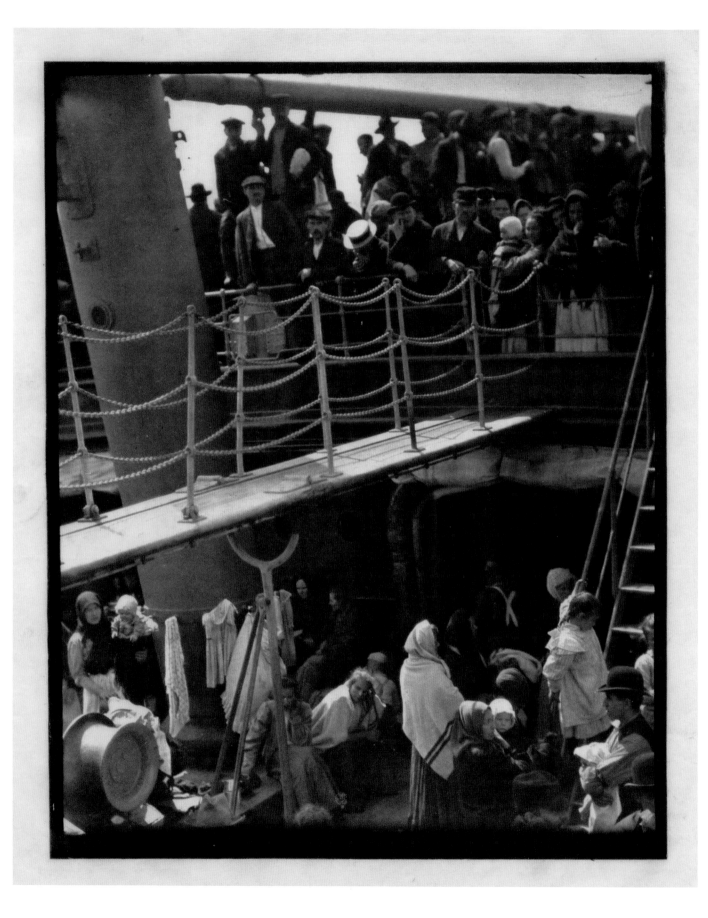

The Unreality of Photography

But what to me is fascinating is that, years and years later he [Alfred Stieglitz] found in the attic of his summer house at Lake George the original negatives, and he had only used a part of the picture. So we have a window within a window; he has only used one-third of the area. Well, he made a magnificent picture, in two separate steps. I see nothing illegitimate about photographing photographs, but in only a few year[s] he was to change his whole attitude, and this is an attitude that has been accepted by many of our fine photographers of the later period. And this is shown in this, perhaps his most famous picture. Certainly in his later years he considered it so: *The Steerage*. In the first place, this is unreal in the sense that it's not what everyone believes it to be and wants it to be, and that is, a perfect symbol of Europeans coming to America, the Promised Land, right around the corner is the Statue of Liberty. It was used, in spite of the fact that I knew it was taken not coming to America, but going to Europe. It was used by the director of one of the large museums in Washington for the opening of a show of immigration. He said, "I don't care, it's a symbol of immigration."

Well actually, we have absolute documentation that is confirmed by the study of the shadows and the orientation that the ship is in the harbor of Plymouth, England, waiting, and it's going to Cherbourg, where Stieglitz disembarked. It's not taken at sea; people couldn't be so casual in a moving vessel. And we know that it was stormy weather on the trip.

That's what's important about this picture: that he saw it in an instant. He was more or less forced to take his bride abroad on a luxury liner, and this was the *Kaiser Friedrich II* (*Kaiser Wilhelm II?*) one of the great German luxury liners, with a dining hall three stories in height; with electric curling irons for the ladies, and cigarette lighters for the gentlemen. First class. Stieglitz looking back on the experience said he hated first class, didn't want any part of it. When walking the deck he saw the steerage. The steerage did not have the deck privileges. While the ship vessel was underway, unless it was a very calm, fine day they couldn't get out of their crowded quarters. But he saw a symbol of a division between first class and steerage with the bridge. He saw in it a picture of shapes and, underlying that, the feeling he had about life. These are almost his very words. And this is precisely the image that he saw in

Alfred Stieglitz
(American, 1864–1946)
The Steerage, 1907
Photogravure on Japan paper,
7¾ × 6¼ in.
Gift of Doris Bry
© 2014 Georgia O'Keeffe Museum/
Artists Rights Society (ARS), New York
2009.15.2

the finder of his Graflex camera. I know it, because I had the privilege of seeing the negative.

This is a wholly different approach from waiting for two hours for something to happen. He stopped this action, and at the same time, he's given us an extraordinary organization. It was hard for his colleagues to understand a picture divided in two, and it was only later, with the advent of a new kind of vision, that it became appreciated, and was seen and praised by Picasso himself.

So much for the frame.

Beaumont Newhall (1908–1993) received a master's degree from Harvard University in 1931 and then continued his studies abroad at the University of Paris and the Courtauld Institute in London. He held numerous teaching, administrative, and museum positions at some of the most respected institutions across the United States, including Black Mountain College, the Philadelphia Museum of Art, the Metropolitan Museum of Art, the George Eastman House, and the Museum of Modern Art, where he was librarian from 1935 to 1942 and curator of photography from 1940 to 1945. His 1939 catalog for the MoMA exhibition *The History of Photography: 1839 to the Present*, still in print today, remains a seminal book in the field. Newhall taught at the University of New Mexico from 1971 to 1984, at which time he retired to pursue independent research, an opportunity made possible by an award from the MacArthur Foundation.

Note

Excerpted from Beaumont Newhall, "The Unreality of Photography" (Twenty-Eighth Annual Research Lecture, University of New Mexico, April 14, 1983). © 1983, Beaumont Newhall, © 2014, the estate of Beaumont and Nancy Newhall. Permission to reproduce courtesy of Scheinbaum and Russek Ltd., Santa Fe, New Mexico.

Stop-Action Photography

In the late 1850s short focal-length lenses were developed for stereo cameras which made it possible for the first time to take photographs of people and animals in motion. Even so, lacking high-speed shutters, the cameras could not stop the action of a moving horse's legs in a reliably sharp fashion. This was particularly true if the animal were moving at a right angle to the camera, the situation that presented the greatest amount of relative motion and which most clearly showed the true position of a horse's legs in various gaits.

The first photograph in which the rapid movement of a horse seen in profile was frozen in mid-stride was taken by Eadweard Muybridge in 1872. Muybridge, an Englishman, had made a considerable reputation as a landscape photographer in California before being employed by Leland Stanford, a former Governor of California and a wealthy horseman, to demonstrate that a galloping or trotting horse was not always in contact with the ground. After a number of inconclusive attempts, Muybridge made some successful single pictures of the horse Occident trotting laterally in front of the camera. The photographer used the cumbersome and relatively insensitive wet plate collodion process, which meant the pictures were not adequately exposed to record maximum details. But even with this handicap, some of Muybridge's photographs plainly showed all four of the horse's feet off the ground, thus settling a long-standing controversy.

Muybridge's work was interrupted in 1874 when he was tried and acquitted of murdering his wife's lover, but in 1877 he resumed his experiments under Stanford's patronage at Palo Alto. In June 1878 in the brilliant California sunshine at about 1/1000 of a second, Muybridge made successful exposures of such horses as Edgington and Occident trotting and of Sallie Gardner running. A thread stretched across the track tripped the shutters as the horses moved in front of a line of twenty-four cameras. The results were first published in October 1878 in *The Scientific American*. Later, cabinet-size photographs of the horses were assembled in a portfolio and widely distributed.

The following year, using an improved electric shutter arrangement, Muybridge photographed even more successfully the sequential action of the legs of the race mare Sallie Gardner and other horses as they galloped over a specially prepared course. These photographs were clear and included precise details. None of the

Eadweard Muybridge (Edward James
 Muggeridge)
(British, active United States,
 1830–1904)
"Daisy" Jumping a Hurdle, Saddled,
 1884–1886, from *Animal Locomotion,*
 vol. 9, plate 640
Collotype, 10 × 12 in.
Gift of the Philadelphia Commercial
 Museum
64.83.37

pictures showed the traditional "rocking-horse" position, a convention used by artists for over a thousand years to indicate rapid motion. Muybridge's photographs again recorded all four hoofs off the ground at one stage of the horse's stride and proved once and for all that it was unnatural to represent the legs of a running horse stretched out in front and in back. These successful stop-action photographs of horses in motion gave rise to unforeseen knowledge and excited widespread interest among artists and the public. . . .

Favorable comments and adverse criticism of the Muybridge chronophotographs reached a peak in 1887 when a large number of Muybridge's action photographs were published in book form. This eleven-volume work, *Animal Locomotion, an Electro-Photographic Investigation of Consecutive Phases of Animal Movements*, was the result of Muybridge's work with the new highly sensitive, gelatin dry plates and contained 781 large collotypes. Muybridge's research had been sponsored by the University of Pennsylvania from the spring of 1884 through 1885. Although he was initially concerned with the motion of quadrupeds, Muybridge also began a series of human-action pictures. Both his photographs of animals, borrowed from the Philadelphia Zoological Garden, and those of people were points of view taken simultaneously from three cameras electrically actuated to record twelve successive exposures on dry plates. Among the most important were photographs of nude and clothed males and females going through a variety of activities. Many of the individuals photographed were associated with the Pennsylvania Academy of Fine Arts. Muybridge's photographs of nudes in action influenced artists as much as did his equine photographic studies. This was true in the nineteenth century and has continued today in ways never anticipated by the photographer.

Van Deren Coke (1921–2004) had a long career in photography and the museum world. He, along with Clinton Adams, founded the UNM Art Museum in 1963, and he served as its first director until 1966 and again from 1971 to 1979. During some of this time he also taught studio photography in the university's Art Department. He was a curator and later the director of the Photography Department at the San Francisco Museum of Modern Art and was a deputy director at the George Eastman House. He curated many significant exhibitions and published many books, articles, and catalogs—*The Painter and the Photograph* and *Avant-Garde Photography in Germany, 1919–1939*, to name just two—all the while continuing his independent photography practice.

Note
Excerpted from Van Deren Coke, *The Painter and the Photograph: From Delacroix to Warhol* (Albuquerque: University of New Mexico Press, 1964), 155, 159. Reprinted with permission from the UNM Art Museum, which holds the copyright for Coke's personal photographs, correspondence, and published works.

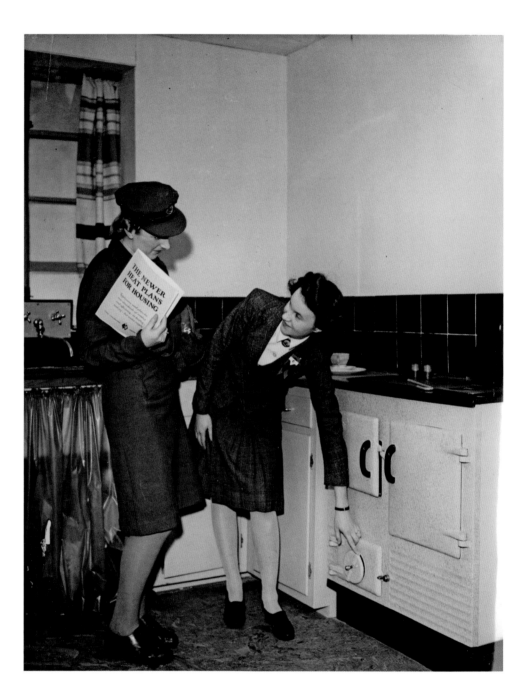

William Gordon Davis
(British, unknown)
Untitled, from the *Housing Manual*, 1944
Gelatin silver print, 8 × 10 in.
99.20.32

Mean Streets

When I arrived at the University of New Mexico in January 1973 to assume my position as associate director of the University Art Museum I had some advance knowledge of the photography collection. I had spent the past eight years at the George Eastman House, the last two with Van Deren Coke, the director who had replaced Beaumont Newhall upon his retirement. Coke often spoke of the photographic degree program and the collection at New Mexico that he had been building before coming to Rochester. After disagreements with the George Eastman House board, Coke resigned and returned to the University of New Mexico. Before leaving he asked if I might be interested in joining the faculty and further outlined his plans for the museum. I spent one more year in Rochester and then moved to Albuquerque.

One of the first people I met upon arrival was Clinton Adams, the dean of the College of Fine Arts and director of Tamarind Institute. He and Coke were the founders of the museum and they soon realized their limited funds would present a challenge to the building of a collection. They decided that they would emphasize prints and photography as the major areas of acquisition. These were their primary areas of expertise and interest, and works in these areas had not yet soared to the prices they command as I write this. They could also describe what they were building as a "teaching collection," which would aid them when they solicited funding from the central administration. This was not convenient hyperbole, since the MFA photography program would make use of prints for study, and the relocation of Tamarind Institute from Los Angeles in 1970 confirmed the logic of their decision.

The history and growth of the print collection are now well documented in several publications, most recently in *Tamarind Touchstones: Fabulous at Fifty*. The growth of the photography collection is less well known. If one looks at the accession information accompanying the images in this book it quickly becomes clear that a large number of works in the early years were gifts of Eleanor and Van Deren Coke. Although Coke died in 2002, his gifts are continuing thanks to the efforts of his widow, Joan. Numerically smaller but of equal importance were the works acquired with funding provided by the National Endowment for the Arts (NEA). In the 1970s an institution could apply for funding to acquire works that would enhance its collection, and smaller museums were particularly encouraged to apply. Coke secured

William Gordon Davis
(British, unknown)
Untitled, from the *Housing Manual*, 1944
Gelatin silver print, 8 × 10 in.
99.20.11

funding from this particular category, again with emphasis on photography and prints, until it was discontinued after arguments were raised in Congress that the government had no business funding acquisition of art.

Despite the loss of NEA funding the photographic holdings continued to grow as more people became aware of the collecting mission and began to add the UNM Art Museum to their favored institutions for year-end gifting. Coke was very adept at keeping the museum visible through modest but informative catalogs of recent acquisitions. He formed a Friends of Art group that donated at least one artwork a year to the collection. That piece was often selected from the annual Christmas purchase exhibition. Coke had made many gallery contacts as he built his own collection and would contact them early in the year and make selections for the exhibit. His selections included all mediums, and a surprising number were purchased by an

expanding collector base in Albuquerque. Usually several pieces were selected by the Friends and voted on, and the winner was acquired for the museum.

One other source that added significantly to the collection was the MacArthur Foundation. When Beaumont Newhall was awarded a MacArthur Fellowship the university received a stipend to go toward maintaining a research facility for Newhall. Since Newhall had recently retired but retained full faculty access to research materials and had an office, the director of the Art Museum, Peter Walch, was able to negotiate with the foundation and the UNM administration to allow these funds to be used for acquisitions in honor of Newhall. Newhall made a number of selections that reflected the photographers he had written about over the years. The accession records show that these selections ultimately numbered 107.

To outline the history of the collection without calling attention to any imagery would miss an opportunity for me to point to one fascinating group of photographs in the museum. I want to avoid what Newhall often called the "chestnuts" and point to a less well-known aspect of our holdings. An area of collecting the museum has proven to be prescient in is that of vernacular photography. Recognition of this mode of work is generally attributed to John Kouwenhoven's writings in his 1962 work *Made in America*. The last decade has seen numerous publications on this subject and there is no end in sight. The photography collection at the University of New Mexico had work in this vein from its inception, in part because of the importance of the development of the hand camera and the work that came to be called the snapshot. There is a very interesting group of prints acquired by the museum in 2000 that has not yet been exhibited and that I think illustrates vernacular attributes but is, strictly speaking, not vernacular. Not vernacular because we know the maker of the

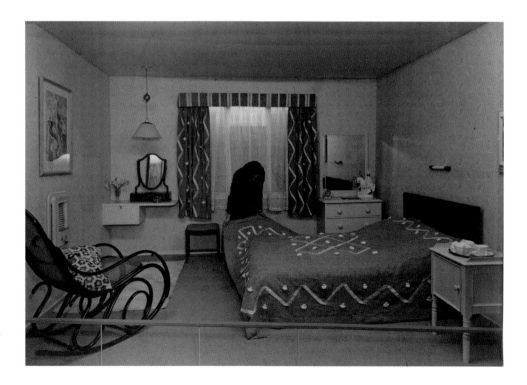

William Gordon Davis
(British, unknown)
Untitled, from the *Housing Manual,* 1944
Gelatin silver print, 8 × 10 in.
99.20.7

prints and the reason for their creation. It is a group of forty-four black-and-white photographs made by William Gordon Davis for a London publication, the *Housing Manual*, in 1944. Like many works in this genre, the images are laden with cultural information, content that vividly recalls many postwar British films and novels. Almost any novelist from this time might be quoted, but this passage from Philip Larkin's 1946 *A Girl in Winter* is particularly apt:

In the main room were two tables—a square kitchen table, with the remains of her breakfast on it, and a small thin one along the wall, littered with all sorts of oddments—and also a large store-cupboard, two straight-backed chairs . . . and a stool on one side of the fireplace. Several shabby rugs overlapped each other on the floor, dingy enough to have been ejected from other rooms of the house. . . . Over the mantelpiece a few cheap postcards were pinned to form a semi-diamond, and the mantel-shelf was piled with empty cigarette boxes.

There are, of course, visual as well as literary references for work of this nature, and they are almost beyond number, but many of Bill Brandt's works fit quite nicely—in particular those that have been reproduced in a relatively obscure 2004 book, *Homes Fit for Heroes, 1939–1943*, commissioned by the Bournville Village Trust. These mock interiors by Davis might exist in Brandt's modest structures that were documented to show how, with proper planning, natural light and fresh air might be brought to those displaced by the war.

Davis's images are made in a traditional documentary style but do possess an appearance we might label "British." I have always suspected it derives in part from the influence of Paul Rotha's books on documentary photography and film. The sheer meanness of living quarters in England have been portrayed over time, and Dickensian squalor is still able to make readers in our modern era cringe. The damage from the Blitz and the deprivations of World War II, with subsequent rationing of virtually everything, made photography the perfect vehicle to propagandize the domestic future. And Davis's images manifest a deceptive neutrality that adds to their appeal for the current age. They also appear to predict the ironies that make the images of Diane Arbus and Robert Frank so powerful.

What makes them important in a collection of historic photographs by some of the great artists of the nineteenth and twentieth centuries? One might give a number of rationalizations for their inclusion, but one that seems beyond question is to remind students and the general audience that the work that we now describe as art photography has had many diverse tributaries and works like these are one of the particularly rich sources for the study of photographic history.

Thomas Barrow studied art at the Kansas City Art Institute and with Aaron Siskind at the Institute of Design at IIT. He was assistant director at the George Eastman House before moving to New Mexico in 1973, where he taught both studio photography and the history of photography. In addition to teaching he also served as associate director of the UNM Art Museum from 1973 to 1976. Barrow received two NEA Photographer's Fellowships (1973, 1978). He is widely exhibited and his work was the subject of a midcareer retrospective exhibition at the San Francisco Museum of Modern Art and the Los Angeles County Museum of Art in 1986–1987. The institutions that have collected his work include the Museum of Modern Art, the San Francisco Museum of Modern Art, the Denver Art Museum, the Getty Center for the History of Art and the Humanities, the George Eastman House, and the Kiyosato Museum of Photographic Art in Japan. The most recent publication that profiles his photographic work is *Cancellations*, with an essay by Geoffrey Batchen, published in 2012 by powerHouse Books. Barrow's archive is held by the Center for Creative Photography at the University of Arizona in Tucson.

Beaumont Newhall
(American, 1908–1993)
Chase National Bank, New York, 1928,
 from the portfolio *Beaumont Newhall*
 Photographs, 1981
Gelatin silver print, 8⅜ × 8½ in.
Museum purchase through the Julius L.
 Rolshoven Memorial Fund
© 1928, Beaumont Newhall; © 2014,
 the Estate of Beaumont and Nancy
 Newhall; permission to reproduce
 courtesy of Scheinbaum and
 Russek Ltd., Santa Fe, NM
86.164.1

Beaumont Newhall

Understanding Photography by Photographing

Erich Mendelsohn
(German, 1887–1953)
New York, Equitable Trust Building, from
Amerika: Bilderbuch Eines Architekten,
plate 3, 1926

When Beaumont Newhall died in 1993, he was hailed as a pioneering historian of photography and "an ardent and articulate champion of the medium."[1] Every obituary noted how, as a young librarian at the fledgling Museum of Modern Art in New York, he organized the groundbreaking exhibition *Photography 1839–1937*. Acclaimed as the first show of its kind to emphasize "the medium's status as an art form," it was also acknowledged as one of the earliest attempts to present a "coherent account of photography from its inception."[2] Many remarked that its success was made all the more notable by Newhall's limited budget—$5,000—and the fact that there were few organized public collections of photographs at the time. Newhall's subsequent work as the founding curator of the photography department at the Museum of Modern Art (1940) and as the first curator (1948) and director (1958) of the George Eastman House in Rochester, New York, was also highly applauded, as were his scholarly activities. Over the course of his lifetime, he published more than six hundred articles, catalogs, and books, including his seminal *Photography: A Short Critical History* (1938) and *The History of Photography: 1839 to the Present* (1948), along with such focused studies as *The Latent Image: The Discovery of Photography* (1961), *The Daguerreotype in America* (1961), *Airborne Camera* (1969), and *Frederick H. Evans* (1975). Extolling his "clear, forceful prose," obituaries praised his ability to "fuse detailed research with the immediacy of contemporary accounts to produce compelling narratives," and they commented that his study of "the development of the medium as both an art and a means of communication quickly became established as the pre-eminent history of photography."[3] In addition, his friendships with many of the most important photographers of his time—including Ansel Adams, Henri Cartier-Bresson, Alfred Stieglitz, and Edward Weston—were celebrated; one writer even stated that these relationships "lent added authority and insight to his writing about the medium."[4] His tireless efforts to achieve intellectual recognition for the medium, along with his work as a teacher, both in Rochester, New York, and at the University of New Mexico in Albuquerque, were also widely commended: "Generations of curators, historians and students will remember him for his extraordinarily vivid anecdotes and his generosity with his vast store of research notes."[5]

But only a few of these obituaries—which were published in newspapers from

New York City and London to Albuquerque and Rochester, New York—noted that Newhall was also a photographer. To be sure, his greatest accomplishments were as a curator, scholar, and author, and he promoted his own photographs only at the very end of his life. But in their assessments of his contributions, did these writers, as well as others who have studied his career, overlook an important aspect of his work that affected not only his judgment on who and what to include in—and exclude from—his history of photography, especially when he first articulated it in the late 1930s, but also how he constructed that narrative? How did Newhall's extensive, firsthand understanding of both the technique and the practice of photography (its technical, chemical, and optical complexities; its reliance on selection, framing, and point of view; its challenge to organize the chaotic flux of the world into a cohesive picture; and its ability to record, interpret, and even distort reality) affect his aesthetic and historical judgments? And how do the influences we can see in his own photographs elucidate the evolution of his understanding of the uses and relative merits of photography as a means of artistic expression and communication? To answer these questions, we need to look at his own photographs, his early training, and his later reflections, published in both *In Plain Sight: The Photographs of Beaumont Newhall* (1983) and *Focus: Memoirs of a Life in Photography*, released just shortly after his death in 1993.[6]

Newhall's interest in the history of photography grew directly out of his work as a photographer. A quiet, reserved, and introverted young man, he was born in 1908 in Lynn, Massachusetts, on the Atlantic coast north of Boston, the son of a well-respected physician. As a young boy, he was entranced with the many sailing vessels that still filled the local harbors and soon became enthralled with building model ships. In order to ensure accuracy, he studied the history of each boat that he built in the Peabody Museum in nearby Salem. Deeming his models "three-dimensional research reports," he soon realized that the more he learned about the subject, the more his fascination grew.[7] This same paradigm proved true with photography, which captivated him from an early age. His mother, Alice, had collected photographs on her European travels as a young woman, and after her marriage she became an "ardent," semiprofessional photographer. She made portraits of her family and friends, as well as others, in a fully equipped studio on the third floor of the family's house. Using a camera that made six-by-eight-inch glass plates, she did all of her own processing and, as was the fashion of the time, made platinum prints. Newhall later insisted, however, that she had no use for the prevailing trend of soft-focus pictorialism and instead made "solid . . . convincing . . . direct" pictures with "a strong feeling of presence." One of his earliest childhood memories was of standing by his mother in the darkroom and watching the image appear "as if by magic" in the tray.[8] Intrigued by this mysterious process, he even dipped his finger into one of the solutions to taste it, prompting his mother to immediately wash his mouth out with soap.

His mother lost interest in photography in 1914 when platinum paper become difficult to obtain because of the war, and Newhall took over her darkroom in 1923

when his own curiosity in model shipbuilding waned. According to his memoirs, he taught himself how to photograph and how to develop and print his images. Using an Ansco folding camera that made 2¼-by-3¼-inch negatives, he, like any amateur, depicted the things that mattered to him—ships in the nearby harbors, family and friends, and his home and bicycle. Yet in 1926, just as he entered Harvard College, he began to use his camera for more than mere record making. That year he discovered two key examples of New Vision photography, which flourished in Europe in the 1920s and early 1930s, especially at the Bauhaus in Germany under the noted Hungarian artist László Moholy-Nagy. The first was *Variety* (also known as *Jealousy*), a 1925 German film directed by Ewald André Dupont and Erich Pommer and filmed by Karl Freund, and the second was *Amerika: Bilderbuch eines Architekten*, a photobook by Erich Mendelsohn, a leading architect of the International Style. Both the film and book embodied a radically different aesthetic of photography than his mother's more staid, late nineteenth-century approach, one based in what were believed to be the medium's inherent characteristics and rooted in the technological culture of the twentieth century. Utilizing a fluid, highly mobile camera, Freund exploited dramatic, unexpected angles and mimicked the fragmented, fast-paced state of modern life. His camera was "now looking up, now looking down," Newhall later recalled, "now frighteningly close to an eye, an ear, now swinging dizzingly from a circus trapeze, now showing multiple overlapping images of seemingly a hundred hands clapping over a single ear."[9] Placing primary importance on the radically new ways the camera could see the world, Freund and other proponents of the New Vision celebrated the mechanical nature of this new machine as a surrogate eye that would provide new ways of comprehending reality.

Mendelsohn was equally innovative. Using both his own photographs made on a 1924 trip to the United States and ones taken by others, his book of pictures of New York, Chicago, Detroit, and Buffalo is a tightly structured sequence, a "voyage of investigation for the eye and brain," as he wrote.[10] The strikingly dramatic photographs include worms'-eye views from the street looking up to the tops of towering skyscrapers, as well as head-on studies that emphasize the massive solidity of the buildings themselves. Mendelsohn hoped to re-create the sensory experience of the modern American metropolis and reveal characteristics he considered inherently American: liberty, measureless wealth, and a celebration of the new, but also unbridled ruthlessness, a love of power, and a need to dominate. Yet what perhaps influenced Newhall the most was the fact that Mendelsohn, like Freund, emphasized both the practical and conceptual importance of photography to the modern era. "Nothing appeals more readily to modern man," Mendelsohn wrote in 1927, "than [the] picture. He wants to understand, but quickly, clearly, without a lot of furrowing of brows and mysticism." And yet, he continued, while photographs provided essential visual information about the world with the rapidity demanded by the modern age, they did not destroy its magic: "with all this," he asserted, it "is mysterious as never before, impenetrable and full of daring possibilities."[11]

The first photograph Newhall reproduced in *In Plain Sight* was *Chase National*

Bank, New York, 1928, a picture that reveals how deeply he was affected by these works, especially Mendelsohn's book. But other influences were equally important. In 1927, after discovering the classic modernist film *The Cabinet of Dr. Caligari*, he saw Henri Chomette's little known *À quoi rêvent les jeunes filles?* (What do young girls dream?), 1924. With its double exposures, upside-down shots, and use of kaleido-scopes—all employed for pictorial, not narrative, effect—the film emphasized, as Newhall wrote at the time, "the true possibilities of that most versatile machine, the motion picture camera," and he admonished all American photographers to "take notice of it."[12] Scholarly concerns also began to affect his own photographs. Unable to take courses in film or photography at Harvard, he started to study art history, first as an undergraduate and, beginning in 1930, as a graduate student, when he worked with Paul Sachs, a professor and associate director of the Fogg Art Museum. Sachs's celebrated course Fine Arts 15a, Museum Work and Museum Practices, was the teaching ground for many future curators and directors, including Newhall. Although the students were introduced to all aspects of museum work, management, and ethics, Sachs was also determined to train a generation of "connoisseur-scholars." Eschewing what Newhall called the "archaeological" approach employed in many of his other courses at Harvard, in which students were required to memorize the title, date, location, and provenance of hundreds of works of art, Sachs instead used his own collection of prints and drawings to conduct seminars with extensive class participation. There he emphasized the centrality of the object itself, the need for close visual analysis, the importance of collecting and interpreting objects, the role of scholarship and conservation, and the hierarchies of aesthetic worth.[13] Other art historians also informed Newhall's thinking at this time. These included the Swiss Heinrich Wölfflin, whose objective classifying principles (painterly versus linear; closed and open forms) were influential in the rise of formal analysis in art history in the early twentieth century; the Viennese Aloïs Riegl, whose investigation of new criteria for the appreciation and analysis of underappreciated genres, such as tapestries and carpets, was the foundation for much modern art history; and the German Wilhelm Worringer, whose ideas on art and empathy (that our sense of beauty comes from our ability to relate to works of art) profoundly affected twentieth-century art historical discourse. All of these art historians' insights reso-nated deeply with Newhall. They gave him the critical vocabulary that he needed and the license to explore new avenues of creative expression.

He began to apply these ideas to his assessment of both his own photographs and those of others in the early 1930s. As an attentive consumer of photography period-icals, he had been increasingly influenced by the growing reaction to what he later termed "the decadent pictorial trend" in most contemporary photographs intended as "art." Applying Sachs's hierarchical aesthetic assessments, he described the tech-nique of these photographers as "very poor, weak and ineffective" and their "soft-focused" pictures, which were riddled with "handwork," as "sentimental."[14] Then, in 1935, when he reviewed *Modern Photography 1934–35: The Studio Annual of Camera Art*, he discovered an essay by Ansel Adams titled "The New Photography," which

also included reproductions of some of Adams's pictures. Adams, as Newhall wrote, insisted that "the ability of the camera to capture the utmost possible detail of the natural world" was the medium's "chief characteristic," and he—and soon Newhall too—stressed that this new "pure" or "straight" photography was the only "legitimate aesthetic."[15] Significantly more dogmatic than Moholy-Nagy's New Vision, less inclusive and more focused on photography as a means of artistic expression, Adams's approach left little room for photographs made for purely scientific, documentary, or amateur purposes. Nevertheless, Newhall was "greatly impressed" by Adams's article and by his photographs, especially *Pine Cone* and *Eucalyptus and Old Fence*. He carefully studied the pictures, articulated their importance, and then, moving back and forth between his roles as a critic and a photographer, went out to his own backyard to photograph a lilac bush. He discovered, however, that the strength of Adams's art lay not in his subject matter but in his vision and technical mastery. The following year, when he reviewed Adams's *Making a Photograph: An Introduction to Photography*, he was "absolutely bowled over" by the modernity of straight photography, which demonstrated "what may be achieved by simple and logical procedure of

unmanipulated negatives and prints."[16] Again drawing on his understanding of what a photographic print should look like, he praised the quality of the tipped-in reproductions in Adams's book, noting that they were so superb they were often mistaken for originals. In addition, Adams's understanding that "it is necessary to interpret the medium in its own terms and within its own limitations" echoed Newhall's own growing belief that photography had unique qualities that grew out of its technique, which needed to be explored and exploited.[17] And Adams's belief that collections of fine art photographs needed to be formed so that the work of individual masters could be studied resonated with what Newhall had learned from Sachs and was daily reinforced by his new job as a librarian at the Museum of Modern Art.

As Newhall's enthuiasm for the American purist or straight photographs of Adams, Alfred Stieglitz, and Edward Weston overtook his love for European New Vision, the style and subject matter of his own photographs began to change. Stieglitz was also a key factor in this transformation. Newhall had first seen Stieglitz's work in 1932 when he visited the elder photographer's exhibition at his gallery, An American Place. In the next few years, he frequented the gallery many times, but he and Stieglitz did not meet until 1935. When they did, Stieglitz was at first cool to Newhall, but he warmed when he saw the younger man's photographs and gave him helpful hints. As Newhall later recalled, Stieglitz "suggested that I acquire a view camera and showed me how to use the swings and tilts. He taught me how to wax my prints and drymount them. He gave me chemicals he was no longer using."[18] But Newhall also learned other things. Stieglitz's "sharp, fully detailed" pictures, with their "bold" compositions, had a great impact on his own photographs, but so too did Stieglitz's choice of subjects, especially his views of his family's simple, late nineteenth-century farmhouse in Lake George, New York.[19] Beginning in the mid-1930s Newhall embarked on his own series of photographs of Victorian architecture that sought to "present a clue to the observant spectator," as he wrote a few years later, of "those evanescent or unnoticed traces of the human hand" in the world at large.[20] Just as Stieglitz sought meaningful elements of the house at Lake George that revealed the character and spirit of its inhabitants, so too did Newhall look for what he called "significant details" in his architectural photographs. Stieglitz, for example, photographed a section of the porch that Georgia O'Keeffe had removed, indicating her profound impact on the place, while Newhall recorded the way a vine curved around the base of a column, echoing the ornate floral brackets at its top and demonstrating the close coexistence of nature and culture. Newhall's early 1940s photographs of New York City also owe a debt to Stieglitz's pictures made ten years earlier. Rejecting Freund's or Mendelsohn's dizzing vision, Newhall presented the buildings as massive and monumental, but also sober and dignified, similar to Stieglitz's powerful but elegiac views made in the early years of the Depression. Yet Newhall remembered that what he learned most from Stieglitz was conceptual, inspirational, and almost "indefinable. . . . He passed on to me some of the intuitive recognition of that spirit he called 'the idea of photography.'"[21]

Weston was equally important to Newhall's ideas and his photographs. They

first met in 1940 when Newhall and his wife, Nancy, went to California to visit Adams. They spent two weeks with Weston and his wife, Charis, accompanying him to his beloved Point Lobos. There Newhall looked under the focusing cloth of Weston's large eight-by-ten-inch view camera at the image after Weston had made his exposure: comparing what was on the ground glass with what was in front of the camera, Newhall remembered, "offered a lesson in seeing." But he took few photographs at Point Lobos because he recognized that he was so "strongly influenced by his [Weston's] vision that I found myself imitating him."[22] Instead, Newhall made carefully composed, direct pictures of objects that spoke of Weston's life and values—his Victorian coffee grinder, his darkroom, and Charis's typewriter—as well as the photographer himself looking out of the window of his unadorned wooden house. Continuing his instruction by "quiet example," Weston took Newhall into his darkroom and showed him how he developed and fixed his negatives and prints and how he even "dodged" his prints (which Newhall had previously considered anathema in straight photography) to achieve his desired results. As Newhall reflected many years later, Weston taught him "more than any other photographer I have ever known, for he demonstrated to me—rather than just telling me about—his brilliant technique."[23]

They also systematically looked at many of Weston's photographs. Weston would carefully place one picture at a time on an easel, lit by a floodlight. The Newhalls would comment on each one and, when they were finished, he would remove it and put another in its place. Although Weston would answer questions if asked, he did not volunteer any information about how, when, or why he made a picture, for the sanctity of the object and its expression of "the thing itself," as he termed it, were of paramount importance to him. Newhall contrasted this approach with Moholy-Nagy's presentation of his own work. When he visited the Hungarian photographer in Chicago and looked at his photographs, "he held a print up for my inspection and never stopped talking, telling us what we should be seeing. . . . Then he casually threw the photograph on the floor." At the end of the session, Moholy-Nagy looked at the pile of pictures on the floor and was thrilled to discover new things on seeing them sideways and upside down. Understanding photography as a means to discern new ideas, not an end in itself, he exclaimed, "Oh Beaumont, this is so beautiful this way. . . . I never saw this before."[24]

Thus we can see the dichotomy that Christopher Phillips noted in his article "The Judgment Seat of Photography" when he observed that the young curator's understanding of photography hovered in the mid- to late 1930s between an approach influenced by Moholy-Nagy's New Vision and one informed by Adams's straight photography. As Phillips writes, Newhall's 1937 exhibition was but one of several shows organized in the early years of the Museum of Modern Art that sought to "impart a convincing retrospective order to their heterogeneous domains, and, by so doing, to confirm MoMA's claim as the preeminent institutional interpreter of modern art and its allied movements."[25] In keeping with the Eurocentric focus of the museum's founding director, Alfred Barr, Newhall's 1937 show was indeed similar to several

other exhibitions that had been organized in Germany between 1925 and 1933.[26] In its display of over eight hundred objects, arrranged in both a chronological order according to technical process (daguerreotype, calotype, wet collodion, and dry plate) and by Newhall's assessment of their current-day application (press photography, X-ray, astronomical photography, and "creative" photography, for example), the show was closer, as Phillips notes, to Moholy-Nagy's more catholic, wide-ranging view of *fotokunst* than Stieglitz's or Adams's rarefied, exclusive notion of *kunstphotografie*. Moholy-Nagy was a member of the advisory committee for the 1937 show (as, ironically, was the photographer Edward Steichen, who would later depose Newhall as the photography curator at MoMA). Yet the first person Newhall asked to join the committee was Stieglitz, who refused. Newhall was too young, too inexperienced, Stieglitz believed, to organize such an ambitious exhibition on a topic to which Stieglitz had devoted his life; in addition, Stieglitz was suspicious of the museum, which had paid scant attention to American artists and purported to champion the modern European artists he had discovered thirty years earlier. However, just as Newhall's own photographs had shed their allegiance to the New Vision by the late 1930s, so too did Newhall assert Stieglitz's prominence the following year when he published a revised and expanded version of his initial catalog essay in *Photography: A Short Critical History* (1938): the book was dedicated to Stieglitz, and his photograph *House and Grape Leaves* was its frontispiece.[27]

While these points by Phillips are well taken, it is also important to note that Newhall did not come to the study of the history of photography as a disinterested historian but as a passionate photographer who was deeply excited about the creative possibilities of his chosen medium. When he developed a history of photography based, as he later said, on the evolution of "technique to visualization," he derived his ideas from Sachs, Wölfflin, Riegl, and Worringer but also from his own firsthand experience as a photographer.[28] He had seen how a change in technique—from his mother's softer platinum prints to Stieglitz's and Adams's sharper gelatin silver ones, or from his own $2\frac{1}{4}$-by-$3\frac{1}{4}$-inch camera to Stieglitz's 8-by-10-inch one—had radically altered the image and its meaning. Thus, when he wrote in 1937 that in order for the aesthetic criteria for the "criticism of photography" to be "valid, photography should be examined in terms of of the optical and chemical laws which govern its production," he was speaking both as an art historian influenced by Wölfflin and Barr and as a photographer who thought that the medium had been corrupted by practitioners who did not respect these inherent "generic . . . laws."[29] And in 1940 when he was named MoMA's founding curator of photography and applied what Phillips calls "the connoisseur's cultivated, discriminating taste" to articulate the "monuments of photography's past," a "canon" of the "masters of photography," and "a historical approach that started from the supposition of creative expression," he did so both as a student of Sachs and Adams and as a photographer who believed, as he wrote in 1940, that "each print is an individual personal expression."[30] In his own photographs, he aspired, as he wrote a few years later, to "above all . . . produce pictures that will not be startling or obtrusive, but will compel attention through

their depth of feeling and their 'rightness.'"[31] As he himself reflected at the end of his life, "it has been important to me, as an historian of photography, to understand photography by photographing."[32]

Sarah Greenough is a senior curator and head of the Department of Photographs at the National Gallery of Art, Washington, DC, where she has worked since 1986. She has authored many critically acclaimed books on modern photography, including *Garry Winogrand* (Yale University Press, 2013), *My Faraway One: Selected Letters of Georgia O'Keeffe and Alfred Stieglitz* (Yale University Press, 2011), *Alfred Stieglitz: The Key Set*, vols. 1 and 2 (Abrams, 2002), *Looking In: Robert Frank's "The Americans"* (Steidl, 2009), and *Walker Evans: Subways and Streets* (National Gallery of Art, 1991). Her scholarship also includes important contributions on the work of Arthur Dove, Roger Fenton, André Kertész, Irving Penn, and Paul Strand. Greenough received her PhD from the University of New Mexico in 1984 under Beaumont Newhall. The title of her dissertation was "Alfred Stieglitz's Photographs of Clouds."

Notes

1. Charles Hagen, "Beaumont Newhall, a Historian of Photography, Is Dead at 84," *New York Times*, February 27, 1993.

2. Valerie Lloyd, "Obituary: Beaumont Newhall," *Independent*, March 9, 1993.

3. Hagen, "Beaumont Newhall"; and Lloyd, "Obituary."

4. Hagen, "Beaumont Newhall."

5. Lloyd, "Obituary."

6. Beaumont Newhall, *In Plain Sight: The Photographs of Beaumont Newhall*, foreword by Ansel Adams (Salt Lake City, UT: G. M. Smith, 1983); and Beaumont Newhall, *Focus: Memoirs of a Life in Photography* (Boston, MA: Little, Brown, 1993).

7. Newhall, *Focus*, 13–14.

8. Ibid., 9–10.

9. Newhall, *In Plain Sight*, ix.

10. Quoted in Michele Stavagna, "Image and the Space of the Modern City in Erich Mendelsohn's *Amerika: Bilderbuch eines Architeken*" (article presented at a conference on architecture and the digital image at Weimar Bauhaus University, 2008), 339, https://e-pub.uni-weimar.de/opus4/frontdoor/index/index/docId/1345.

11. Quoted in ibid., 340.

12. Newhall, *Focus*, 22.

13. See Sally Anne Duncan, "Paul Sachs and the Museum Course at Harvard" (MA thesis, Tufts University, 1996).

14. Newhall, *Focus*, 45.

15. Ibid., 45, 33.

16. Ibid., 45.

17. Newhall, *In Plain Sight*, x.

18. Ibid.

19. Newhall, *Focus*, 46.

20. Newhall to Nancy Newhall, February 2, 1944, quoted in Newhall, *In Plain Sight*, xi. In the early 1930s Walker Evans also photographed American Victorian houses, and these pictures were shown at the Museum of Modern Art in 1933 in an exhibition organized by Lincoln Kirstein, Newhall's classmate and a fellow Paul Sachs student. Newhall mentions Evans and this exhibition in *Focus* (43) but does not address Evans's photographs.

21. Newhall, *In Plain Sight*, x.

22. Newhall, *Focus*, 62–63.

23. Ibid., 63.

24. Ibid.

25. Christopher Phillips, "The Judgment Seat of Photography," *October* 22 (Autumn 1982): 32.

26. Ute Eskildsen, "Innovative Photography in Germany between the Wars," in *Avant-Garde Photography in Germany, 1919–1939*, ed. Van Deren Coke (San Francisco, CA: San Francisco Museum of Modern Art, 1980), notes that there was a series of exhibitions in Germany from 1925 to 1933 that were similar in format to Newhall's show. An expanded version of Coke's catalog was published two years later: Van Deren Coke, *Avant-Garde Photography in Germany, 1919–1939* (New York: Pantheon, 1982).

27. Beaumont Newhall, *Photography: A Short Critical History* (New York: Museum of Modern Art, 1938).

28. Beaumont Newhall, "Program of the Department," *Bulletin of the Museum of Modern Art* 8 (December–January 1940–1941): 4.

29. Beaumont Newhall, *Modern Photography, 1839–1937* (New York: Museum of Modern Art, 1937), 41.

30. Phillips, "Judgment Seat of Photography," 35; and Beaumont Newhall, "The Exhibition: Sixty Photographs," *Bulletin of the Museum of Modern Art* 8 (December–January 1940–1941): 5.

31. Newhall to Nancy Newhall, February 2, 1944, quoted in Newhall, *In Plain Sight*, xii.

32. Newhall, *In Plain Sight*, xiii.

Encountering the Vernacular

Strangely enough, I first encountered the vernacular in New Mexico. I had been writing an essay about some of the many contemporary artists who incorporated photographs into three-dimensional objects or who turned their photographs into such objects.[1] I was well aware that the Art Department at the University of New Mexico featured artists famous for intruding on their photographs in similar fashion, with Thomas Barrow scratching his negatives to make the *Cancellation* series in the early 1970s and Betty Hahn embroidering her prints during the same period.[2] But my efforts to make sense of the relationship between photography and sculpture in the 1990s led me to reflect on the long history of this relationship, not just in art practice but more broadly in the culture at large. During my frequent visits to local antique stores, often accompanied by Barrow (another inveterate junker), I began to notice nineteenth-century examples that had previously been invisible to me. Not just cased daguerreotypes, photographic jewelry, and snapshot albums, all forms of photography that insist on the involvement of one's hand as well as one's eye, but also elaborately framed tintypes and similarly hybrid photographic objects designed to be seen on a wall. Suddenly it seemed as if photographic sculptures of one sort or another were everywhere.

In my very first week in Albuquerque I bought a framed tintype showing a little girl perched on a man's knee, with the photograph surrounded by a black velvet mat that had been embellished with a wreath of stitched flowers. Here was a kind of work that had entirely escaped consideration by a history of photography still anxiously, insecurely, tied to the lofty values and myopic vision of a formalist art history. It was work that reeked of sentiment and middlebrow taste and yet that also conjured a multisensory experience (not just touch and sight but also an imagined scent emitted by those flowers) and a complex reflection on time and space. Roland Barthes had indelibly associated photographs with the "that-has-been," with a tracing of some past moment.[3] But this object sought to give its departed subject an ongoing presence in the present, both literally through its location of the photograph in a three-dimensional setting and symbolically through its addition of a circular wreath of flowers, a sign of eternity and renewal. It simultaneously declared that the little girl was dead and that she was still alive, in memory and in the afterlife. It was, in

Mary Georgiana Caroline, Lady Filmer
 (née Cecil)
(British, 1838–1903)
Untitled, from the *Filmer Album*,
 mid-1860s
Watercolor with albumen prints,
 11¼ × 9 in.
Gift of Harry H. Lunn Jr.
84.102.2

other words, a kind of icon in which the girl depicted in the photograph could hover, permanently suspended between life and death.

Already, then, a close attention to this object suggested there is much that is extraordinary about otherwise ordinary photographs. But it was also a stark reminder that photographs are indeed objects, comprising diverse shapes, materials, and dimensions as well as various textures. They engage not only the sense of sight but also touch, smell, and even sound. One of the great things about teaching at the University of New Mexico was that you could collaborate with the Art Museum and embody your latest research in exhibition form. After hearing of my research, the museum's curator, Kathleen Howe, generously invited me to organize an exhibition

for the small study gallery. *Photography's Objects* opened there in August 1997.[4] Items were borrowed from the museum, but also from the Palace of the Governors in Santa Fe and from the owner of the antique mall where I found my embroidered tintype. These loans significantly enhanced the exhibition, allowing me to include, for example, a wonderful Plumbe daguerreotype in a thermoplastic frame, two pages from Lady Filmer's decorated album of albumen prints, and a deck of photographic playing cards from about 1900. Despite these additions, I was surprised at how difficult it was to find certain kinds of photographs in public collections. Hence a fair few of the exhibits came from my own collection, gathered primarily from local antique stores.

A modest illustrated catalog was prepared with the help of two MFA students, Kim McLain and Marcell Hackbardt. They ensured that each object that was reproduced threw shadows back onto the page, a subliminal reminder of the exhibition's thesis. The essay inside gave me a chance to explore these kinds of photographs in words for the first time. I described Lady Filmer's album pages, for example, as an "artful collage": "attention is drawn to the edges of its constituent images, disrupting the seamlessness of photography's representational claims to fidelity and realism as well as its role as an inscription of the past (these photographs are harshly located in the here and now of the page itself)." On this basis, the essay was able to conclude that "these everyday objects of the nineteenth century" were "sensual and creative artefacts" but also "thoughtful and provocative meditations on the identity of photography itself." One striking thing, though: nowhere in the essay did I use the word "vernacular."

This was a term, however, that was soon to become an integrated part of photographic discourse. As a consequence of my little exhibition, I was invited in 1998 to be one of the speakers at what was billed as *The 1st "Vernacular" Photography Fair* in New York, where I found myself in debate with such luminaries as Douglas Nickel, Bill Hunt, Peter Galassi, Stanley Burns, and Daile Kaplan.[5] It was rare to find representatives of the auction, museum, collecting, and academic worlds all in one place

Antoine François Jean Claudet
(French, active England, 1797–1867)
Untitled, ca. 1850s
Hand-colored stereo daguerreotype,
 4 × 7½ in.
Gift of the Estate of F. Van Deren Coke
 and Joan Coke
2011.24.1 a-b

and exchanging views on a topic of common interest. I began to reflect on the methodological implications of this kind of material for a history of photography and gave lectures on this topic in a number of places. One of those places was Amsterdam, and I was subsequently asked to curate a more extensive version of *Photography's Objects* for the Van Gogh Museum in that city, a project that became *Forget Me Not: Photography and Remembrance*.[6] It ended up touring to Iceland, Britain, and the United States. I also guest edited an issue of the journal *History of Photography* in 2000 on vernacular photography and wrote an extended meditation on the issues that a study of this material might entail.[7]

In the same year that *Photography's Objects* was shown at the Art Museum, I also taught a new seminar titled Exhibitionism: Curatorial Practice. Students were required to develop a "real-life" exhibition proposal, based on, among other inputs, meetings with staff at the museum. Indeed, the director, Peter Walch, and Kathleen Howe were invited to help adjudicate the final proposals. One of those was composed by master's student Monica Garza and focused on a previously unresearched

John Plumbe Jr.
(American, born Wales, 1809–1857)
Untitled, ca. 1845
Daguerreotype in thermoplastic frame,
 3 × 2½ in.
Purchased through the UNM Alumni Fund
X0.297.1.158

Photographer unknown
(Mexican, 20th century)
Untitled, *foto-escultura*, ca. 1940
Photograph mounted on carved wood
 paint and tacks, 9½ × 11⅛ × 2¼ in.
Anonymous gift
96.34.1

Mexican genre of photography known as *foto-escultura*. Garza had first encountered these objects in my office. And I had first had my attention drawn to them by then UNM librarian Stella de Sá Rego, who showed me some she had collected and lent me snapshots of the same. These are what I shared with Garza.

Inspired to pursue research on an aspect of her own cultural heritage, Garza discovered that her own family owned some examples (although they had never previously shown them to her). It also turned out that a shop in Albuquerque dedicated to Mexican arts and crafts was selling examples, and a number of my colleagues ended up buying one or more (I bought five). These colleagues included Peter Walch, who bought two very fine examples and donated them to the Art Museum. Garza was invited to turn her proposal into an exhibition about foto-escultura, and this opened in April 1998.[8] Like *Photography's Objects* it was accompanied by a small illustrated catalog. Once again, it was a striking example of the mutually supportive interaction between the museum and the teaching program at the university. As a result of all this, a large color reproduction of a foto-escultura now features in a global history of photography, Mary Warner Marien's *Photography: A Cultural History*.[9]

With this research behind me, and a growing body of literature to draw on, I decided in 2002—my last year at the university—to offer a seminar that looked exclusively at vernacular photography and the practices associated with it. The first session was spent in the Art Museum's print room, looking at examples from the collections. The aim was to impress on students that research could and should be focused on actual objects, and on quite ordinary objects at that (and that this ordinariness should not be written out of our analyses of them). In May of this same year I guest edited a special issue of the journal *Afterimage* on this same topic, and it featured three essays by UNM students; one by Garza on foto-escultura, one by MFA graduate Jina Chang that compared a photograph of her grandfather with a painted tintype, and one by MA graduate Erin Garcia that looked at a pillow that comprised thirty cyanotypes printed on cotton.[10]

This brief history of my time at the University of New Mexico has ended up being a tribute to the interaction between the studio art and art history programs and the Art Museum. It reveals the potential richness of such an interaction. It also provides evidence that some modest beginnings, such as these initiated in the junk stores of Albuquerque and given both substance and presence by the Art Museum, can go on to have national, and even international, impact. Certainly, my own work as a historian continues to engage with issues first encountered in this context. I feel lucky to have had that encounter.

GEOFFREY BATCHEN

Geoffrey Batchen's work as a teacher, writer, and curator focuses on the history of photography with a particular interest in the way that photography mediates every other aspect of modern life. Batchen has published extensively, in eighteen languages to date. He is the author of *Burning with Desire: The Conception of Photography* (MIT Press, 1997), *Each Wild Idea: Writing, Photography, History* (MIT Press, 2001), *Forget Me Not: Photography and Remembrance* (Princeton Architectural Press, 2004), *William Henry Fox Talbot* (Phaidon, 2008), and *Suspending Time: Life, Photography, Death* (Izu Photo Museum, 2010). He has also edited an anthology of essays, *Photography Degree Zero: Reflections on Roland Barthes's Camera Lucida* (MIT Press, 2009) and coedited *Picturing Atrocity: Photography in Crisis* (Reaktion, 2012). He taught at the University of New Mexico from 1996 to 2002 and currently is the Professor of Art History at Victoria University, Wellington, New Zealand.

Notes

1. See Geoffrey Batchen, "On Post-Photography," *Afterimage* 20.3 (October 1992): 17; and Geoffrey Batchen, "Post-Photography," in *Each Wild Idea: Writing, Photography, History* (Cambridge, MA: MIT Press, 2001), 108–27, 211–15.

2. I ended up writing about this too. See Geoffrey Batchen, "Cancellation," in *The Last Picture Show: Artists Using Photography, 1960–1982*, ed. Douglas Fogle, exhibition catalog (Minneapolis, MN: Walker Art Center, 2004), 62–67.

3. See Roland Barthes, *Camera Lucida: Reflections on Photography* (New York: Hill and Wang, 1981).

4. *Photography's Objects*, University of New Mexico Art Museum, Albuquerque, August 26–October 31, 1997.

5. *The 1st "Vernacular" Photography Fair*, Metropolitan Pavilion, New York, October 2–4, 1998.

6. *Forget Me Not: Photography and Remembrance*, Van Gogh Museum, Amsterdam, March 26–June 6, 2004.

7. Geoffrey Batchen, "Vernacular Photographies," *History of Photography* 24, no. 3 (Autumn 2000): 262–71.

8. *Foto-Escultura: A Mexican Photographic Tradition*, University of New Mexico Art Museum, Albuquerque, April 14–June 14, 1998.

9. Mary Warner Marien, *Photography: A Cultural History* (Upper Saddle River, NJ: Prentice Hall; New York: Harry N. Abrams, 2002), 459.

10. "Vernacular Photography," special issue, *Afterimage* 29.6 (May/June 2002).

Double Life

In 1897 someone captured Émile Zola in a garden, completely absorbed, photographing a doll. He's seated behind a large portrait camera, having arranged his diminutive model, a china-headed beauty, on a child's chair against a background of stretched fabric, specially constructed for portraits of his friends. The doll, like a friend, is alive in this private fantasy. She's another of Zola's many readers. On her lap he's placed what appears to be a book. He's about to squeeze the shutter bulb when the stealthy interloper clicks the shutter on him.

By 1897 Zola was a passionate amateur photographer of cities, railroads, and villages along the Seine. He documented the pavilions and grounds of the Universal Exposition of 1900 in several hundred images, and by the end of his life he'd exposed thousands of negatives. He collected all kinds of cameras, and each of his residences had a darkroom where he spent hours with the mysteries of photographic chemistry. A secret also consumed him. The charade had been going on for nearly ten years.

It started back in 1887. Zola had nearly completed his twenty novels detailing the monstrous moral decline of the Rougon-Macquart family when two events transformed his existence. Victor Billaud, the mayor of Royan, who had joined the social set of the writer and his wife, Alexandrine, during their maritime adventures on the French seacoast, introduced the Zolas to photography. Both men were excited when George Eastman's portable Kodak appeared in 1888. That year, a third person accompanied Zola and his wife to Royan. She was Alexandrine's new chambermaid, Jeanne Rozerot, a beautiful, tall, and slender twenty-one-year-old. Friends warned Alexandrine against hiring such a temptation, but she waved them away. At Royan she suffered migraines and other indispositions that kept her in her room, leaving her husband to entertain the lovely newcomer. It wasn't long before the two fell deeply in love.

Zola, at forty-eight, was ripe for a passionate encounter. Sedentary and short of stature, he deplored his forty-two-inch waist and began a crash diet, which consisted mainly of water. He even considered sport and took riding lessons in order to comport himself on horseback in the Bois de Boulogne, a notion his friends found laughable.

After the Zolas returned to Paris from Royan, Jeanne quit her post, and Zola installed her in an apartment where she lived in virtual seclusion while the writer

Photographer unknown
Untitled; Émile Zola photographing a
 doll, Verneuil-sur-Seine, ca. 1897
Gelatin silver print, 3 × 2 3⁄16 in.,
 ca. 1975
Gift of Jean Adhémar
76.47

spent most of the year at his mansion in Médan, one of many rural villages along the Seine where his friends the impressionists found their subjects. He wrote to his mistress and visited her when he could find an excuse to slip away.

Zola was devoted to his wife. Alexandrine was the perfect friend and helpmeet. To her care and support he owed all the achievements of his writing life. But he loved Jeanne Rozerot. He couldn't leave either of his muses. The torment led to uncharacteristic lethargy and nervous attacks. For months he couldn't pick up a pen.

On September 21, 1889, things changed. Jeanne gave birth to a daughter, Denise. By then Alexandrine knew of the affair and was outraged—the Zolas' long marriage had produced no children. Two years later, when the couple were traveling, trying to rebuild mutual trust, a second child was on the way. Zola couldn't control his curiosity. He had a friend post a notice in the personal correspondence column of *Le Figaro* to tell him if the child was a boy or a girl. The friend had to use a code of Zola's devising: *faisan* (male pheasant) for a boy, *faisanne* (hen pheasant) for a girl. Jeanne called the second child Jacques.

Zola was crazy about his mistress and children. They were beautiful. After 1895, with the Rougon-Macquart novels completed and while he was starting to photograph in earnest, he photographed his shadow family incessantly. The pictures made his three darlings real and concrete. Jeanne sews. She arranges flowers. The children take tea, play croquet, ride bicycles, blow bubble pipes. They water a parrot cage with sprinkling cans.

He assembled a leather-bound album with this inscription: "To my beloved Jeanne, I dedicate this album of photographs of our dear children Denise and Jacques, in their garden at Verneuil, from June to September 1897. Emile Zola." Stamped in gold on the album's cover is the title:

DENISE
ET
JACQUES
HISTOIRE VRAI
PAR
EMILE ZOLA

Histoire vrai. True story. Photographing was another kind of writing. For the famed exponent of descriptive realism, the photographs described his secret truth. They told the story of his love.

He was a kind and indulgent father, showering Denise and Jacques with trinkets, candy, and toys. He photographed them with their playmates, dolls, puppets, and stuffed animals. He all but made love to their toys, as he did when photographing the little doll. He read to them and helped them with their studies, insisting on guiding nine-year-old Jacques through all the pavilions of the 1900 Universal Exposition to explain to him the miracles of modern science.

He hated not being a real husband to Jeanne or a constant *bon papa* to Denise and Jacques. He lamented their being unable to share in the highly publicized accolades to his genius. To bring his family closer to him at Médan, he lodged them in rented houses in nearby villages during the summer. When he couldn't visit them in the rented house at Cheverchemont, he stood on the balcony of his study and watched them through binoculars.

Another of these villages was Verneuil-sur-Seine, downriver from Médan. Zola split his time between the two households in a carefully choreographed routine. He wrote in the morning and lunched with Alexandrine, then bicycled the five kilometers to Verneuil to spend the afternoon with Jeanne and the children. It was a painful split, sacrificing one ménage in order to give himself part time to another. Somewhere in his mind the two places were one. His descendants noticed that his photographs of family interiors show that Zola equipped both houses with identical pieces of furniture.

As with his other residences, he kept a darkroom and cameras at Verneuil. Nothing stopped him from coming. He pedaled in bad weather, even when he was ill. He had on his cycling clothes when he photographed the doll.

Zola's sudden death from asphyxiation in 1902 was a mystery and a shock. Alexandrine befriended Jeanne, and the two widows soothed their grief by sharing the job of raising and educating Denise and Jacques. Alexandrine was just an old lady to the children, but she was devoted. Her husband remained alive to her through them,

which is why she went through the complicated process of making Émile-Zola their legal surname.

Works Consulted

Adhémar, Jean. "Émile Zola, Photographer." In *One Hundred Years of Photographic History: Essays in Honor of Beaumont Newhall*, edited by Van Deren Coke, 1–6. Albuquerque: University of New Mexico Press, 1975. Discusses Zola's images of the Universal Exposition of 1900 and mentions the cache of unprinted negatives in the Émile-Zola family archives.

Braive, Michel F. *The Photograph: A Social History*. Translated by David Britt. London: Thames and Hudson, 1966. Discusses Zola's photography (199), includes *Zola Photographing a Doll* (201), and indicates that the work belongs to the author.

Brown, Frederick. *Zola: A Life*. New York: Farrar Straus Giroux, 1995.

Dieuzaide, Jean. "Le troisième oeil d'Émile Zola." In *Émile Zola: Photographe*, exhibition catalog. Toulouse: Galerie Muncipale du Château d' Eau, January 1982. For five years, this municipal gallery worked with the Émile-Zola heirs to publicize the writer's photographs. The catalog includes images of Jeanne and the children that were printed from original negatives in the family archives.

Zola, François Émile, and Massin. *Zola photographe: 480 documents*. Paris: Éditions Denoël, 1979. François, grandson of the writer (son of Jacques Émile-Zola), discusses Zola's life pertaining to his photography. Massin, a writer, printed Zola's negatives from the family archives, which demonstrate the range of Zola's photographic subjects. Plates also illustrate his cameras and maps of the villages along the Seine. The image of Zola photographing the doll is not included. It may not have been part of the archives. Plates 141 and 142 show Zola's own photographs of Denise and Jacques with their dolls. Jean Adhémar, chief curator at the Cabinet des Estampes at the Bibliothèque Nationale, Paris, was in dialogue with the Émile-Zola family before the book's production and acquired modern prints from the negatives from them for his article on Zola (above). This is verified in his letter of October 4, 1975 (University of New Mexico Art Museum archives). How Adhémar acquired the doll image is unknown.

Immaculata

The language of the symbol, the original language of the unconscious and of mankind.

—Erich Neumann, *The Great Mother*

She's a prostitute, one of many contemporary Venuses cloistered in the brothels of Storyville. Her world, defined by what body and soul will tolerate, is chaotic and coarse, like the rooms she frequents with their garish wallpaper and university pennants, as if college girls lived there among the cheap calendars, snapshot mementos, and bawdy come-ons:

> Oh! Dearie I Give U Much Pleasure!
> Daisies Won't Tell
> Dearie U Ask for Marguerite

He sees in her something else, something pensive and noble. He invites her to sit and loosen her hair, which he arranges over her bare shoulders so it flows in rivulets toward an ample lap. She lowers her eyes toward the spray of roses he's brought, cradling them to her breast. He clicks the shutter. For the next shot she embraces the roses with both arms, lovingly, as a mother would an infant. Her bracelet is burnished gold set with tiny diamonds—too costly for her kind. It may have once been his mother's. He liked lending jewelry to the Storyville girls who posed for him.

He has reimagined this girl to represent an ancient idea. It's an instinct, deeply engrained through his education. She's a goddess, enthroned and chaste. Her roses are the attributes of Mary, Queen of Heaven, Mater Dolorosa. The photograph recalls T. S. Eliot's address to the rose in "Ash-Wednesday." Its beauty is many-sided, never far from anguish:

> Lady of silences
> Calm and distressed
> Torn and most whole
> Rose of memory
> Rose of forgetfulness
> Exhausted and life-giving
> Worried reposeful

John Ernest Joseph Bellocq
(American, 1872–1949)
Storyville Portrait, New Orleans,
 ca. 1911–1913, printed after 1966
Printing out paper, gold chloride toned,
 8 × 10 in.
Image by E. J. Bellocq; © Lee
 Friedlander; courtesy of Fraenkel
 Gallery, San Francisco, CA
81.105

II

Ernest J. Bellocq was the son of an aristocratic white Creole family, baptized at the Church of the Immaculate Conception in New Orleans. For ten years he was schooled by the Jesuits at the college attached to the church. The Jesuit order is known for its rigorous classical education and its centuries-old defense of the Virgin Mary's privileged exemption from the stain of original sin. Bellocq was trained to venerate the purity of Mary, Mother of God. His younger brother Leon became a Jesuit priest.

The Bellocqs' home in the French Quarter was only a block from Storyville. In 1898, Alderman Sidney Story declared whoring illegal outside this district, which he

designated and which, to his chagrin, bore his name. By 1898, Bellocq, at twenty-six, was well known as an amateur photographer and man-about-town with access to prestigious and fashionable social circles. Not much more than five feet tall, he had fair skin and a high forehead. He dressed with flair, sporting a signature red scarf, a monogrammed diamond jewelry set by Tiffany, and gold cufflinks, each bearing a woman's head in sculpted relief. When his mother died in 1902, he added to his collection the jewels and rosary she bequeathed to him.

Storyville was a notorious hole of debauchery. It was also Bellocq's neighborhood, as normal and familiar as the corner bakery. After his mother's death, a weight lifted because he gave up trying to work in his father's wholesale business and began photographing seriously, eventually making a living from various documentary commissions throughout the city. He also remained attached to the Church and College of the Immaculate Conception and often returned to photograph the buildings and the students.

It isn't clear when he began frequenting Storyville's bordellos. But by 1912, he'd befriended many prostitutes in the district. He posed them in front of an eight-by-ten view camera using glass plate negatives. He liked the formality that his camera required. He was never good at capturing anything that moved. He wasn't after cheesecake or the lewd poses he'd seen in French picture postcards.

The Storyville girls became the actors of his dreams. Some took the lead and played

John Ernest Joseph Bellocq
(American, 1872–1949)
Storyville Portrait, New Orleans,
 ca. 1911–1913, printed after 1966
Printing out paper, gold chloride toned,
 8 × 10 in.
Image by E. J. Bellocq; © Lee
 Friedlander; courtesy of Fraenkel
 Gallery, San Francisco, CA

themselves—lying on an ironing board and playing with a tiny dog, posing nude wearing only a mask, donning underclothes and tight bodysuits, or, more modestly, dressed in the starched white cotton skirts and jackets of summer. He let them parody their trade with broad humor when they donned striped stockings and sat with a bottle of whiskey to become the cliché of what a prostitute was supposed to look like.

What should she look like? Bellocq had no plan. Some of the girls he photographed in evening gowns, furs, and jewels could be mistaken for bankers' wives or divas from the French Opera House. No matter what guise they assumed before his camera, none of them betrays the misery of prostitution. Each is a Magdalene, eternally violated in fact, but in every photograph inviolate.

Bellocq's pictures of the girls remained his secret. Though Storyville was legal, pictures of prostitutes were deemed pornographic and their makers liable by law. There may be other reasons why he hid the pictures. They weren't pornographic, but how could he explain his adoration of these fallen women?

The scandal of the pictures wasn't that Bellocq had photographed prostitutes but that he'd photographed them as individuals. At the same time, he discovered qualities in the women that recalled the sacred paragons he'd venerated from childhood. No one had dared elevate marginals, the lowest of the low, to the status of normal women, not to mention holy queens. If he thought about it, the consistency of his vision might have surprised him.

He probably didn't think about it. Instead, he made two photographs of his desk

(left)
John Ernest Joseph Bellocq
(American, 1872–1949)
Untitled, ca. 1911–1913
Printing out paper, gold chloride toned,
8 × 10 in.
Image by E. J. Bellocq; © Lee
Friedlanderl; courtesy of Fraenkel
Gallery, San Francisco, CA

(right)
John Ernest Joseph Bellocq
(American, 1872–1949)
Bedroom Mantel, Storyville,
ca. 1911–1913
Printing out paper, gold chloride toned,
8 × 10 in.
New Orleans Museum of Art, museum
purchase, 73.241

and fireplace mantel that declare his passions. Each is a shrine to the Eternal Feminine, with framed, deliberately arranged paintings and photographs exclusively of women, dressed and undressed. Many of the photographs appear to be his own. Most of the ceramic figurines on the mantel are female. The clockface hanging on the rolltop desk shows a woman whose arms form the clock's hands.

John Szarkowski observed that "the portrait of his work desk describes a man of uncultured tastes and unexercised intellect." Bellocq's purpose had nothing to do with taste or intellect. The shrines are psychic maps that celebrate every Mary, every Magdalene, the duality of womankind—absolute purity and sexual allure. He even toasts this mystery with the little stein of beer and miniature bottle of champagne in a bucket that he placed on the desk. The assemblage is meant to transcend time and place. He emphasized the contrast by placing a clock dead center in each shrine, which marks the moment when he clicked the shutter. The dusty almanacs of American photography behind the women's images also allude to the passage of time and to Bellocq himself, a knowledgeable professional behind the camera but, unlike the transcendent feminine, a mere mortal stuck in the annals of photographic history.

III

Our knowledge of E. J. Bellocq barely transcends the level of rumor.

—John Szarkowski, *Looking at Photographs*

A lot of nonsense has accumulated around Ernest J. Bellocq since 1966, when the photographer Lee Friedlander, visiting secondhand shops in New Orleans, discovered and acquired some eighty-nine of Bellocq's glass plate negatives. Friedlander had never heard of Bellocq. Besides, biographical details meant little to him. He cared only for what he saw—the artistic quality of the pictures. He took great pains to learn how to print the negatives. As soon as people began to examine his prints, they wanted information.

There wasn't any. But plenty of people in New Orleans, some of whom had known the photographer and/or had published articles and books about Storyville, were happy to concoct it. Bellocq, short, with a high forehead, was turned into a surly, hydrocephalic dwarf with a fat behind. Stunted and at home in brothels, he was nothing less than another Toulouse Lautrec.

Museum curators in New York accepted the trumped-up portrait. Bellocq as a strange and mythical fairy-tale creature somehow fit the uniqueness of the pictures. Besides, made in Storyville, birthplace of jazz, they embodied the down-and-out glamour of New Orleans, a hub of joyous, artistic innovation, unlike any other place in America.

Bellocq respected his subjects. In this alone he could be called modern. His prostitutes displayed so much cheerful self-possession that some photographic experts began weaving stories around the possibility that the women might not have been prostitutes at all.

Good information was mixed with bad in recorded interviews with jazz musicians, junk-shop owners, and photographers who had known Bellocq only as an old man, by then drunken and diseased, eccentric and superstitious—eighteen bank accounts, no faith in trolley cars, preferring to walk. The interviews included testimony from a prostitute from the district named Adele. "A waterhead," she called him. "You know one of them high heads. . . . He behaved nice. You know, polite. . . . I don't know if he ever wanted to do anything but look, but I know he done a few months in the icehouse, so you can't tell." Waterhead? The icehouse? Adele sounded pretty authentic.

But Dan Leyrer, a New Orleans photographer, revealed how wobbly the recollection enterprise was: "There were other things that we have to tell you about him, that I can't quite remember—oh, things that really did happen."

Transcriptions of the interviews found their way to the Museum of Modern Art. They were turned into a confabulated text in the book published by the museum to accompany the first Bellocq exhibition there in 1970.

In 1996, more than twenty-five years after the first show, the same book (with additional pictures and an appreciation by Susan Sontag) was published in a deluxe edition that included the invented interviews, verbatim.

The myth remained intact, but only for some. In 1996 the New Orleans Museum of Art staged an exhibition, determined to return its native son to where he belonged. Called *Welcome Home E. J. Bellocq*, it replaced rumor with documented archival research in city, medical, and church records by Rex Rose, the son of Al Rose, a New Orleans jazz promoter whose extravagant imagination in his book *Storyville* (1965) was a principal source for some of the scrambled fantasies about the photographer. The exhibition had no catalog. Rex Rose published his findings in a long article published on the Internet in 2001.

Through this work, we know much more than anyone thought possible. We learn about a Catholic boy educated to believe in women as fonts of sacred mysteries, and we begin to reflect on the young man who would never love one woman enough to marry her. How could he? He loved them all. Instead, he made love to an idea. That his models were socially despised was immaterial. He adored their vibrant beauty. It stood for something higher, which he consecrated through photographing and making offerings of roses.

Works Consulted

Eliot, T. S. "Ash-Wednesday." In *Collected Poems, 1909–1962*, 87–88. New York: Harcourt, Brace & World, 1970.

Neumann, Erich. *The Great Mother: An Analysis of the Archetype*. Bollingen Series 47. Princeton, NJ: Princeton University Press, 1963.

Rose, Rex. "The Last Days of Ernest J. Bellocq." *Exquisite Corpse: A Journal of Letters*

and Life 10 (Fall/Winter 2001/2002): 1–13. http://www.corpse.org/achives/issue_10/gallery/bellocq/index.htm. This is the first extended account of Bellocq's life based on archival research. Note 7 gives Bellocq's birth year as 1872, based on baptismal records from the Church of the Immaculate Conception. Rose's text gives it as 1873. He has acknowledged the discrepancy. The correct date is 1872.

Szarkowski, John. *Bellocq: Photographs from Storyville, the Red Light District of New Orleans*. Reproduced from prints made by Lee Friedlander. Introduction by Susan Sontag. New York: Random House, 1996. The portrait is on page 27; a variant from the same sitting is on page 29.

————. *Looking at Photographs: 100 Pictures from the Collection of the Museum of Modern Art*. New York: Museum of Modern Art, 1973. The epigraph for this essay is on page 68.

Warner, Marina. *Alone of All Her Sex: The Myth and the Cult of the Virgin Mary*. New York: Vintage Books, 1983.

For Al Rose's reputation as an extravagant poseur and prevaricator, see Rex Rose, "Al Rose: His Secret Life," http://rexrose.com/alrose.htm.

Steve Maklansky, former curator of photography at the New Orleans Museum of Art, aided by Rex Rose's research, mounted *Welcome Home E. J. Bellocq* in 1996 (no catalog). I am grateful to them for generously sharing the new data about the photographer, on which the exhibition was based. Their retelling of Bellocq's story inspired my interpretation of the photographs in this essay.

Leap

I loved a child for a long time
who had a tiny feather on his tongue
and we lived a hundred years inside a knife.

—Federico García Lorca

We have surrealism in this century because we're interested in how the brain really works. That's what the American poet Robert Bly decided in 1975. His insight came rather late, given that surrealist painters, photographers, and poets from the 1920s onward had been assaulting the public with the verbal riddles of automatic writing and the illogical associations stimulated by found objects. But Bly was caught in the web of American literature. He had just discovered the Spanish surrealist poets. He was translating their work into English, and he was flabbergasted.

Federico García Lorca, César Vallejo, and other Spanish surrealist poets were leaping tigers. They tore up time and space. Ordinary things were aggressive and benign by turns. Tongues sprouted feathers. A knife was a home. Bly was blinded by these leaps. Things from the dark corners of the unconscious disappeared, then reappeared, like the flashing lights of flying saucers.

The Spanish poets relied on the part of the brain that doesn't think, the part that feels with the fury of duende and sees with closed eyes. Their paths were those of dreamers who led Bly to the secret corridors of the soul. By comparison, Auden and Eliot weighed like lead.

In France in the 1920s and 1930s, an international crowd was rejecting the intellect's smug pleasures. These surrealists shocked with objects because they looked at them closely. In the ordinary, they discovered convulsive, delirious eroticism that erased the line between what is possible and what is not.

This wasn't new. It was always happening, but no one had called it surrealism. Take Gertrude Stein's success story at Radcliffe College, which may be one of the earliest recorded expressions of the possible/impossible. In the 1890s, Gertrude was taking a philosophy course with William James. She hadn't studied for the final exam and wrote on her exam book, "Dear Professor James, I am so sorry, but really I do not feel a bit like an examination paper in philosophy today." And she left the room. James replied on a postcard: "Dear Miss Stein, I understand perfectly how you feel. I often feel like that myself." And he gave her the highest grade in the course.

Things came easily to slothful Gertrude. But the real significance of her leaping effrontery is that the eminent professor leapt in return. Professor James wasn't

partial to Miss Stein. She was one among many in his class, an unknown. James liked disconnects. This young woman's insubordination showed the dark side of intelligence. Making the impossible possible, he rewarded what wasn't there. Night is also a sun, Georges Bataille mused. Surrealism wasn't a style. It was a state of mind.

Later, living in France, Gertrude Stein knew many artists. She wasn't interested in dreams. She didn't think much of André Breton's automatic writing, or anything he wrote about surrealism. She told Georges Braque that in a hundred years no one would remember Breton's name. She had to protect her priority. She knew plenty about automatic writing and free association. She published *Tender Buttons* in 1914, years before Breton published the first Surrealist Manifesto. Her book is coleslaw. It called

SALAD— . . . a winning cake; DINING—Dining is west; EYE GLASSES—a color in shaving, a saloon is well placed in the centre of an alley; CARELESS WATER—No cup is mended in more places and mended, that is to say a plate is broken and mending does do that it shows that culture is Japanese.

Meaning what? What anyone thought it meant. Some praised Gertrude's concoctions. Others scratched their heads.

Gertrude knew Spaniards. She and Picasso were friends and mutual bêtes noires, especially when he tried writing poetry. She admired Salvador Dalí because, as she explained, he had to overcome his father having been a notary and his mother dying when he was very young. But Dalí really endeared himself to her and the surrealists when he wrote on one of his paintings, "I spit upon the face of my mother." Outrage? Or leap? Gertrude called it symbolism.

Her recollections appeared in *Everybody's Autobiography*, published in 1937. That year Georges Hugnet, a poet, designer, publisher (not the most notable of the surrealists because he spread himself too thin), conceived of a project.

It appeared to be a commercial venture, a series of simulated postcards that photographically reproduced twenty-one surrealist images. Not a random selection. These were icons of surrealism by a stellar international group of men and women. Hugnet had them printed as collotypes, reduced them to postcard size, and on the verso, as if they were meant to be sent, designated places for the message, address, and postage stamp.

The surrealists had a great affection for the lowly postcard. The cheaply printed throwaway excited the imagination. Slipped into a mailbox, it surrendered to the great beyond. It might arrive at its destination. Or end up—who knows where? That was the point. Like a message in a bottle from an unknown sender discovered by an unintended recipient, the postcard, which was supposed to be useful, was ripe for surrealistic sabotage.

Besides embodying risk and uncertainty, its message space constrained the writer to very few words. The artists saw in these jottings a kind of involuntary poetry, to which they could attribute fantastic meanings or, preferably, none at all.

a.

b.

c.

d.

e.

f.

g.

*La carte surréaliste (garantie). Première
série, vingt-et-une cartes,* 1937
Edited and published by Georges
Hugnet (1906–1974)
21 postcards by 21 artists, collotype on
metallic paper, 3½ × 5½ in. each

h.

i.

j.

k.

l.

m.

n.

o.

p.

q.

r.

s.

t.

u.

a.
Marcel Duchamp, *Ampoule contenant 50 cc d'air de Paris* (Ampoule containing 50 cc of the air of Paris)
© 2014 Artists Rights Society (ARS), New York; © 2014 Succession Marcel Duchamp/ADAGP, Paris/Artists Rights Society (ARS), New York
99.22.1

b.
Max Ernst, *Le triomphe de l'amour* (The triumph of love)
© 2014 Artists Rights Society (ARS), New York/ADAGP, Paris
99.22.3

c.
André Breton, *Poème-objet* (Poem-object)
© 2014 Artists Rights Society (ARS), New York/ADAGP, Paris
99.22.2

d.
Paul Éluard, *On tue comme on respire* (They kill as easily as they breathe)
99.22.4

e.
Dora Maar, *29 Rue d'Astorg*
© 2014 Artists Rights Society (ARS), New York/ADAGP, Paris
99.22.5

f.
Joan Miró, *Horaire* (Timetable)
© 2014 Successió Miró/Artists Rights Society (ARS), New York/ADAGP, Paris
99.22.6

g.
Salvador Dalí, *La mélancolie gâteuse des chiens comme une vertignieuse descente en ski* (The senile melancholy of dogs like a dizzy ski-glide)
© Salvador Dalí, Fundació Gala–Salvador Dalí/Artists Rights Society (ARS), New York/ADAGP, 2014
99.22.7

h.
Man Ray, *Ce qui nous manque à tous* (What we all lack)
© 2014 Man Ray Trust/Artists Rights Society (ARS), New York/ADAGP, Paris
99.22.9

i.
Yves Tanguy, *Le marchand de sable* (The sandman)
© 2014 Estate of Yves Tanguy/Artists Rights Society (ARS), New York
99.22.10

j.
Hans Bellmer, *Deux demi-soeurs* (Stepsisters)
© 2014 Artists Rights Society (ARS), New York/ADAGP, Paris
99.22.8

k.
Georges Hugnet, *Au pied de la lettre* (Word for word)
© 2014 Artists Rights Society (ARS), New York/ADAGP, Paris
99.22.13

l.
Oscar Dominguez, *Overture* (Opening)
© 2014 Artists Rights Society (ARS), New York/ADAGP, Paris
99.22.11

m.
Meret Oppenheim, *Ma gouvernante* (My nurse)
© 2014 Artists Rights Society (ARS), New York/Pro Litteris, Zurich
99.22.14

n.
Hans (Jean) Arp, *Côté à ouvrir* (Open this side)
© 2014 Artists Rights Society (ARS), New York/VG Bild-Kunst, Bonn
99.22.12

o.
René Magritte, *La solution de rébus* (The key to the riddle)
© 2014 C. Herscovici, London/Artists Rights Society (ARS), New York
99.22.15

p.
Jacqueline Breton, *Pont du demi-sommeil* (Bridge of drowsiness)
© 2014 Artists Rights Society (ARS), New York/ADAGP, Paris
99.22.16

q.
Wolfgang Paalen, *A l'échelle du désir* (The scale of desire)
Succession Wolfgang Paalen et Eva Sulzer, Berlin, the Paalen Archives
99.22.19

r.
Roland Penrose, *La terre en bouteille* (Bottled earth)
© Roland Penrose Estate, England 2015, all rights reserved
99.22.17

s.
Nusch Éluard, *Bois des iles* (Precious woods)
99.22.20

t.
Marcel Jean, *Paris à vol d'oiseau* (Bird's-eye view of Paris)
© 2014 Artists Rights Society (ARS), New York/ADAGP, Paris
99.22.18

u.
Pablo Picasso, *Poisson d'avril* (April fool)
© 2014 Estate of Pablo Picasso/Artists Rights Society (ARS), New York
99.22.21

The postcard was modern folklore, naïve and fantastic. But especially, it was a supreme vehicle of chance. Surrealists collected old postcards and puzzled over the written messages. They wrote their own messages on postcards and tossed them into the mail.

Hugnet was turning something with no status into a collective masterpiece. *La carte surréaliste (garantie)* was the title of the series. It was Man Ray's idea to add *garantie*, which gave the enterprise the cachet of authority. Printing the cards on silver stock imposed another kind of authority—glamour. It contradicted the postcard's original purpose and expressed the sensual excitement that the surrealists already felt about postcards. Hugnet was only following what Breton wrote in 1937 in *Mad Love*: "We will never be done with sensation. . . . Astonishment excites logic. . . . Surprise must be sought for itself, unconditionally . . . in the interweaving in a single object of the natural and the supernatural." This is why Hugnet's surrealist postcards look like first-class tickets for a show on the silver screen.

The Hollywood chic shouldn't throw us off. What is astounding in this stack is that even after reducing the images and rendering them as photographs, none suffers in the transformation. Instead, unpacking the envelope, we enter the world of silvery palm-of-the-hand enchantment. Duchamp offers the air of Paris in a bottle. Penrose offers a bottle of dirt. Dalí joins puppies to the feeling of senile melancholy on a dizzying ski slope. Arp instructs. Paalen measures longing. Magritte has the key to the riddle. Ernst triumphs with love. Man Ray shows what we all want. Oppenheim insists that a tethered pair of high-heeled shoes is her nurse.

When Robert Bly plunged into Spanish surrealist poetry, he thought he had discovered how the brain really works. He discovered how the *limbic* brain works, the part that sings to children, the part that plays and frolics, says one thing and means another, has to connect even when there's no logic in the connection.

As Breton observed in *Mad Love*, there's no such thing as forbidden fruit.

Works Consulted

Bataille, Georges. *The Absence of Myth: Writings on Surrealism*. Translated and with an introduction by Michael Richardson. New York: Verso, 1994. Pages 48, 55.

Bly, Robert. *Leaping Poetry: An Idea with Poems and Translations*. Boston, MA: Beacon Press, 1975. The epigraph for this essay is from Lorca's "Landscape with Two Graves and an Assyrian Hound," page 7.

Breton, André. *Mad Love (L'amour fou)*. Translated by Mary Ann Caws. Lincoln: University of Nebraska Press, 1987. Pages 83–84, 87–88, 93.

Lewis, Thomas, Fari Amini, and Richard Lannon. *A General Theory of Love*. New York: Vintage Books, 2001. On the limbic brain, see especially pages 24–26.

Malcolm, Janet. *Two Lives: Gertrude and Alice*. New Haven, CT: Yale University Press, 2007. Stein's note to William James and his response are on page 14.

Stein, Gertrude. *Everybody's Autobiography*. 1937. Reprint, New York: Vintage Books, 1973. On Dalí and Spaniards, see pages 20–38; on Breton never being remembered, see page 36.

―――. *Tender Buttons: Objects, Food, Rooms*. 1914. Reprint, Los Angeles, CA: Sun & Moon Press, 1991. Pages 21, 56, 57.

The papers of Georges Hugnet, dating from 1920 to 1971, are in the Harry Ransom Research Center, University of Texas at Austin.

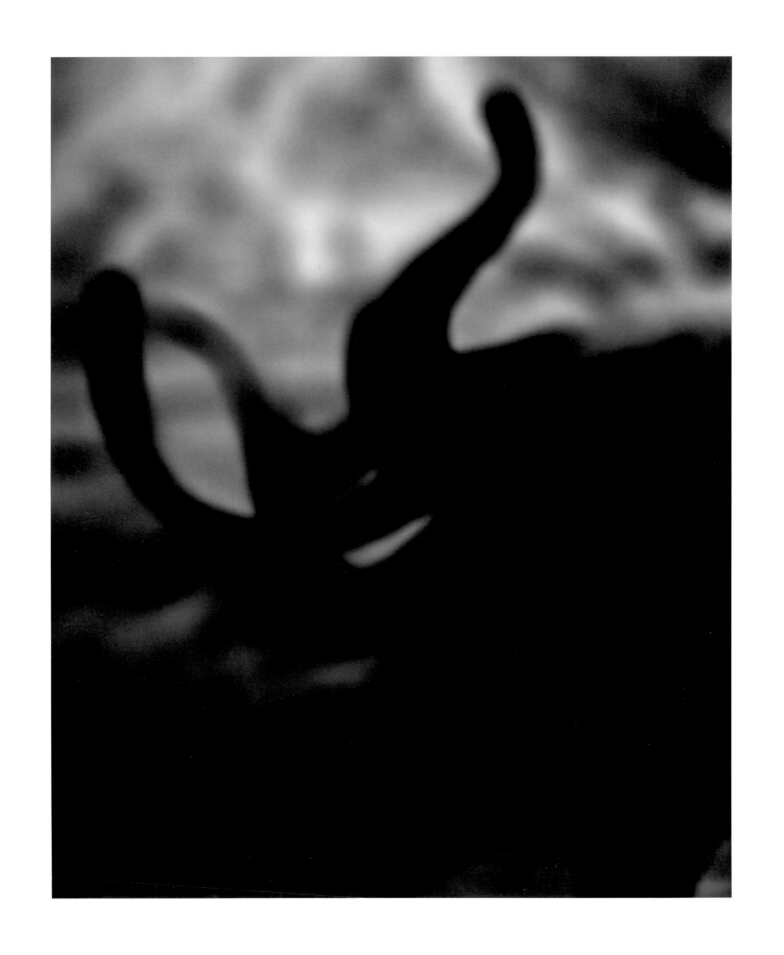

As If

Robert Stivers has to put up with friends who overflow with good intentions and advice. Elephants. Get yourself to Africa if you want to photograph elephants. You won't believe how big their trunks are, or their tusks. You'll shake in your boots when those giants pass. You've got to smell them and hear them wail.

Robert couldn't care less about Africa. He doesn't need to travel to another continent for screaming elephants. They're authentic enough stuffed, like the marvels of taxidermy he sees in natural history museums, or in miniature, as plastic toys. He looks at animals the way he looks at everything else. It has little to do with a need to describe.

For Robert the physical world is not a banquet of facts. Every tree, flower, skyline, ocean, cloud, woman, elephant, or flamingo is more like a nudge, a whisper in his ear, to which he responds by blunting the identifying externals, pooling them in shadow and gossamer light.

Unlike most photographers, he doesn't want a rendition. He wants an approximation.

Robert's pictures don't say THIS IS. They dwell in the subjunctive mood of PERHAPS. They straddle what is and what is not. They make an issue of uncertainty.

Federico Fellini, a great extrovert, loved interviews. They allowed him to exploit his self-definition as "a born liar." He digressed with flamboyant responses for his own amusement, but he gave a surprising answer when asked what feeling or emotion inspired or nourished him most: "I don't know. Perhaps the attempt to recapture, to hear once more an utterance that's been interrupted, repeated each time with a weaker and weaker voice until I could no longer hear it. This feeling of grasping at the frayed ends of a broken string . . . this . . . straining to hear, with my ears and my heart, something that's been nearly forgotten." *Weaker . . . until I could no longer hear it*. The filmmaker isn't faking this time. He's confessing to a struggle, to the tentative, always uncertain process that exposes his vulnerability, his incapacity, and reveals to himself the depths of how he really feels. Not knowing is essential to the way he creates. He has his driver take the long way to the studio because he needs time to decide how he's going to do a shoot—on awakening, his mind had been a complete vacuum.

Weaker until I could hardly see it. Robert's grasp of things feels like Fellini's frayed piece of string. He asks us to acknowledge in the world and accept in ourselves what

Robert Stivers
(American, b. 1953)
Elephants, series 5, 1997
Gelatin silver print, 20 × 16 in.
Edition 4/15
Gift of Stephen J. Nicholas, MD
© Robert Stivers; courtesy of the artist
2013.18.67

will always be half-known, the torn fragments of what we've experienced but have forgotten. He recognizes our helplessness and his own in straining at the mystery of what knowing is.

Fellini believes in enigmas, in anything that makes him wonder. Behind the stories in his films are remembered fragments of his hometown of Rimini, a kind of reservoir "where certain presences are stored." Again and again, he reimagines what growing up in this tedious place meant. From a reservoir of human behavior, still unexplainable to him, he invents his screenplays.

Robert's enigma is water. Certain presences are stored in Lake Arrowhead, east of Los Angeles in the San Bernardino Mountains. The lake is his reservoir and oracle. He visits it continually, for information and consolation. The lake makes him wonder. It exudes the magic he needs. He struggles with Arrowhead's changing moods— murky depths, engulfing mist at twilight, choppy waves at midday—because they mirror his own. Something in him *longs to be liquefied*, he notes in his journal. He takes a rowboat at night and joins his lake, drifting, feeling its silence and the muted energy in its impenetrable depths. The lake is the model for how his photographs speak. Darkly. Always in flux, like possibilities.

From replicas in a natural history museum, Robert creates possible elephants, a possible flamingo. He relies on the beholder's share, what we bring to images from memories and associations to fill in the blanks. He wants us to struggle with seeing because he knows it isn't about what our eyes take in. His pictures don't define or explain. They are schemas that guide us through the swimming depths of our experiences. They vibrate with our wavering souls.

Works Consulted

Coleman, A. D. *Robert Stivers: Photographs*. Santa Fe, NM: Arena Editions, 1997. Plate 15, *Flamingo*, 1996; plate 30, *Elephants*, 1997.

Fellini, Federico. *I'm a Born Liar: A Fellini Lexicon*. Edited and translated by Damian Pettigrew. New York: Harry N. Abrams, 2003. Based on interviews conducted in 1991 and 1992.

Parry, Eugenia. "Into a Moonless Black / Deep in the Brain Far Back." Unpublished essay for a book on Robert Stivers's color photographs.

———. "Prisoner of the Lake." In *Robert Stivers: Sanctum*. Santa Fe, NM: Twin Palms, 2006. The book is an in-depth study of Stivers's sources and creative process based on the photographer's thirty years of journal entries.

Quotes from Fellini are from archival holdings of filmed interviews with Federico Fellini, RAI (Italian Television), Rome, undated, the Criterion Collection.

Robert Stivers
(American, b. 1953)
Flamingo, series 5, 1996
Gelatin silver print, 20 × 16 in.
Edition 5/15
Gift of Stephen and Eileen Nicholas
© Robert Stivers; courtesy of the artist
2012.25.93

Fool's Errand

All my life I've wanted to get to the bottom of it. —Michael Howells

You have no idea what it was like. —George Henry Weiss

The crematorium ran out of coal. They couldn't incinerate any more bodies. Besides, most of the camp's personnel had fled, leaving their wives and children behind with cyanide capsules.

On April 29, 1945, when allied forces entered Dachau, they saw piles of rotting corpses throughout the camp and hundreds of *little people*, emaciated Jewish survivors shrouded in their own filth.

The liberators noticed a freight train parked on the railroad tracks outside the camp. It had forty roofless boxcars filled with thousands of bodies in advanced stages of decay.

These were prisoners from Buchenwald. In the panic before the end of the war, they had been evacuated to Dachau with no food, water, or sanitation. Along the route, heavy Allied air strikes killed many prisoners in the open cars, and Allied bombs destroyed sections of the tracks, forcing repairs and detours through various Bavarian towns. A trip of two hundred miles took nearly three weeks. During the delays, those who survived the shelling starved to death. The train arrived at Dachau three days ahead of the liberators. As everyone fled, the boxcars and the rotting cargo were forgotten.

The Allies were supposed to follow strict Geneva Convention protocol, which protected prisoners of war. Flags of surrender waved from Dachau's towers and buildings. When they opened the boxcars the soldiers heard moaning. They saw movement. They wept as they extracted over one thousand survivors from the mounds of stinking flesh.

Weeping turned to rage. The soldiers went berserk. They needed to punish someone. They stormed the camp looking for someone to kill. In a hospital, wounded SS soldiers, some of them amputees and others too weak to flee, saw them coming. They begged for mercy. They raised trembling hands in surrender. The Americans ignored their cries. They dragged the patients from their beds, marched them to an empty coal yard, lined them against a wall, and shot them with a .30 caliber machine gun. A GI filmed the whole thing.

This was phase one of what was dubbed the Dachau Massacre. In phase two, the Allies proceeded to murder several hundred more German POWs in the camp. They

Photographer unknown
Corpses piled in the crematorium in the
 newly liberated Dachau concentration
 camp, Dachau, Germany, May 1945
Courtesy of the US Holocaust Memorial
 Museum, Washington, DC

gave guns and shovels to the Jews and other survivors to help them satisfy their
own passion for revenge.

The incident was reported and recorded. So were many conflicting accounts and
details. Who were the Americans? How many POWs did they actually murder? Who
manned the machine gun? Who had the movie camera? When General George Pat-
ton received the paperwork he tossed it in a wastebasket with a lighted match. Case
closed. No one was court-martialed. The rampage became another of the war's top
secrets. The Dachau liberators were forbidden to speak about it.

George Henry Weiss was a captain in the US Army under Patton's command. He
was twenty-six when he entered Dachau in late April 1945. His name doesn't appear
on the list of those involved in the death-train rampage and the ensuing massacres.
He must have witnessed them. Like the other liberators, he took photographs of
what he saw at Dachau. After the war he was mute on the subject. He was by nature
inclined to silence. Legally, he was sworn to secrecy.

Of German descent, Weiss loved Germany. He stayed to command several army
bases there after the war. He and his wife called these years a *golden time*. The pic-
tures Weiss took of the atrocities vanished in a flood on his Florida property in the
1970s.

Weiss had a favorite grandson named Michael. He was a lost boy, a toddler when
his father abandoned him and his mother. He harbored unpleasant memories of life
alone with her and the string of suitors he met. He longed for a male parent, a father,

Michael Howells
(American, b. 1967)
Dachau Crematorium, 1991
Gelatin silver print, 14 × 11 in.
Edition AP
Gift of the artist
© Michael Howells; courtesy of the artist
2014.17

a man he could admire. George Weiss was not only Michael's surrogate father. As a former military commander, he became the boy's idol.

Michael was precocious. By the time he was eight or nine, he was obsessively poring through the captioned photographs in his grandfather's books about Germany and the Second World War, especially Albert Speer's *Inside the Third Reich* and *Spandau: The Secret Diaries*. He wanted to know what his grandfather had done, what it was like to kill Nazis. He asked about the concentration camps. No answer. He nagged and badgered. Nothing.

He wanted to climb onto his hero's lap and hear his stories. This turned into a frantic need to rub against anything and everything associated with Hitler and all things Nazi. Hitler was colorful and creepy. His grandfather had actually seen Hitler's Berghof at the end of the war but wouldn't talk about it. The photographic evidence of what he saw was destroyed when Michael was three years old.

Other people's secrets are frustrating. George Weiss's silence stimulated Michael's passion and resolve. For years, it was the focus of his life.

◆

In the late 1980s Michael Howells was an innocent, younger than his years, studying at the University of New Mexico, mad about photography, curious about architecture. Trying everything, reading everything, he was in love with the strange literary style of the Austrian novelist Thomas Bernhard, a rabid anti-Nazi. Michael liked contradictions and later began collecting Nazi memorabilia. By 2000 he was flaunting his treasures, which amused some of his friends and offended others.

He preached about Hitler like he preached about the virtues of Bernhard and everything else he felt people should know about. It didn't occur to him that he was telling them what they already knew. His energy drove them from the room.

He didn't see the difference between his fascination with Hitler's barbarism, Bernhard's baiting of Nazi-loving Austrians, and his other manias: Lou Reed, the Beach Boys, or Sting. He had blond Germanic looks. Did he imagine himself, in some adolescent fantasy, as a latter-day Nazi? Who could tell? He wasn't explaining. His enthusiasm was confusing.

Reading about Hitler, he discovered that those he assumed should know better, like the historian David Irving, were denying that Heinrich Himmler's Final Solution of the Jewish question ever existed. Irving's wasn't the only voice. Holocaust denial in the 1980s and early 1990s was a craze.

Michael wondered about this as he sat alone in his room. He was good at photography, but he didn't see how it fit into his future. He had no particular vision with which to infuse his pictures, no meaningful subject matter. He wondered what he really cared about. *Think of something! No evidence for the elimination of the Jews? What about the camps? My grandfather photographed the camps. The buildings still exist. You can't deny buildings. . . . What can I do to* fix *this?*

After college he got a job assisting Harry Lunn, a prominent New York

photography dealer. In the summer of 1991 he helped Lunn with his booth at the Basel art fair and after the fair went to Germany to begin his search for Holocaust evidence. It amounted to buildings. In Munich he photographed the Haus der Kunst and the Adolf Hitler Platz; in Berlin, the Olympic stadium and the Luftwaffe headquarters. He photographed two concentration camps: Buchenwald, outside of Weimar, and Dachau, northwest of Munich.

Dachau was a munitions factory during the First World War. By March 1933 Himmler's SS had expanded it into a vast work camp, a structural and administrative model for the many concentration camps that followed. At first, the number of Jews at Dachau was small. Dachau wasn't conceived as an extermination camp. It had vegetable and herb gardens. Built to house and employ political prisoners, it worked most of them to death. Before the end of the war, over thirty thousand inmates died from disease, malnutrition, and hard labor. *Arbeit Macht Frei* was posted on all German concentration camp gates. At Dachau, death, not work, made you free.

With German efficiency the corpses were stripped and their clothing disinfected and deloused by gas for distribution to the German population. The bodies were stacked in piles for cremation. The original crematorium had only one two-chambered oven. By 1943, with the Final Solution in full swing, so many had died in Dachau that several coal ovens were installed in a new and larger brick building with a huge chimney. The unspeakable was reduced to smoke and ashes. Today, except for the chimney, the crematorium looks as benign as a schoolhouse.

The Dachau concentration camp that Michael saw in the summer of 1991 was a German reconfiguration turned into a tourist stop. Lawns and plantings carpeted the sites of the atrocities. Monuments honored the dead. Strict limits were placed on what visitors could see: only the entrance gate, the barracks, and the crematorium.

The crematorium was spotless. Michael shot a porcelain sink. One room, lighted by a small window, resembled a refurbished apartment ready for its next occupant, except for a drain in the middle of the cement floor. He shot the space with an architect's attention to rectilinear structure and evenly distributed light. The picture assures us that he didn't find any ghosts there.

Nothing reveals how Michael felt in this place. On the Internet he found a view of the very room he'd photographed. It was made when his grandfather and the Allies arrived in late April 1945. The image shows a stack of corpses wrapped in blankets. The walls are marked with blood or excrement. Stained water pools on the floor. Michael likened these marks to something aesthetically pleasing, marks that could have been made by an artist like Cy Twombly. He wasn't able to connect them to human misery. The windows of the two images differ, but the sill and drain reveal it as the same room. He kept this evidence. It only hints at what his grandfather experienced at Dachau.

Michael made lots of pictures of Nazi-era buildings in 1991. He didn't let his knowledge of Third Reich horrors interfere with his architectural project. He found points of view that revealed the quality of materials and the buildings' placement in space. Since he was employed by an art dealer, word of his consuming interest

traveled through art circles. In late 1991 the Atlanta art dealer Fay Gold gave him a one-man show of his Nazi buildings. Gold appreciated the pictures' aesthetic qualities, but as a Jew, she also felt the weight of what lay behind them.

Winfried Nerdinger at the Neue Pinakotek in Munich also heard about Michael's photographs. He was doing a comprehensive study of Bavarian buildings constructed under Hitler. As the director of the National Socialist Documentation Center in Munich, he asked Michael to continue photographing in 1992 under the auspices of the Architektur Museum at the Munich Technical University. The result was an exhibition at the Munich Stadtmuseum in 1993. It included several dozen of Michael's photographs—He was *fix*ing it. So he thought.

Michael proved to his satisfaction that the Holocaust was real. His cause became an architectural exercise, which inadvertently contributed to the cooling down and dissipation of German guilt. He wasn't aware that the meticulous inventorying of Hitler's architecture was another way in which postwar Germans continued to disconnect themselves from what those buildings stood for and the horrors that had occurred within their walls. How could he know this? The Germans themselves were hardly conscious of the enormous industry that lay behind their need to forget.

Besides, Michael was still in his midtwenties and proud of the international prestige. His photographs were being praised and exhibited. As far as he could see they were serving a useful documentary purpose.

Before the Munich exhibition, he brought the pictures to show his grandfather. The old man was a heavy drinker, too sick and distracted to pay much attention. The images were descriptive architectural studies. The compositions were simple and elegant. George Weiss could have praised his grandson's persistence and talent, but he waved the pictures away.

Weiss was a career soldier. For decades, memories from his midtwenties had been too terrible to think about, more indelible than any photograph. He blunted the images in his head with cigarettes and booze. His only response to Michael's offering was, *You have no idea what it was like.* That was all he said. And he was right.

Michael made excuses for his grandfather's distraction. The old man was grieving. His wife had just died. He was almost dead himself. Michael didn't know what his grandfather was hiding. He couldn't imagine it. The Dachau Massacre: What was that? His reading about Germany and the Second World War, his collection of Nazi memorabilia were as close as he could come to experiencing what gradually killed his grandfather. His pictures didn't get to the bottom of it.

◆

Today Michael Howells is a practicing Zen Buddhist and a successful architect. On reflection, he condemns his youthful photography project as *a fool's errand undertaken by a blind person.* His regret lies deeper than this. Michael loved George Weiss because the old soldier loved and protected him. Yet in 1994, as his grandfather lay dying, he was afraid to enter the hospital room. He didn't see the blood that gushed from the

old man's mouth, or the tears, or the twisted face as the spirit left the body. Michael was too young for death scenes. He waited in the car.

Works Consulted

Nerdinger, Winfried et al. *Bauen im Nationalsozialismus: Bayern, 1933–1945*. Munich: Ausstellung des Architekturmuseums der Technischen Universität München und des Münchner Stadtmuseums, 1993. Museum catalog. Michael Howells's architectural photography for this compendium is credited throughout. His photograph of Dachau, illustrated on page 553, is misidentified as Flossenbürg. It was not made specifically for Nerdinger's project. It was among the photographs Howells made that later became part of Nerdinger's study.

Walden, Geoff. "The Third Reich in Ruins." http://www.thirdreichruins.com/dachau. htm. In this long, photographically illustrated Internet article Walden recounts the Dachau Massacre with links specifically detailing the legal issues around American involvement and the cover-up, which lasted until 1991, after many of the perpetrators and witnesses had begun publishing memoirs of the events.

I was Michael Howells's art history professor at the University of New Mexico. After his graduation, I helped him focus on becoming an architect. I am grateful for his candor and courage in providing me so much personal information about his family via our e-mail exchanges in January and February and the summer of 2014. His quoted statements here derive from those exchanges.

Eugenia Parry has been discovering new ways to write about art and photography for over forty years. *Crime Album Stories: Paris 1886–1902* (2000) won the International Center of Photography's Infinity Award for Writing in 2001. She continued her approach in *Shooting Off My Mouth, Spitting Into the Mirror: Lisette Model, A Narrative Autobiography* (2009) and in "Fool for Christ," the principal essay in *Joel-Peter Witkin* (2012). As a professor, she taught the histories of art and photography at Wellesley College (1968–1986) and the University of New Mexico (1987–1993), where she held the Public Service Company of New Mexico Foundation Endowed Chair. She lives in Cerrillos, New Mexico.

The Echo Mirror

The subject of this essay, the photograph *Caribbean Sea, Jamaica*, 1980, by Hiroshi Sugimoto, and his collection of seascapes from 1980 to 1991, are part of the University of New Mexico Art Museum's permanent collection. In a portfolio titled *Time Exposed*, produced by Kyoto Shoin Corporation, these fifty offset lithographic prints were originally produced in conjunction with two exhibitions, one at the *Carnegie International*, Carnegie Museum of Art, Pittsburgh, Pennsylvania, October 19, 1991–February 23, 1992; and one for the IBM Courtyard, Tokyo, October 30, 1991–February 29, 1992.

In Search of the Offing

Hiroshi Sugimoto's seascapes have often provoked questions of what awaits the traveler at the sea's offing. I know that roughly three miles—the distance my eye can perceive while standing at the shore—is not far. Before the invention of the telegraph, a similar distance was roughly the point at which communication or "reception" could be established, eventually aided by the eighteenth-century Fresnel lens and its ability to focus light.

For Sugimoto, as he tells us in the 2011 documentary *Memories of Origin*, the ocean frames some of his earliest memories of childhood.[1] Having grown up in Tokyo, he spent time southwest of the city in the coastal town of Odawara. During the fifty-two-mile journey on the Tokaido Line from Tokyo's Taito ward, along the coast of Sagami Bay, he would stare out from the train at the moving panorama of ocean. It is no surprise that this left an enduring impression on him, as the Tokyo of the mid-1950s was a densely populated metropolis with over eight million people living in close quarters.[2] To be periodically released from the city's persistent visual foreground by the coastline journey allotted him a distance of vision. This would have been both astonishing and alien.

Now well into his sixties, Sugimoto has created over two hundred images of seascapes taken from many of the world's great shores.[3] His Seascape series, made over a period of more than thirty years, is a collection of individual encounters in collapsing space, time, and memory. For Sugimoto, these images function well beyond the self-conscious work of making art. The creation of these photographs appears to have

ulterior motives; they are in fact the physical residues of his personal acts of contemplation and possibly meditation.

In the closing scene from *Memories of Origin*, he provides us with foreboding insight into the series. He tells us—as the camera follows him conversing with a *mikan* (mandarin orange) orchard farmer, then climbing a ladder to the roof of a house from which he presents us with an ocean view—that this property he recently purchased is his return to Odawara. Located on a gentle slope facing the Pacific Ocean, it leaves one to wonder if it eventually will be the final scene of Sugimoto's series. As he reminds us, the ocean is the one unchanged view of our planet. The act of setting our eyes on the ocean's horizon links us across millennia to all those who have gone before us.

From Illusions of Exceptionalism
For many people in the United States, western landscapes are imbued with the idea of rebirth, salvation, and freedom. A rich body of photographic images spanning over

one hundred years has been complicit in symbolically aestheticizing these environments against ingrained beliefs. New Mexico has played no small role in providing artists the environmental ambience, in its diverse ecosystems, from which to match their beliefs. From the alpine/conifer and juniper/scrub areas scattered across the western and northern parts of the state, to desert/basins that extend from Mexico and plains/mesas of its eastern half, to the riparian networks driven by annual snow accumulation at the higher elevations, all bring their own unique characteristics for understanding one's self in nature.[4]

The nature of these landscapes is shaped by their own particular climates. New Mexico ranges in elevation from 2,817 feet (Red Bluff Reservoir) to 13,161 feet

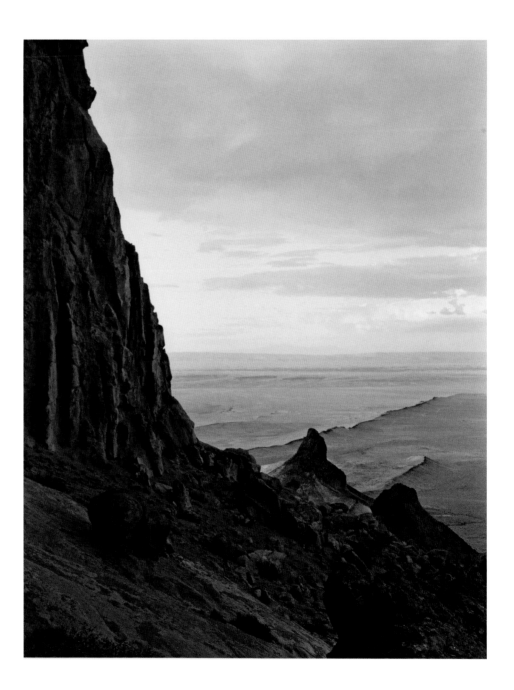

William Clift
(American, b. 1944)
View from Shiprock, New Mexico, 1991
Gelatin silver print, 9½ × 7⅜ in.
The Eliot Porter Fellowship Collection
Gift of the New Mexico Council on
 Photography
© William Clift
2012.3

(Wheeler Peak), and the average rainfall, depending on elevation, is ten to twenty inches and the humidity is anywhere between 2 and 30 percent.[5] This data is important, as it quantitatively verifies the clarity of atmospheric conditions that so many photographers have exuberantly recounted. With mountain ranges creating a Chinook effect across its mesas, unique atmospheric convection gives rise to the buildup of cumulus, cirrus, and lenticular clouds. These clouds create unusual patches of shading across its dry landscapes, add dramatic forms and patterns to the sky, and engulf the presunset minutes of the horizon in an inferno of brilliant color.

Japanese philosopher Tetsurō Watsuji wrote in the 1920s that when we experience changes in weather, we first apprehend changes in ourselves. An example of this can be found in the experiences we create from heat; we put on clothes of lighter material, set our bare feet in water, turn on a fan, or put ice cubes in our beverage. From the simple question, What is this heat that we feel? we ask to discover heat, which is to consciously feel heat. This creates an image in our mind of us in the temperature of heat.[6]

When we are aware of changes in atmospheric conditions, it causes us to behave in a particular way or use a particular tool. This is true for photographers, who anticipate both a psychological and a physiological transformation while in the presence of a particular scene. However, before these changes take place a mental comprehension must first be established. For Watsuji it is through the mental relationship with that atmospheric condition that we begin to gain a particular understanding of ourselves. As he states, "The basic essence of what is 'present outside' is not a thing or object such as [heat], but we ourselves. . . . We feel the [heat] is an intentional experience in which we discover our selves in the state of 'ex-sistre' [Latin for 'exist'], or our selves already outside in the [heat]."[7]

The idea of an intentional experience, also described in philosophy as intentionality, is the unique relationship our mind forms with the outside world.[8] It is a way in which we internalize our experiences with the environment as something existing separate from our physical being; this experience exists because we are conscious of it, and the residue left behind by our actions begins to define a regional culture. It is because of this collective response to climate that Watsuji expands his definition of intentionality in the acknowledgement of a "mutual relationship of existence"; he provides us with a definition of "ex-sistre" as "to be out among other 'I's' rather than 'to be out in a thing such as [heat].'"[9] These two definitions assist us in acknowledging that not everyone responds identically to the same atmospheric conditions, hence the temperature a New Mexican feels at Trinity Site may not be the same temperature that someone from Japan may feel.

For those artists who encounter New Mexico landscapes for the first time, this intentionality, mixed with the self-absorption of the ego, can bring a heightened sense of being in the presence of a perceived supernatural force. For many contemporary photographers this is a welcome possession and a necessary catalyst in the process of their art making. It is only through directing the lens, releasing the shutter, and previewing the image on an LCD screen that they can be certain they have

found themselves. What they have chosen to frame speaks more of the photographer's intentions at that moment than it does of the actual scene and its atmospheric affects attempting to be captured.

In New Mexico this frequently is a placebo condition, a subconsciously desired distraction supplementing a discord of the ego with that of knowing a place. Rather than making visible "a way in which our selves are exposed to ourselves," the photographer projects an ideal of the self, extraordinary, otherworldly, beyond the banality of a mortal being.[10]

This suggests an explanation for the attraction of dramatic landforms and clouds for so many; it also emphasizes Watsuji's revelation "If man is already suffering climatic limitation when he attains self-comprehension, then the character of climate cannot but become the character of this self-understanding."[11] Of course, why photograph drumlins of the northeastern United States—remnants of slow-moving glacier flows begun over one and a half million years ago—when you can be dwarfed by landforms built up from the fallout of explosive collapses of volcanoes, of the more recent age of one million years?[12]

For the landscape photographer in the United States the choice of which environment to photograph is ultimately a choice of whether or not to confront the subjective self; the more dramatic and alien the landscape one is in, the further one can stand from one's self, and for some, the further the better.

The Seriality of Super Normal

I would argue that the motivations that underlie Hiroshi Sugimoto's utterly static ocean views represent another type of subjective self. From *Time Exposed*, the photo *Caribbean Sea, Jamaica*, 1980, is not only the first photograph of the portfolio but also the first in the entire series of seascapes. This photograph, as Sugimoto tells us in *Memories of Origin*, hung in his apartment as he waited to convince himself that he had not made a boring photograph. Of course, he did find its significance, and he found significance in other views atop the cliffs of the peninsulas in various countries.

What this story reveals is the edge of banality from which this image hangs, an uncertainty of where exactly this line lies, the line from which the subject matter could fall into insignificance. You could say that its normality has been elevated, even heightened, representing super normal.

The idea of something as super normal originates from an exhibition of the same name held in 2006 by designers Naoto Fukasawa and Jasper Morrison in Tokyo's Axis Gallery.[13] In the accompanying catalog Fukasawa states, "Super Normal consists of the things we overlook. . . . I believe Super Normal is the inevitable form that results from the lengthy use of a thing—shall we say, a core of awareness."[14]

Sugimoto's seascapes are the inevitable distillation of his lengthy visual contemplation of the horizon high above the ocean's edge. It is a use measured not in the quantity of fish caught or in knots achieved by winds thrusting crafts across the ocean's surface but rather in the unquantifiable cerebral impression formed from

time spent trying to see. Its potential is rendered through an awareness brought about by the cognitive tools for defining some elastic dimension in the synapses of one's imagination. The horizon is not determined by the symbolic, measurable facts of the saline whole; two-thirds the earth's surface is covered in it, 310 million cubic miles is approximately its total volume, and 12,080 feet make up its average depth.[15]

The awareness brought about by *Caribbean Sea, Jamaica*, 1980, is born of confrontation. With no single point of reference, no sign of human occupation, with little tonal gradation and two fields joined together at either end of the gray scale, we are either repulsed by its arrogant simplicity and impudent assurance that it is art or we are shocked by having seen something so unnoteworthy composed with such resolute spirit.

For those who first presume it a scene of Mars, possibly from the robotic rover *Spirit*, or a detail section of a carbon nanotube, to have it later revealed as the bisection of our two hemispheres along a sea exposes the illusion that makes this image and the others in the series so uncanny. Its abstraction of nature combines with the abstraction of the subject matter's normalcy to place viewers in direct opposition to themselves, as they are reflected back onto the self.

Because the eye is given no single point on which to rest and at times falls out of focus, the ghost image burned from this Caribbean seascape is merely an image of our lives' previous encounters. Like a continuous feedback loop of infinite reverberation, its quiet oscillation makes the scene unmemorable on one hand and yet on the other awakens an event of super normality. For in the end, it is only one's self that has been circumnavigated in what one initially thought was to be the beginning of a one-way cosmic journey.

The Reintroduction to a Terrestrial Landscape

In both this photograph and the series, abstraction is the interpretive mode from which the reduction in subject matter is filtered; this provides a medium for transcending real space and time. And yet, over the years, Sugimoto has presented opportunities to approach this work within the grounded states of designed installations. From within these fabricated environments have come vehicles for attributing concrete symbolism to these seascapes, ultimately providing a greater depth of meaning.

My first encounter with Sugimoto's seascapes was at the exhibition *End of Time* at the Mori Art Museum in Tokyo.[16] As a large retrospective of Sugimoto's work, the Seascapes, or rather the Seascapes' installation, was the most compelling of all galleries in the museum. Installed in a darkened room, this series of photographs dimly glowed from the walls with single spots focused on each surface. Along one wall a platform constructed of *hinoki* (Japanese cypress) emitted a warm, dim pool of light as if to anticipate the start of an event. Here was a short thrust stage from which Noh theater had been performed just months prior. The repetitive patterns of the planks echoed the barely visible ocean surfaces in many of the gelatin silver

prints. I wanted to stand on that wood structure, to look out at this group of photographs, envisioning them as a constellation of monocular-focused, hydrological cycle stars.

I imagined the intended Noh play of *The Hawk Princess* (Takahime)—adapted from *The Hawk's Well* (Taka no Ido; 1916) by Irish poet W. B. Yeats—being performed under this celestial body.[17] *The Hawk's Well* is a play that combines elements of both traditional Celtic and Japanese literature; the juxtaposition of theatrical allegory enveloped in two-dimensional spatial entities of heightened super-(normal) natural phenomena brings mythological significance to these photographs that would otherwise be unreadable. Set in the time of the "Irish Heroic Age," this play is a cautionary tale of the search for everlasting youth. It centers around a warrior character from Irish mythology, Cuchulain, who by chance comes across an Old Man and a well filled with the waters of everlasting life. While both want to drink from this well, one is distracted by mortal desires while the other waits a lifetime by its edge. In the end, neither finds immortality. Yeats sends Cuchulain to his death via a witch/hawk spirit, and we are made to assume that the Old Man eventually perishes at the well.

Catching myself consumed in shadow at the center of the gallery, the scale of the room collapsed until the visceral shock subsided and the foreground returned to focus. I wanted some small evidence of life to reveal itself in these images. As I confronted each individual print, bringing my eyes closer to their spatial flattening,

Kikuji Kawada
(Japanese, b. 1933)
The A-Bomb Dome, Stain, 1959–1960
Gelatin silver print, 4 × 5 in.
© Kikuji Kawada; courtesy of Photo
 Gallery International

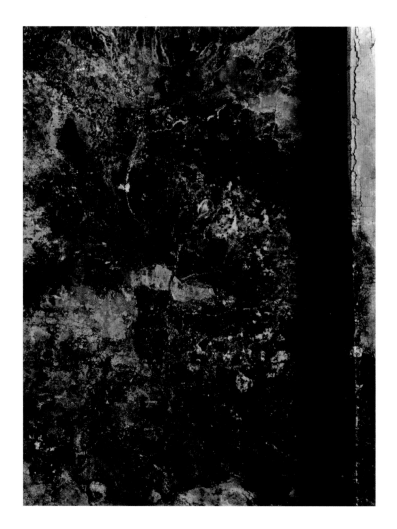

Kikuji Kawada
(Japanese, b. 1933)
The A-Bomb Dome, Ceiling, 1959–1960
Gelatin silver print, 4 × 5 in.
© Kikuji Kawada; courtesy of Photo
 Gallery International

the temporal became episodic. From my memory a series of events—at another museum, some years prior—came into focus.

Sitting in a room on the top floor of the Tokyo Metropolitan Museum of Photography, I was handed a book: Kikuji Kawada's *Chizu/The Map* from 1965.[18] Kyoko Jimbo, a scholar of Japanese surrealist photography and at that time a curator at the museum, patiently introduced me to the world of this artist and the designer of the book. She had curated an exhibition on Kawada's work that included images contained in *The Map.*[19]

Originally published on the twentieth anniversary of the dropping of the atomic bomb on Hiroshima, *The Map* is a collection of black-and-white photographs that include those taken in the burnt-out shell of the Hiroshima Prefectural Commercial Exhibition building, also known as the Hiroshima Peace Memorial, not more than fifteen years after the atomic bomb was dropped and flattened all but a few structures in an area of 4.4 square miles.[20]

In the interior of this 1915 ruin, Kawada was able to find the physical residue of an important moment in human history and the atmospheric effects on the aftermath of an explosion equivalent to sixteen kilotons of TNT.[21] The chemical reaction

of paint and other interior finishes to the extreme force and heat of the fission reaction to uranium is what Kawada found in the remains of the exhibition building. However, it is in what he chose to frame and the level of contrast from which he printed from the negatives that a familiar mirror, similar to Sugimoto's Seascapes, was crafted.

Against the surface of the ruined walls time itself is penetrated to reveal not only frozen gases but also millions of stars; an entire universe swirls in a single image. Unfathomable and yet penetrable, these images are an abstraction, although of a different magnitude from Sugimoto's Seascapes. Like the opposite sides of the same coin, where Sugimoto creates flattened space from a landscape of great distance, Kawada creates great depth within the surface of a wall. Both recognize that their own focused gaze—one of a real ocean scene abstracted, the other an abstraction made to resemble a distant universe—compresses time, space, and memory.

As with the Seascapes, views of the evening sky are also an experience that we have shared with all humans before us. These may both be understood to represent a loss of innocence, a reminder of our mortality. While the world has known armed conflict for centuries, the use of nuclear weapons brought a new comprehension to the instantaneous totality of destruction to human life at the hand of man. For many landscape photographers a scene void of human inhabitation is an attempt to reimage that innocence.

Most landscapes do embody the often hidden effects of human inhabitation, and New Mexico is no exception. In fact, the landscape of New Mexico is inextricably linked to the events of August 6 and 9, 1945. It too bears the residue of the extraordinary force of atomic weaponry. However, like the city of Hiroshima, this has largely been absorbed back into the physical and natural environment.

From the dry desert/basin of New Mexico's Jornada del Muerto (translated as "single-day's journey of the dead man"), one can stand at Trinity, the site where the first nuclear bomb was detonated, and confront miles of unending desert.[22] Staring out across the desert is equivalent to staring out into a vast ocean or even staring at a marked, blemished, discolored wall: little visual differentiation is seen. Its creosote and mesquite provide unending patterns of dark greens against monochromatic gradations of Chihuahuan desert brown. Here, too, within the visual blandness of this arid environment—inconsequential for most New Mexicans—a high level of introspection is inescapable. Within its evening sky the effects of light pollution are completely absent; here the natural illumination of the stars and the moon can be felt, making it almost possible to draw in those celestial bodies with one's breath. But as Hiroshi Sugimoto acknowledges with the placing of a theatrical installation into the quiet stillness of his oceanic scenes, life does play out behind the camera, back on terra firma. Before the mind, the eyes and ears must bear witness to life's unfolding events. Our own chance meetings provide larger allegories to the past, present, and future; these are moments that cannot be summed up in a single image or even a series of images, moments when we cannot say for certain that the person we just crossed paths with was not a demon.

CHRISTOPHER KALTENBACH Christopher Kaltenbach is a designer, writer, and photographer who has worked in interdisciplinary roles in design and design education in Australia, Canada, Japan, Macau, and the United States. Kaltenbach received his BFA in studio art from the University of New Mexico in 1992. His recent interdisciplinary design work includes a window display for Aigle's North American flagship store in Halifax and a color monograph, *Desire for Magic*, published in 2010 to accompany the thirty-year retrospective of Patrick Nagatani's photographic œuvre organized by the UNM Art Museum. His critical writing appears regularly in the Dutch architecture magazine *MARK* and the Australian design magazine *AR*. He is based in Japan and North America. Currently he is an associate professor of interdisciplinary design in the Master of Design and Division of Design Programs at Nova Scotia College of Art and Design (NSCAD), runs the design studio actionfindcopypaste, and is a PhD candidate at Royal Melbourne Institute of Technology (RMIT) in Melbourne, Australia.

Notes

1. Hiroshi Sugimoto, *Memories of Origin*, directed by Nakamura Yuko (Tokyo: TV Man Union / WOWOW, 2011), http://sugimoto-movie.com/ (accessed June 20, 2014).

2. Tokyo Metropolitan Government, "Population of Tokyo," http://www.metro.tokyo.jp/ENGLISH/PROFILE/overview03.htm (accessed June 20, 2014).

3. Based on a phone conversation with Gallery Koyanagi, Ginza, Tokyo, April 12, 2014. "Sugimoto is still making images for this series, however, he is unaware of the exact number in the series."

4. New Mexico Museum of Natural History and Science, "New Mexico, Living Landscapes," http://www.nmnaturalhistory.org/bioscience.html (accessed June 20, 2014).

5. Western Regional Climate Center, "Climate of New Mexico," http://www.wrcc.dri.edu/narratives/NEWMEXICO.htm (accessed June 20, 2014).

6. Tetsurō Watsuji, *Climate and Culture: A Philosophical Study* (New York: Greenwood Press, 1961).

7. Ibid., 4.

8. Pierre Jacob, "Intentionality," *The Stanford Encyclopedia of Philosophy* (Winter 2014 ed.), ed. Edward N. Zalta, http://plato.stanford.edu/entries/intentionality/ (accessed June 20, 2014).

9. Watsuji, *Climate and Culture*, 4.

10. Ibid., 3.

11. Ibid., 15.

12. J. E. Ansley, "Glaciers of the Northeastern U.S.: A Brief Review," pp. 59–73 in *The Teacher-Friendly Guide to the Geology of the Northeastern U.S.*, Paleontological Research Institution, Ithaca, NY, geology3.teacherfriendlyguide.org/downloads/ne/TFGG_NE-Glaciers.pdf; US Department of the Interior, National Park Service, "Geology Fieldnotes, Bandelier National Monument, New Mexico," http://www.nature.nps.gov/geology/parks/band/ (accessed June 20, 2014).

13. Naoto Fukasawa Design, "NFD Major Exhibition List," http://www.naotofukasawa.com/Exhibitions_home_e.html (accessed June 20, 2014).

14. Naoto Fukasawa and Jasper Morrison, *Super Normal: Sensations of the Ordinary* (Baden, Germany: Lars Müller, 2007), 99.

15. "Volume of Earth's Oceans," The Physics Factbook: An Encyclopedia of Scientific Essays, edited by Glenn Elert, http://hypertextbook.com/facts/2001/SyedQadri.shtml (accessed June 20, 2014); M. A. Charette and W. H. F. Smith, "The Volume of Earth's Ocean," *Oceanography* 23, no. 2 (2010): 112–14, http://www.tos.org/oceanography/archive/23-2_charette.html (accessed June 20, 2014).

16. I attended the exhibition in December 2005.

17. Mori Art Museum, "Hiroshi Sugimoto: End of Time," Special Noh Performance, http://www.mori.art.museum/english/contents/sugimoto/nou/index.html (accessed June 20, 2014); W. B. Yeats, *"At the Hawk's Well" and "The Cat and the Moon": Manuscript Materials*, ed. Andrew Parkin, (Ithaca, N.Y.: Cornell University Press, 2010).

18. Kikuji Kawada, *The Map* (Tokyo: Masao Oshita, Bijutsu Shuppan-sha, 1965).

19. Kikuji Kawada, Mark Holborn, and Kyoko Jimbo, *Kikuji Kawada: Theatrum Mundi* (Tokyo: Tokyo Metropolitan Museum of Photography, 2003).

20. "U. S. Strategic Bombing Survey: The Effects of the Atomic Bombings of Hiroshima and Nagasaki," June 19, 1946, p. 8, President's Secretary's File, Truman Papers, *The Decision to Drop the Atomic Bomb*, Harry S. Truman Library and Museum, http://www.trumanlibrary.org/whistlestop/study_collections/bomb/large/documents/index.php?pagenumber=8&documentid=65&documentdate=June%2019,%201946&studycollectionid=abomb&groupid= (accessed June 25, 2014).

21. *The Spirit of Hiroshima: An Introduction to the Atomic Bomb Tragedy* (Hiroshima: Hiroshima Peace Memorial Museum, 1999), 27.

22. F. A. Wislizenus, *Memoir of a Tour to Northern Mexico: Connected with Col. Doniphan's Expedition, in 1846 and 1847* (1848; reprint, Glorieta, NM: Rio Grande Press, 1948), 38.

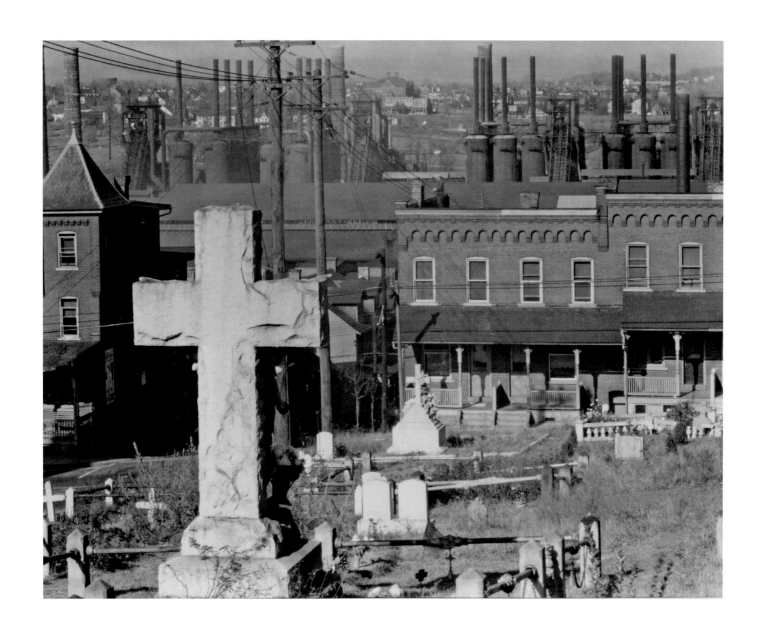

Walker Evans
(American, 1903–1975)
Bethlehem Graveyard and Steel Mill, PA,
 1935
Gelatin silver print, Library of Congress,
 8 × 10 in., ca. 1981
68.106

Five Photographs from Twentieth-Century America

An archangel contemplates Earth as he stands on the edge of a cloud. He turns and gestures for an acolyte angel to approach him. The acolyte gives the archangel a photograph. It is an image of a dog trapped in a store window. The archangel looks at the photograph, then responds, "Yes, this says much about the condition of human existence."

The five photographs I have chosen represent personal visions from life that engage darker conditions of existence. I call this form of photography the Redemptive Mode, since the need of these artists, myself included, is to bring light and understanding through the conditions of reality they've photographed. These images are not the "feel-good variety." Instead they are tough, deep, and depict the reality of our lives, lives in real time. Their purpose is to be meditated upon by the viewer because they show our needs, our natures, our histories, and the life lessons that hopefully will bring us closer to our own transcendence.

Art is a bridge connecting the realms of Nature and Truth. Allow me to share with you a brilliant description of an artist written by Albert Camus: "The Artist is a patient and clairvoyant swimmer making her way up strange streams to forgotten headwaters which have a distant and unwonted air, the sonorous sweetness of the muffed mystery of the lost paradise."

All life, all art, can be said to be the purity of that search. Humankind's newest art form in that quest is photography. In photography, it doesn't matter if the subject of the photograph is likeable or not, if the subject is posed or not, or if the subject is presented as narrative or an abstraction. What matters is that a great photographer has created a totally new and indelible reality out of the passing one. The photographs presented here are new visions of life, yet they describe the hope and wonder of life—as all great art must. When we experience this level of discovery we are changed because we've been given the courage to extend the love of our human hearts—to make life better than it is.

P.S.: When the archangel looked at Lee Friedlander's photograph of the dog trapped in the store window and said, "Yes, this says much about the conditions

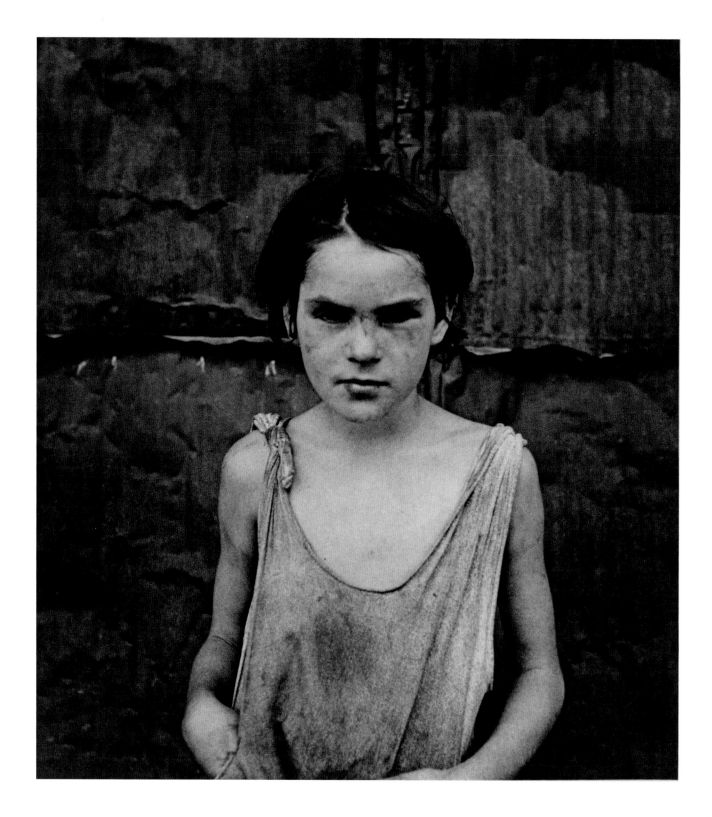

Dorothea Lange
(American, 1895–1965)
Damaged Child, Shacktown, Elm Grove,
 Oklahoma, 1936
Gelatin silver print, Oakland Museum,
 11 × 14 in., ca. 1972
72.622

Ralph Eugene Meatyard
(American, 1925–1972)
Untitled, 1971
Gelatin silver print, 7⅜ × 7⅜ in.
Gift of the Estate of F. Van Deren Coke
 and Joan Coke
© The Estate of Ralph Eugene Meatyard;
 courtesy of Fraenkel Gallery, San
 Francisco, CA
2012.23.1

of the human experience," the archangel was overwhelmingly positive about us, and about Lee's (I met him once) masterpiece.

Note to Reader

When I requested permission from the Arbus estate to reproduce *A Young Brooklyn Family Going for a Sunday Outing, N. Y. C.*, 1966, for this current publication, the estate lawyer asked that the print be sent to New York to be authenticated. Because former curator Kevin Donovan did this in 1987 shortly after the museum acquired the work, I felt it unnecessary to repeat the process. Thus the estate would not give permission to reproduce the image.

MMP

Lee Friedlander
(American, b. 1934)
Jersey City, New Jersey, 1963
Gelatin silver print, 7⁹/₁₆ × 11⁵/₁₆ in.
Given by Eugenia Parry to honor
 Jacqueline J. West
© Lee Friedlander; courtesy of Fraenkel
 Gallery, San Francisco, CA
2012.21

Image not available

(top)
Anonymous
Untitled, 2014
Graphite on paper, 11½ × 8¼ in.
Private collection

(bottom)
Diane Arbus
(American, 1923–1971)
*A Young Brooklyn Family Going for a
 Sunday Outing, N. Y. C.,* 1966
Gelatin silver print, 14¾ × 14⅝ in.
The Beaumont Newhall Collection,
 purchased with funds from the
 John D. and Catherine T. MacArthur
 Foundation
86.176
See Note to Reader

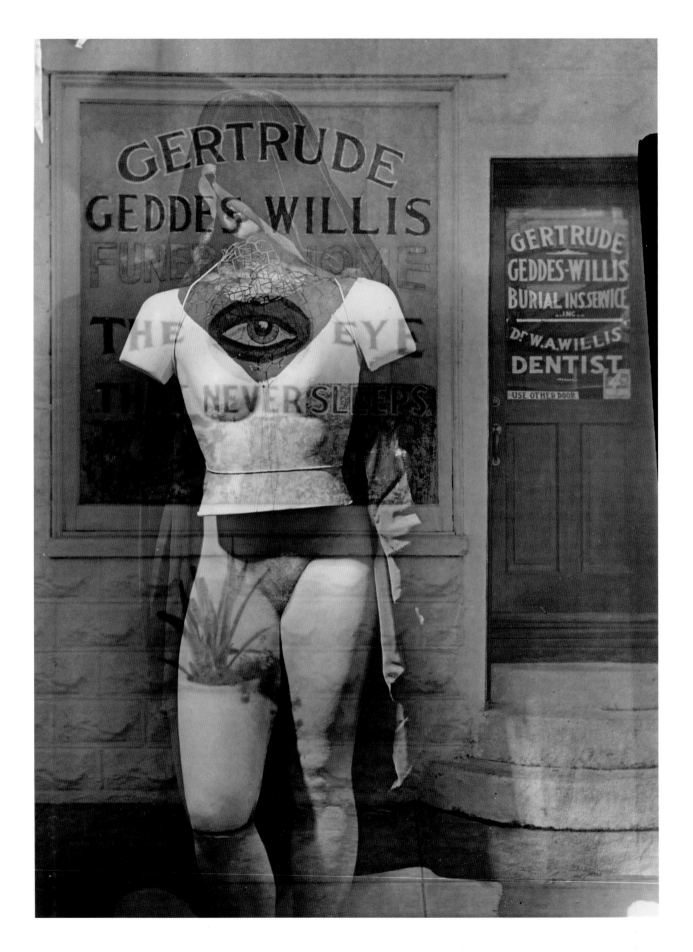

What Else Is There?

When I look at this photograph I know that the person who created it was in love with something, more than himself or anyone else. That something was the idea of his deliverance, the transcendent force of his search in life. Even though he, and all of us, are falling on all sides—he was able to see what no other person could see, and offer it to us. It is a perfect thing, representing perfect mystery.

Joel-Peter Witkin's provocative, disturbing, and original photographic œuvre is steeped in the history of art, literature, and the human condition. Witkin has received many distinguished honors and awards, including four National Endowment for the Arts fellowships. He was knighted by the French government in 1990 and received from Cooper Union in 1996 the August St. Gaudens Medal as a distinguished alumnus. In 1959 Edward Steichen selected one of Witkin's pictures to include in the exhibition *Great Photographs from the Collection* at the Museum of Modern Art. And in 1970 John Szarkowski acquired several Witkin photographs for MoMA's permanent collection. Witkin's work has been featured in over one hundred solo exhibitions throughout the world and has been the subject of twenty monographs and several films. He received an MA in art in 1976 and an MFA in 1986, both from the University of New Mexico.

Clarence John Laughlin
(American, 1905–1985)
The Eye That Never Sleeps, 1945
Gelatin silver print, 11 × 14 in.
Courtesy of the Clarence John
 Laughlin Archive at the Historic
 New Orleans Collection,
 Acc. No. 1981.247.1.2365
74.11

Matthew B. Brady
(American, 1823–1896)
Alexander Gardner
(Scottish, 1821–1882)
*A Lone Grave on the Battlefield of
 Antietam*, 1862
Reprinted from *The Civil War Photo-
 graphs of Matthew Brady*, Library of
 Congress, 1983
Gold-toned albumen print, one half of a
 stereograph, 7¾ × 10⅜ in.
Gift of Beaumont Newhall
86.155.12

Lone Grave

It seems all too perfect in the aftermath of war; the camera perspective is set low with an air of theatricality. How strange to find those toylike soldiers perfectly posed on a little hillside with no distant horizon line, just a shallow foreshortened space; it could be a miniature stage set. It's a Brady photograph, after all, an image taken during the Civil War entitled *A Lone Grave on the Battlefield of Antietam*. Most people would perceive this photograph as a descriptive, "truthful" document, taken during a tumultuous time in American history. When studying this photograph closely, I can't help but sense a pervasive air of contrived drama. The soldiers seem like actors, taking a break from performing war games. I am reminded of first seeing Brady's photographs while working as a photography intern at the Hallmark Card collection in Kansas City and then again a few years later as a graduate student at the University of New Mexico Art Museum. Those haunting images in the UNM Art Museum's photography collection eventually inspired the aesthetic quality of my work.

In *Lone Grave* you can count only five solders, but I count six when I include the dead soldier buried beneath a fresh mound quite near the roots of that cryptic tree. How strange and ironic that all men in this photograph are portrayed in various staged poses: guarding, standing, leaning, reclining, sleeping, and dead. I look even closer and struggle to read the name of the fallen solder on a makeshift gravestone. Perhaps it's one of their colleagues or even a brother. I make out only a few letters, but no specific name unfortunately; a noble effort by the other soldiers nonetheless.

Then there is the sky—that heavenly placid bright sky. I believe the sky is one of the most important qualities of a Brady photograph. That light frames a stark landscape, defines trees, and outlines famous historical figures or piles of decomposing bodies. Existing as an illuminated light box, the sky also serves as a bright void of angelic glow, thus revealing the drama of violence below. To describe the skies in Brady's photographs as white is misleading. Most photographs from this time period did not have pure, lily-white highlights but rather an ivory, warm coloration, like a tea stain on a white shirt—it's a beautiful patina highlight that I admire in many nineteenth-century photographs.

Most Brady photographs appear iconic and aesthetically satisfying. Perhaps it is the lure of the nineteenth-century photographic processes captured on glass

with light-sensitive chemicals—standing in stark contrast to the redundant digital photography of recent decades. I believe the aesthetic beauty of Brady's work and that of other photographers at this time is found within careful composing and the "staginess." Brady's images appear epic, almost Wagnerian. Yes, it's true; photographers such as Brady and others in the nineteenth century arranged details in their compositions like a set designer to heighten our viewing experience. Looking at the *Lone Grave* photograph, I can almost hear a photographic director in the background yelling out, "Hey, you over there in the Civil War hat, rest easy on your gun for heaven sake, it's a goddamn war after all, give it more of a melancholy feel."

Approximately twenty-three thousand soldiers had fallen to their deaths in one of the bloodiest battles in American history; it was September 1862, the battle of Antietam Creek near Sharpsburg, Maryland. Brady quickly assigned photographer Alexander Gardener and assistant James Gibson to photograph the aftermath. Upon arrival, Gardner and Gibson experienced death still hanging fresh in the air. There were countless battered and bloody bodies littering the terrain. The surviving soldiers wearily dug graves for their fellow fallen soldiers. The landscape itself appeared as an apocalyptic wasteland—a stage set suited for Beckett's *Waiting for Godot*. And then there was that lone, sad tree on the hillside, standing stoic, a beacon of life. Everything the two photographers experienced seemed touched by the brutality of war, especially in stark contrast to the glowing sky above. Battered bodies on war-torn earth captured on light-sensitive glass plate negatives spoke poetically about the realities of war. These images stir up timeless memories and nightmares of the brutality of humanity in the name of "honor thy country." The two photographers subtitled the collection of their battle-site photographs (which included the *Lone Grave* photograph) *The Death Studies*.

Gardner did in fact capture something innovative and different in *The Death Studies*—brutality, flesh and blood made real in these photographs. Up until this point in the nineteenth century, most photographic imagery portrayed only war-damaged landscapes long after battle. *The Death Studies* pictured something different and shocking: countless human bodies—husbands, brothers, and friends—savagely left for dead after a painful battle. Once published, these photographs sent a searing chill through our nineteenth-century nation. I think of a similar reaction in the late 1960s when America tuned in to the nightly television news feeds about the Vietnam War. The American public viewed horrific scenes of dying soldiers and innocent Vietnamese ravaged by war. A toddler in diapers at that time, I was unaware of the realities conveyed through the television in our living room. The power of photographic documentation bears witness especially to the violence of war. Demonstrations and a counterculture erupted around our nation. But in the late nineteenth century, *The Death Studies* sent a ripple of astonishment and horror over images never quite seen in photographs before then.

Over time we learned that Gardner had his share of controversy as a photographer—fudging the truth due to his modes of staging and arranging his photographs

that were otherwise thought of as "truthful" documents. At one point, Gardener worked with assistants, Timothy O'Sullivan and Gibson, and resorted to dragging a dead man's body several yards to another location in order heighten the drama in the photograph. Much has been written about this image, but really, Gardener wasn't the only photographer to intervene and manipulate the truth of an image. Nevertheless, dragging bodies from one location to the next in order to create a perfect photographic scene is an appalling and downright disrespectful act. Was the battle site not enough without that extra body?

Now, as I look closely at the *Lone Grave* photograph, I see the power of Gardner's theatrics. This image appears like a tableau vivant rather than a documentary photograph. Perhaps this explains why I find this image so compelling. As I continue to study the *Lone Grave* photograph, I'm skeptical if that grave site below the tree is really a true grave containing a fallen soldier. In the other images in *The Death Studies*, all the other dead bodies appear lined up on the ground for examination or burial. Why bury this lone soldier near the roots of that cryptic tree? The lone grave site certainly gives this image impact, not to mention an appealing title. Then again, why just document when you can arrange the scene and thus create a more dramatic and poetic photograph? Was this an unethical act or creative license? I guess if you are expecting truthfulness in this form, don't hire an artist. Nevertheless, these photographs awakened a society to the pathos of war and the brutality of mankind. Today I see the drama and madness of war in the *Death Studies* tableau photographs as some pretty great art. When truth and fiction collide, intriguing things happen.

After he completed his MFA at the University of New Mexico in 1994, Robert ParkeHarrison quickly earned a national and international reputation for his enigmatic photographs in which he himself plays a central, iconic role. This project, *The Architect's Brother*, was the subject of a traveling exhibition that circulated throughout the United States and abroad and was also the subject of the first of his four monographs, published in 2000 (Santa Fe, NM: Twin Palms). This book was named by the *New York Times* as one of the Ten Best Photography Books of the Year in 2000. He received a Guggenheim Fellowship in 1999 along with honors and awards from the Aaron Siskind and the Nancy Graves Foundations. He is currently a professor of studio art at Skidmore College.

Note to Reader

It is widely known that Matthew Brady operated various photography studios under his own name but often did not photograph his subjects nor print his negatives. Instead, he employed other camera operators and artists to actually make the photographs and prints. These other photographers were typically not credited for their work. Alexander Gardner (1821–1882) worked for Brady from 1856 to 1862 and covered the Battle of Antietam on September 17, 1862. Gardner left Brady's studio later that year to establish his own photography business.

As indicated, this particular image in the museum's collection is part of a larger portfolio of reprints made from the original glass plate negatives by the Chicago Albumen Works and published by the Matthew Brady Society in 1983. While the image was executed under Brady's imprimatur, Alexander Gardner's name is written on the negative's sleeve. The original negative is one half of a stereograph image and belongs to the Library of Congress (LC-B811-570).

MMP

A Picture Points Beyond Itself
Robert Adams's Romanticism

Along the banks of Saint Vrain Creek in north central Colorado, a tangle of wildflowers sprouts from the earth. The light suffusing the scene is not the pellucid midday blast of western sun, but the moodier, subdued glow of dawn or dusk, which renders the foreground blooms in shadow. In the distance, the sky retains an even glow. The riverbank pictured here is what Robert Adams might describe as "satisfying" rather than monumental. His photograph serves as a melancholic observation that beauty, however transient, exists in small subjects and discrete moments, "along some rivers" in the American West.[1]

Characteristically, Adams avoids picturing the iconic mountain ranges and dramatic geological formations that many associate with the American West. Rather, his subject is a humble slice of land, one that might otherwise go unnoticed were it not for the photographer's close, respectful attention. Adams embraces photography's descriptive capacities so that his photographs might point to a deeper meaning beyond his subjects. A photograph such as this one thus becomes more than simply a record of Adams's encounter with a modest plant. It functions, rather, as an intimate meditation on our relationship with the natural world; a reminder, perhaps, that though our ties to nature continue to erode through human neglect and abuse, there remain small places of transcendent beauty capable of connecting us to the land, and to one another.

Since the beginning of his artistic career in the mid-1960s, Adams has photographed the landscape of the American West both as means for coming to terms with human-wrought environmental devastation and as a way to look beyond these hard truths. Though his explorations do not shy away from picturing the destructive aspects of what humans have done to the land (and by extension, what we've done to ourselves), he retains a deep reverence for the transformative power of light, which always assumes an integral presence in his photographs. "The challenge for artists is just as it is for everyone," Adams has stated, "to face facts and somehow come up with a *yes*, to try for alchemy."[2]

Though he claims to be classicist when defining the lofty qualities of beauty, and he consciously avoids aesthetic tropes about the West that might suggest sentimentality or epic grandeur, Adams is also, philosophically, a romantic.[3] His appreciation of wilderness as a vital source of artistic inspiration and spiritual sustenance

Robert Adams
(American, b. 1937)
Saint Vrain Creek, Boulder County,
* Colorado,* 1985–1987
Gelatin silver print, 7¾ × 5³⁄₁₆ in.
Gift of Ray A. Graham III with artists
 Robert Adams and John Gossage
© Robert Adams; courtesy of Fraenkel
 Gallery, San Francisco, CA
2006.6.1.6

harkens back to Henry David Thoreau's assertion that the direct experience of wilderness is a necessary component of enlightened civilization. In his own essays and interviews, Adams often cites writers such as Wallace Stegner and Edward Abbey, who have drawn from Thoreau's transcendentalism. In his "Wilderness Letter," for example, Stegner associates wilderness with a "geography of hope," as "a means of reassuring ourselves of our sanity as creatures."[4] In his introduction to *Along Some Rivers*, Adams similarly alludes to the importance of retaining hope, as "promise," when picturing the landscape. As he writes, "Should I, having photographed this landscape, try to talk about it? By what right or obligation? Perhaps only by the privilege of having seen the West when it was more open, so that nothing that has happened since then, no matter how bad, can entirely obscure its promise."[5]

Edward Abbey similarly conceived of wilderness in *Desert Solitaire*, a diaristic account of his experiences working as a park ranger in Utah. Abbey upholds the importance of untouched nature as an emotional and psychic necessity for human survival. Significantly, Abbey also suggests that understanding wilderness as a kind of "Paradise" derives from direct, lived experience with the changing realities of the landscape. Abbey writes, "Paradise is not a garden of bliss and changeless perfection. . . . The Paradise of which I write and wish to praise is with us yet, the here and now, the actual, tangible, dogmatically real earth on which we stand."[6] This sentiment resonates with Adams's own philosophy. Even if the photographer feels he cannot in good conscience idealize the West in his pictures—that he must "show the facts without blinking"—he also believes that retaining some poetic conception of a "Paradise" is necessary.[7]

Adams articulated this idea in a "fan" letter he penned to Ansel Adams on June 26, 1979, when he wrote to his predecessor, "I am grateful to you for your pictures, which have rescued me often from my own despair. . . . One wonders, at times, whether one actually did live in a cleaner world. It is the power of your pictures to confirm that it existed. And to suggest, I think, that it is eternal, no matter what happens to be out in front of us at the moment."[8] Adams's words suggest he clearly believed, on a personal level, in the psychological, emotional, and spiritual significance of picturing the American West as a place of undisturbed natural beauty, even if he could not do so himself. As he once stated, making oblique reference to Ansel Adams's photographs, "I knew the Garden was off limits," however enticing that prospect may have seemed.[9]

When Ansel Adams responded to Robert Adams's letter, he wrote to the younger photographer with equal reverence, if not exactly a thorough understanding of his realist perspective. "I fear you are prone to underestimate yourself and your work!" the elder photographer wrote. He continued to explain his own aesthetic choices in wholly optimistic terms: "I think the world remains as beautiful as it ever was but that we are a little more aware of the human grime. . . . I admit, I believe in, and have practiced as much as I could, a positivistic attitude in my work. I find it very difficult to comprehend much of the view-points of the art expression of our era."[10] Though Robert Adams's photographs, cumulatively speaking, pay greater attention

to "the human grime" Ansel Adams describes, they also revere the same transcendent beauty that compelled both photographers to devote a significant portion of their careers to picturing the American West, despite the reality that this landscape changed radically, if not irrevocably, in the span of the generation that separates them.

As the stature of Robert Adams's formidable career now rivals that of Ansel Adams at the height of his popularity in the mid-1970s, the concerns of the forty-two-year-old "pestiferous upstart" who wrote to Ansel Adams seem prophetic.[11] As Robert Adams's recent three-volume retrospective publication and exhibition make clear, *The Place We Live* (2009) is a complex landscape, littered with dire warnings yet populated with the enduring signs of human aspiration.[12] Uniting everything, for the photographer, is light. As Adams has written, "Nothing permanently diminishes the affirmation of the Sun."[13]

Notes

1. In an introductory quote to *Along Some Rivers*, the publication that includes this photograph, Adams writes, "There aren't many big rivers in the American West, but there are a satisfying number of washes, creeks, and irrigation ditches, the roots and branches of rivers." Robert Adams, *Along Some Rivers: Photographs and Conversations* (New York: Aperture, 2006), 11.

2. Quoted in "About Turning Back with Students from Reed College," in *Along Some Rivers*, 72.

3. This sensibility may derive from Adams's academic background in English literature, a subject he taught at the college level for nearly a decade before turning full time to a career in photography in the mid-1960s.

4. Wallace Stegner, "Wilderness Letter," written to the Outdoor Recreation Resources Review Commission in December 1960 and subsequently included in his "Wilderness Idea," in *The Sound of Mountain Water* (Garden City, NY: Doubleday, 1969).

5. Adams, *Along Some Rivers*, 11.

6. Edward Abbey, *Desert Solitaire: A Season in the Wilderness* (New York: McGraw-Hill, 1968), 166–67.

7. Robert Adams, *The New West* (Boulder: Colorado Associated Press, 1974), 11.

8. Robert Adams to Ansel Adams, June 26, 1979, Ansel Adams Archive, Center for Creative Photography, University of Arizona, Tucson, Folder AG 31:1:1:1.

9. Robert Adams, interview in *Landscape: Theory* (New York: Lustrum Press, 1980), 6.

10. Ansel Adams to Robert Adams, June 20, 1979, in Allison N. Kemmerer, *Reinventing the West: The Photographs of Ansel Adams and Robert Adams* (Andover, MA: Addison Gallery of American Art, Phillips Academy, 2001), 10. The reason for the chronological discrepancy between the date of this response and the date of Robert Adams's letter to Ansel Adams is unknown.

11. The full quote derives from Robert Adams's June 26, 1979, letter to Ansel Adams, cited earlier: "Let me add that I suspect it might seem a little pestiferous to have some upstart, albeit obscure [photographer], running around with the same name doing photographs."

12. Robert Adams, *The Place We Live: A Retrospective Selection of Photographs, 1964–2009* (New Haven, CT: Yale University Art Gallery, Yale University Press, 2009).

13. Robert Adams, *New West*, 12.

A Matter of Cleavage

Garry Winogrand's *Women Are Beautiful,* Revisited

A young brunette woman bursts forth from a tightly packed, well-heeled crowd at the Metropolitan Museum of Art's Centennial Ball. She is dressed to make an impression: her white bodice, splayed wide down the middle, barely contains her breasts, while an array of baubles and beads hangs in her cleavage. Around her shoulders floats a large white feather boa, further extending her physical presence in the photographic space. Set apart from the crowd, she raises a glass and smiles dazedly beyond the picture, appearing to revel in the moment. In the foreground, a man wearing a large bowtie looks back at her. Between them stands another male figure with his back to the camera and his hand resting lightly on her hip. A woman standing next to the central, feather-festooned subject looks back at the photographer. She meets Winogrand's eye, catching him in the act of photographing what was for him an irresistible, recurrent subject: attractive young women.

Simply put, this is a picture about looking, and the desire to be seen. Winogrand's voyeurism is both the act that sparked the picture's creation and the subject of the photograph itself. The charge of unapologetic male gazing, often leveled at Winogrand's pictures of women, is certainly justified. By his own admission, Winogrand was a "male chauvinist pig" who compulsively photographed women throughout his career.[1] As subjects, women also threw Winogrand off his game. "Is it an interesting picture or is it interesting because the woman is attractive?" the photographer once asked, rhetorically. "I don't think I always got it straight." Indeed, the aesthetic justifications Winogrand often used to describe his impetus for picture making—the notion that he "photographed to find out what something will look like photographed"—often failed him when an attractive female came within shooting range.[2]

Winogrand included *Metropolitan Museum of Art Centennial Ball, New York City, New York* as one of eighty-four images in his 1975 publication *Women Are Beautiful*. Most of these pictures date to the height of the women's liberation movement, a time when feminists—a diverse and often divided group—hotly debated the objectification of women in magazines, the media, and everyday interactions with men. While some activists felt that any provocative bodily display reinforced an oppressive patriarchy in which women lacked agency over self-representation, others embraced a newfound freedom, publicly displaying sexual self-confidence through their dress

Garry Winogrand
(American, 1928–1984)
Metropolitan Museum of Art Centennial Ball, New York City, New York, 1969
Gelatin silver print, 11 × 14 in.
Gift of Michael Kaiser
© The Estate of Garry Winogrand; courtesy of Fraenkel Gallery, San Francisco, CA
80.42

and demeanor. Although Winogrand had regularly photographed women since the mid-1950s, for both commercial and personal purposes, his earlier street pictures include subjects with the white gloves, clutch purses, bras, and girdles typical of that era's fashions. Their body language tends to be more controlled and contained than that of the women featured in *Women Are Beautiful*, who, by contrast, inhabit the streets, public parks, and cultural institutions of Manhattan with a palpable exuberance and physicality. As the streets of New York during the late 1960s and early 1970s became sites of political protest, exhibitionism, voyeurism, and freedom from the moral constraints of a previous generation of women, Winogrand responded instinctively, though perhaps not always respectfully, to the same subject he had been photographing for years. Whereas ten years prior, Winogrand might have encountered a woman such as the one pictured at the Met's Centennial Ball only within the semiprivate confines of a burlesque theater or nightclub (both places in which he photographed), by 1969 he saw her at one of New York City's premiere cultural institutions. "Acceptable" notions of public bodily display had changed radically for women, and Winogrand certainly seemed to delight in what he saw. Significantly, in his best pictures of women, such as this photograph, he took pleasure in picturing the act of looking itself.

The evolution and eventual publication of *Women Are Beautiful* was also shaped by the cultural force of the women's liberation movement. It was the first book published by Light Gallery, established in 1971 under the direction of Tennyson Schad. By that time, Winogrand was proven talent.[3] When he and Schad entered into a verbal agreement in June 1973 to produce *Women Are Beautiful*, both men hoped to capitalize on the era's heated sociopolitical context to stir up controversy and boost sales. The book's timing was unquestionably opportunistic. In the book's early planning stages, Winogrand noted that *Women Are Beautiful* might have an appeal for those men who enjoyed "girl watching." Schad and Winogrand sought a well-known writer to pen an introductory essay for the book but had little success in securing one. Interestingly, Winogrand wanted "a feminist," and his first choice was writer Erica Jong, whose bestselling, controversial novel *Fear of Flying* (1971) had brought her enormous fame. Schad felt that this only "made sense [if] counter-weighted by a male writer who would make it a dialogue."[4] The two men considered just about every major contemporary literary and cultural figure: Joan Didion, Betty Freidan, Kate Millet, Gloria Steinem, Tom Wolfe, Terry Southern, John Updike, Jimmy Breslin, George Plimpton, and Philip Roth.[5] None, it seems, was interested. Ultimately, Helen Gary Bishop, "a fine writer with a feminist outlook," as recommended by literary agent Nat Sobel, was given a contract.[6] It was Bishop who suggested that Winogrand change the proposed title of his book from "Women Are Beautiful: Confessions of a Male Chauvinist Pig" to "Women Are Beautiful," as she felt the photographs offered a more nuanced perspective than the former suggested.[7] Her first-person, autobiographical essay celebrated the independence and sexual freedom she felt as a young woman in the city. As such, she was sympathetic to Winogrand's female subjects, even if her writing and lack of celebrity failed to impress potential book distributors.[8]

Although Schad felt the book had all the potential to be "a significant money-maker," he was ultimately unable to secure wide distribution outside photographic circles.[9] Critics, most of whom were male, seemed confused by the whole project and were divided in their opinions. One writer noted that Winogrand's images were not titillating enough for certain heterosexual male viewers. "Not recommended for cynics or confirmed lechers," he wrote.[10] Another writer observed that many of the women in Winogrand's pictures seemed flattered by the photographer's attention, such that the viewer could detect "the glowing hint of pleasure" at being looked at.[11] Gene Thornton, writing for the *New York Times*, didn't know what to make of Winogrand's photographs. For him, the female subjects were neither the idealized visions of commercial beauty nor "the beautiful heroines of consciousness raising."[12]

Few women wrote about the photographs. Aside from Helen Gary Bishop, the reporter Linda Kerr reviewed *Women Are Beautiful* for the *Austin American-Statesman*. Unlike her male contemporaries, Kerr went beyond categorizing Winogrand's subjects as simply female types. Instead, she emphasized the importance of the city as setting: "The city is, in fact, as central to the book as the women themselves."[13] Kerr's observations echo those of Bishop. In her *Women Are Beautiful* essay, "First Person,

Feminine," Bishop wrote about New York City as a place of excitement, opportunity, and individual freedom for her as a young woman. It represented the antithesis of small-town and suburban life, which tended to advocate for and reinforce conservative strictures on female behavior.[14]

Later in his life, Winogrand confessed to the book's shortcomings. When asked about the photographs in a 1981 interview with Barbaralee Diamondstein, he joked, "That's all we need, another book like that!"[15] Winogrand died five years later, leaving posthumous interpretations to John Szarkowski, with his modernist slant, and to postmodern critics, who often dismissed the work as misogynous.[16] The recent Garry Winogrand retrospective and publication edited by Leo Rubinfien pays scant attention to *Women Are Beautiful*, noting simply that the photographer felt it to be "his least successful volume."[17]

Looking back at *Metropolitan Museum of Art Centennial Ball, New York City, New York* more than forty-five years after its creation, it is impossible to ignore the impact of the historical moment in which the photograph was made and seen. Winogrand's female subject likely had no control over the way Winogrand photographed her, nor the way the image publicly circulated in exhibitions and in print. However, her exuberant physical presence and sexual self-confidence, her flouting of conservative behavioral strictures, resonate powerfully with feminist debates of the period. As this woman bursts through her clothing, she also, in a larger sense, breaks through the confines of a previous generation. The cleavage Winogrand shows here thus goes well beyond the woman's extreme décolletage. Metaphorically, it points to a moment in American history in which the social mores and gendered behavioral strictures of the 1950s and early 1960s split apart, exposing, in full public view, the fleshly self-expression of female sexuality as well as its uncertain public reception.

Notes

1. The legal contract between Winogrand and Tennyson Schad notes that the provisional title of *Women Are Beautiful*, suggested by Winogrand, was "Women Are Beautiful: Confessions of a Male Chauvinist Pig." This title was changed by the time of its publication. Garry Winogrand Archive, Center for Creative Photography, University of Arizona, Tucson, AG 72:1.

2. See interview with Barbaralee Diamondstein in *Visions and Images: American Photographers on Photography* (New York: Rizzoli International, 1981), 185, 187.

3. Winogrand had received the second of three Guggenheim Fellowships and was regularly championed by MoMA curator John Szarkowski, who included his work in five exhibitions, including the influential 1967 show *New Documents* (along with works by Lee Friedlander and Diane Arbus). In Szarkowski's estimation, there was "no young photographer 'more interesting, valuable or important' than Garry Winogrand." Tennyson Schad, Memorandum to File, February 13, 1974, Light Gallery Archives, Center for Creative Photography, University of Arizona, AG194, Box 34.

4. Garry Winogrand Archive, AG 72:1.

5. Schad, Memorandum to File, January 27, 1975, Light Gallery Archives, AG194, Box 34.

6. Schad, Memorandum to File, February 3, 1975, Light Gallery Archives, AG194, Box 34.

7. Garry Winogrand Archive, AG 72:1.

8. According to Schad, David Godine was approached with the possibility of distributing the book. Godine refused, noting that he "did not like Helen Bishop's essay, [and] he did not trust Winogrand." Schad, Memorandum to File, April 8, 1975, Light Gallery Archives, AG194, Box 34.

9. Tennyson Schad to Garry Winogrand, June 27, 1974, Light Gallery Archives, AG194, Box 34.

10. "Rose-Tinted Lens," review of *Women Are Beautiful*, *Afterimage*, February 23, 1976, 13.

11. Phil Patton, *Artforum*, February 1976, 65–66.

12. Gene Thornton, "The Quintessential Street Photographer," *New York Times*, December 7, 1975.

13. Linda Kerr, "Show World," review of *Women Are Beautiful*, *Austin American-Statesman*, February 8, 1976. Typewritten copy in Garry Winogrand Archives, AG 72:1.

14. Betty Friedan upheld this conception in her description of city versus suburban life for women in *The Feminine Mystique*. For Friedan, suburbs were "ugly and endless sprawls," and the lifestyle they mandated was monotonous, conformist, and stifling. As she wrote, "The ability of suburban life to fulfill . . . the able, educated American woman seems to depend upon her . . . strength to resist the pressures to conform, resist the time-filling busywork of suburban hours and community, and find, or make, the same kind of serious commitment outside the home that she would have made in the city." Betty Friedan, *The Feminine Mystique* (New York: Dell, 1963), 233.

15. Winogrand followed up this quote by saying, "I think it's an interesting book, but I don't think it's as good as the other books I've done." Diamondstein, *Visions and Images*, 187.

16. Arthur C. Danto noted that Winogrand's images suggested a behavior that was "extremely aggressive towards the women for whom [he] hungers" and that the photographer tilted his camera "in such a way that it is impossible to suppress the thought that the camera offered Winogrand a way of looking down bosoms." Arthur C. Danto, *Playing with the Edge: The Photographic Achievement of Robert Mapplethorpe* (Berkeley: University of California Press, 1996), 27.

17. Leo Rubinfien, "Garry Winogrand's Republic," in *Garry Winogrand* (New Haven, CT: San Francisco Museum of Modern Art in association with Yale University Press, 2013), 47.

Piecing History Together
Édouard Baldus at the Cloister of Saint-Trophîme

During the nineteenth century, France forged a new vision of national identity through a variety of social, cultural, and political initiatives. The emergence of a single language and a clarified national history and the state-funded expansion of the railway system were aspects of this broader campaign. Interest in cataloging, preserving, and restoring France's rich architectural patrimony increased during this period. Many of the country's Roman ruins, medieval castles and cathedrals, and Renaissance châteaux had fallen into ruin from neglect or been badly damaged

Édouard-Denis Baldus
(French, born Prussia, 1813–1889)
Cloister at St. Trophîme, Arles, 1851
Salt print from multiple paper negatives,
 15¼ × 15¾ in.
Gift of Eleanor and Van Deren Coke
72.214

during the revolutionary period. Government organizations such as the Commission des Monuments Historiques, founded in 1837, set out to document these buildings and determine preservation priorities. These efforts ultimately resulted in an established roster of national monuments.

Photography became an instrumental tool in the commission's endeavors. As early as 1843, three years after Louis-Jacques-Mandé Daguerre and William Henry Fox Talbot publicly announced their inventions, the architect Eugène-Emmanuel Viollet-le-Duc, who oversaw many key restoration projects for the commission, wrote to the minister of justice and religious rites to champion the medium's capacity for "supplying indisputable reports." He went so far as to suggest that the camera superseded the human eye, noting, "Photography cannot be too sedulously used in restorations; for very frequently a photograph discovers what had not been perceived in the building itself."[1]

By 1851, technical improvements in paper photography—specifically, Gustave Le Gray's waxed-paper negative process—made results more predictable, and the medium became better suited to the type of fieldwork required of photographers who needed to travel long distances.[2] Advances in rail travel, particularly during the first decade of the Second Empire (which lasted from 1852 to 1870), connected the provinces to Paris, the capital, greatly facilitating and expediting access to once-remote sites. The moment was ripe for the first government-sponsored photographic survey, and by February 1851 five photographers—Hippolyte Bayard, Henri Le Secq, Édouard Baldus, Gustave Le Gray, and Auguste Mestral—were awarded *missions héliographiques* by the commission. Given a detailed list of structures and specific itineraries, each man traveled to a different region of France, with Le Gray and Mestral combining their itineraries and working collaboratively for most of their journey.

Baldus went south, travelling from Paris to Provence and a portion of the Languedoc region. In Arles, he photographed many of the city's Roman ruins and medieval masterpieces, including the twelfth-century cloister of Saint-Trophîme. Here Baldus faced a technical and artistic dilemma. His lens could not adequately encompass the entirety of the space, and his negatives lacked the degree of chemical sensitivity required to ensure sufficient overall detail in areas either illuminated by direct sunlight or steeped in shadow. Trained as a painter and accustomed to composing scenes through synthetic means, Baldus solved the problem by making about a dozen negatives, exposing each one to best render a section of the cloister's north gallery. He then meticulously cut and pasted these components, joining them along architectural features that best hid evidence of his alterations. Finally, using ink applied with a brush, Baldus retouched his negatives by painting in certain areas of stonework and accentuating details. The resulting print is a tour de force of early photographic manipulation, and a testament to Baldus's artistic ingenuity and technical mastery.[3]

Baldus's *Cloister at St. Trophîme, Arles* thus exists as both a believable account of its subject and a complete fabrication. Akin to the idea of nation itself, his picture is a conscious construction, a whole pieced together by jigsaw parts. As the vision of

France shifted over the course of the nineteenth century from a patchwork of provincial and regional identities toward that of a more centralized nation-state, Baldus and his fellow *peintres photographes* pictured the nation as a palimpsest of architectural styles and traditions. Using the most modern of technologies to photograph and preserve the past, they helped shape the nation's sense of itself as it moved anxiously into the industrial age.

April M. Watson is the curator of photography at the Nelson-Atkins Museum of Art in Kansas City, Missouri, where she oversees a collection of works that span the history of the medium from the nineteenth century to the present. Her curatorial endeavors include exhibitions of historical as well as contemporary works. Some of her museum publications include *Impressionist France: Visions of Nation from Le Gray to Monet* and *Heartland: The Photographs of Terry Evans*. Watson received her MA in art history from the University of New Mexico in 1994, where she wrote on Julia Margaret Cameron. She completed her PhD in art history at the University of Kansas in Lawrence in 2013.

Notes

1. Eugène-Emmanuel Viollet-le-Duc, "Rapport adressé à M. le Ministre de la Justice et des Cultes," 1843, quoted in *The Architectural Theory of Viollet-le-Duc: Readings and Commentary*, ed. M. F. Hearn (Cambridge, MA: MIT Press, 1990), 277–78.

2. For the formative history of early French paper photography, see Andre Jammes and Eugenia Parry Janis, *The Art of French Calotype: With a Critical Dictionary of Photographers, 1845–1870* (Princeton, NJ: Princeton University Press, 1983). Since Jammes and Janis's publication, Sylvie Aubenas and Paul-Louis Roubert have greatly enlarged and expanded the field's understanding of this period and its practitioners with their definitive work, *Primitifs de la photographie, 1843–1860* (Paris: Gallimard and Bibliothèque Nationale de France, 2010).

3. Malcolm Daniel compiled formative research on Baldus's career and working methods. See Malcolm Daniel, *The Photographs of Édouard Baldus* (New York: Metropolitan Museum of Art; Montreal: Canadian Center for Architecture, 1994).

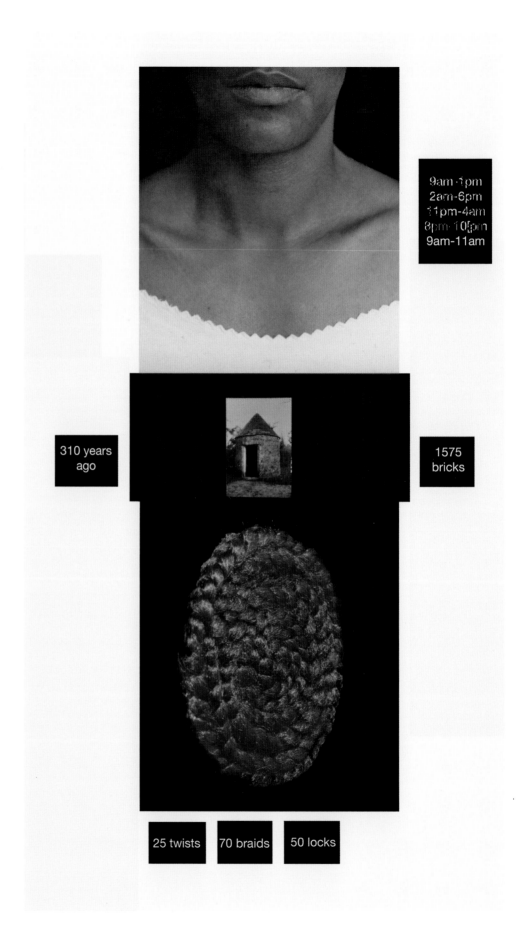

Lorna Simpson
(American, b. 1960)
Counting, 1991
Photogravure and silkscreen,
 165 × 37½ in.
Edition 17/60
© Lorna Simpson; courtesy of the artist
91.49

Carrie and Lorna

I was a graduate student at the University of New Mexico when I first saw the work of Lorna Simpson and Carrie Mae Weems. At the time I was making self-portraits that dealt with African American representation, and I had few points of reference from which to draw. In the late 1980s there was no Internet access; books and magazines were then the only venues for someone in Albuquerque to experience this work. When I was an undergraduate in the early 1980s, the only photographs by black photographers I ever saw in class were the work of Gordon Parks and Roy DeCarava, and I can't 100 percent attest to having seen works by either of them before. There were no African American art history courses where I studied, and black photographers simply weren't integrated into the curriculum—their works certainly weren't represented in our library, which also meant they weren't in the slide library, which meant they weren't shown in lectures or in any way taught in the curriculum. Of the hundreds of photography books at which I looked in my four years as an undergraduate, I don't think I ever saw a single title by a black photographer.

The 1980s, however, ushered in the discussion of postmodernism, and integral to that discussion was the reevaluation of strategies of representation. It was the first time that the ethnicity, race, gender, and/or sexual orientation of the maker—not just the subject—were considered as significant factors in determining who has the authority to picture whom. So I voraciously read every contemporary publication, looking for images, until I discovered the name and work of Deborah Willis, an artist, curator, and photo historian who, beginning in the early 1980s, became largely responsible for founding the discipline of African American photographic history.

Willis's first bio-bibliography of black photographers was published in 1985, but I wasn't aware of it until I got to the University of New Mexico the following year. However, it only covered work made up to 1940.[1] Four years later she followed up with *An Illustrated Bio-bibliography of Black Photographers, 1940–1988*, and that same year she published two exhibition catalogs: *Constructed Images: New Photography* and *Black Photographers Bear Witness: 100 Years of Social Protest*.[2] It was in these three publications I first saw the work of Lorna Simpson and Carrie Mae Weems. I still remember the exact images: Simpson's *Waterbearer* (1986) and Weems's *Jim, if you . . .* (1986), *Black Man with a Watermelon* (1988), and *As a Child I Loved the Aroma of Coffee* (1988). Both artists had studied in California, from where I hailed; both used images

Carrie Mae Weems
(American, b. 1953)
Untitled, from the *Kitchen Table* series,
 1990
Gelatin silver print, 7½ × 7½ in.
Edition A.P.
© Carrie Mae Weems; courtesy of the
 artist
98.16

and text in their work (which I never mastered).[3] Though both initially had made the more documentary or street-style photographs traditionally associated with photographers of color, by that time each had moved into more conceptual, larger-scale work that was as heavily influenced by art history as cultural and identity politics. It would be impossible to overstate the influence that their work had on me.

Simpson and Weems would eventually become the two most successful and important African American photographic artists to emerge from the multicultural

dialogues of the 1980s and 1990s. Each has published so many monographs and catalogs that I have actually lost count. In 2012 Weems became the subject of a traveling career retrospective. For the past decade or so my friends and I have joked (with much truth) that, to look at contemporary photo histories, in thirty-plus years *CarrieandLorna* (as one word) would appear to be the only successors to Parks and DeCarava, as the only two of a second generation of black photographers whose names ever appear in general photo history texts. Of course, whether we now personally know them or not, we all pretend to be on a first-name basis with them, perhaps because from the very beginning it was so essential to claim them as our own. But the reality is that because of them, because of Willis, there are *a lot* more of us. And now that's my life's work, to make all of these names known.

Counting and the *Kitchen Table* series were created after I left the University of New Mexico, so I never had the opportunity to see them or touch them there.[4] Yet it is personally gratifying—almost as though I were responsible for their acquisition myself—to know that any UNM student way out there in New Mexico now can go into the museum and request to be in the presence of either of these major works and have her or his communion with them. I know what it would have meant to me. Last year I was beyond fortunate to finally acquire a Weems of my own (from this era, too, which made it all the more meaningful), but it remains far more significant that these artists continue to be collected by public institutions. Because of its rich history of faculty, students, and friends, the University of New Mexico has long had a world-class photography collection, and with the work of artists such as Simpson and Weems (and, it turns out, DeCarava), it is that much stronger and representative of the tremendous history and contributions of black photographers.

Carla Williams is an artist, educator, curator, author, and editor. Since receiving her MFA from the University of New Mexico in 1996, Williams has held teaching posts at Stanford University, San Francisco Art Institute, and Rochester Institute of Technology. She was the editor for *Exposure* magazine from 2005 to 2011 and presently is the managing editor for the CHROMA book series, a project for The Arts at CIIS (California Institute for Integral Studies). Williams has written many articles, essays, and book chapters regarding issues of gender and African American identity. In addition, she is a practicing artist with an extensive exhibition history, and her photographs have been acquired by the Museum of Fine Arts, Houston; the Art Museum at Princeton University; and the Chrysler Museum of Art, to name just a few institutions. Williams currently lives and works in New Orleans, Louisiana.

Notes

1. A slightly earlier publication, Valencia Hollins Coar's *A Century of Black Photographers, 1840–1960*, was a catalog for a traveling exhibition with the same title that originated at the Rhode Island School of Design in 1983. But even at that time the catalog was virtually impossible to find; according to legend the printing plates were destroyed in a fire so it could never be reprinted (I never learned if that was true or not), and Hollins Coar did not remain in the field of photo history.

Willis's *Black Photographers, 1840–1940: An Illustrated Bio-bibliography* (New York: Garland, 1985) was a more encyclopedic approach to the artists who worked during the period that Hollins Coar had covered in her book.

2. Deborah Willis, *An Illustrated Bio-bibliography of Black Photographers, 1940–1988* (New York: Garland, 1989); Willis, *Constructed Images: New Photography* (New York: New York Public Library, 1989); Willis, *Black Photographers Bear Witness: 100 Years of Social Protest* (Williamstown, MA: Williams College Museum of Art, 1989).

3. The New York–born Simpson received her MFA from the University of California, San Diego; and Portland, Oregon, native Weems received her BFA from California Institute of the Arts and her MFA from UC San Diego. She later attended the University of California, Berkeley, for graduate study in folklore.

4. In graduate school I worked as a preparator's assistant in the museum, where I was awed to find myself actually handling the works of art, an incomparable privilege.

Two Images

Julia Margaret Cameron and Emmet Gowin

Two images, so opposite in nature.

The first, this beautiful young woman with hair like moving river water and skin like marble. She is incandescent, pensive and self-contained. She transcends being merely an object of great beauty and passivity. Instead the action of her hair and a degree of suffering in her gaze give her a sense of agency, of feminine power. She can change stillness into action.

The second, a cold, luminous fish, carved out of ice, shines brilliantly out of darkness on a barn floor. It is the complete opposite of the first image. Instead of warm tones and soft focus, this image is cold and crisp—it is one hundred years newer.

It is cold toned, sharp and convex, with an enigmatic, chilling object pointing the way. This image comes alive in the visual questions it asks. Why is this fish out of water and why out of ice? This image is so masculine and yet mutable at the same time. It is powerful but in transition—it will melt into softness like the denouement of the sexual act.

My choices are both soft and hard, feminine and masculine, but in each the predominant quality contains its opposite. Each image is in transition, the first stillness into action, the second melting away from something to nothing.

What a wonderful experiment to be asked to take on this task of writing on a select group of photographs. To choose from a magnificent collection such as that at the UNM Art Museum is very different than choosing from a collection like that of the Metropolitan Museum of Art in New York. That's not to say that newly seen photographs on a museum's wall won't draw you in and change your life.

It is just that I learned photography from this collection at the start of my career. So many of the images are old friends and many still inform the work I do. I've chosen these two images based on how they still speak to me after almost forty years. Until I wrote the descriptions above, I had no thought as to how these two choices might be related or why I selected such different images.

Perhaps it's the life experience that I was in the midst of as I gazed at them at the University of New Mexico in 1973. I had studied photography only one year with Minor White at MIT, when he wrote a letter of introduction for me to Beaumont Newhall. So there I was very shortly after, an MFA student learning the history of

Julia Margaret Cameron
(British, born India, 1815–1879)
The Wild Flower, 1867
Albumen silver print, 11¼ × 9⅛ in.
Gift of Eleanor and Van Deren Coke
72.484

photography through original prints from Beau and Van Deren Coke. I was one of the youngest, the least trained, the only one with no prior accomplishments, the only woman in my class. I was a beginner. There were only eleven women mentioned in Beaumont's *History of Photography*, among hundreds of other names. There was only one woman professor of printmaking/painting in the entire department, who used a nom de plume when exhibiting her "secret" body of works that were non-abstract, very personal, sensual images.

So imagine seeing the work of Julia Margaret Cameron and reading excerpts from her unpublished biography, *The Annals of My Glass House*, and *Freshwater*, a play about her by her great-niece Virginia Woolf. This image, circa 1867, is of Julia Prinsep Jackson, Cameron's niece and goddaughter, whom she photographed many times. I loved a slightly later version of her in an oval format as Mrs. Herbert Duck-worth. She shortly thereafter became widowed, soon the wife of Leslie Stephens and

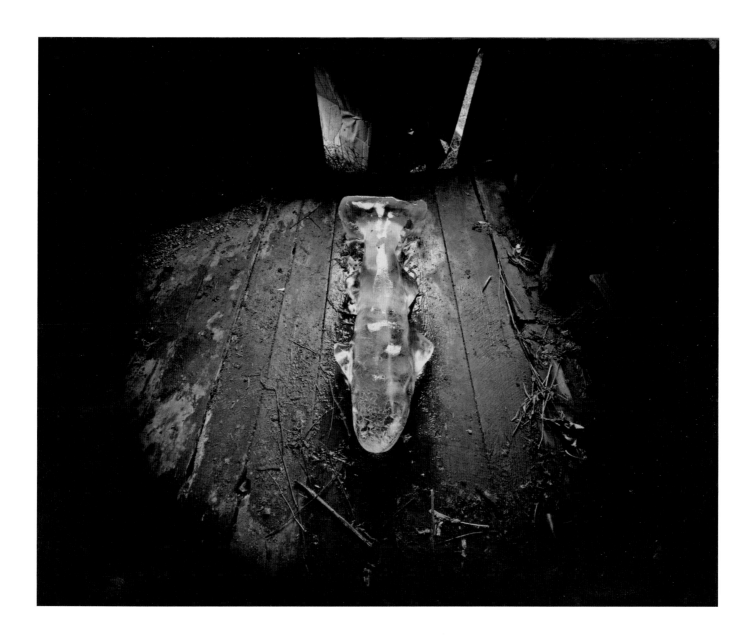

Emmet Gowin
(American, b. 1941)
Icefish, Danville, Virginia, 1971
Gelatin silver print, 8 × 9⅞ in.
Purchased with funds from the National
 Endowment for the Arts with matching
 funds from the Greater University of
 New Mexico Fund
© Emmet and Edith Gowin
73.49

the future mother of Virginia Woolf. This oval portrait hung in Beaumont's house, where I would see it for many more years to come.

Cameron's work was passionate, hasty. The other photographers reacted to her, in 1865, much the way the men had reacted to me in my first year at MIT in 1972. I was always making mistakes in my drive to learn. I was a nuisance, one they thought could never succeed. So they were so surprised when Minor gave me an exhibition in the school gallery my first year at the University of New Mexico.

I really understood Cameron, how with her subjects waiting, and her ideas exploding, she barely had time to distribute the liquid emulsion evenly on the photographic paper surface. Developing streaks and mottled colors gave the men pause, reason to ridicule. But in fact, these marks of the artist's hand were later appropriated by Van Deren Coke, and by future UNM alums such as Joel-Peter Witkin and Robert and Shana ParkeHarrison.

Virginia Woolf lovingly pokes fun at Cameron's zaniness in her play *Freshwater* (1923/1935). Cameron appropriated overused genres from Pre-Raphaelites, Shakespeare, Dante, and the Bible. But if we look at her subjects and actors as a celebration of an artist's life in an artist colony on the Isle of Wight, they have exuberance unmatched in her day. You need that exuberance to steady your doubts when you're the only woman artist around.

Emmet Gowin also made *Icefish* early in his career, in 1971 (in Danville, Virginia). Danville is where both he and his wife, Edith, whom he so often photographed, originated. Origination, Creation, and the Mother are his BIG themes, but these have been hidden in an exacting specificity of family rituals, birthing and dying of both people and places. Edith and her family became Emmet Gowin's root image source, where he could explore the vernacular snapshot, then metaphysical icon, and finally a view from above of the mother body—this changing earth: volcanoes, crop circles, toxic-waste sites.

He first turned his eye on family gatherings and rituals, creating many formative images for me when I later married into a rooted, extended New Mexico family. A watermelon split open with seeds proudly displayed at a family picnic, a little girl dancing with an egg, two little children rolling in the grass like future lovers—all portend generational continuity in due time. Perhaps the image that most gripped me in its totality is one of a naked, pregnant Edith in a riverbed with their young son Elijah. Her luminous body, like the *Icefish*, designates her as the creative force in the universe; Elijah and the dark, star-studded rocks in the water are planets in her orbit.

In 1967 Gowin discovered an eight-by-ten-inch view camera with a lens only long enough to cover a four-by-five-inch area. The image cast on the ground glass was vignetted in black. He thus found a new strategy for suggesting the great round, the circle of life. The ice fish sits in this great round of fecund and precious darkness. The lens's lack of coverage creates a centrifugal force drawing the viewer both in and outward.

In his book *Changing the Earth* (2002), Emmet Gowin says, "The landscape gives the heart a place to stand." I use this quote in all of my classes to give a foundation to students' image making, so they will see that whatever they do, their sources of creativity emanate from where they are located, physically, mentally, and spiritually. You could say that this is what Cameron and Gowin most have in common. In their own moment in time, they each drew on their personal locales—islands of origination and inspiration. Peopled with kindred spirits, embodied in the physical, their family members became their conduits to express the infinite.

Aesthetically they might seem miles apart in time, materials, optics, and intent. But they both used nontraditional (for that moment) strategies to let emphasized qualities do the talking. For Cameron: soft focus, soft light, waves of emulsion and emotion, warm tone, and sometimes the egg-shaped oval border. For Gowin: rich, deep tonal scale, dramatic contrast of light and dark, extreme detail, and the wide-angle vignetted circle form.

Cameron was already forty-eight when she took up photography, and she had a very brief span of production. After ten years she left the Isle of Wight and returned to Ceylon with her husband and seems to have given it up at that point. We can feel the depth of her adult experience filling her albumen portraits. Ten years beginning at age forty-eight, 140 years ago, was probably a long time.

Gowin, on the other hand, began to photograph Edith in his midtwenties. He has returned repeatedly to her as his subject for almost fifty years, while also departing for places on the planet that demonstrate the life cycle in more threatened ways.

The root for the word "ecology" comes from home (οἶκος, "house"; λογία, "study of") Ecology is the study of the relationships between organisms and their environment. There are many different kinds of ecologies. Both Cameron and Gowin studied their houses well in advance of our increasingly clearer understanding of the relationship between our lives and the earth on which we rest. These two artists have made this understanding so much more evident for me. As kindred artists, they've lit my way.

Meridel Rubenstein has been engaged in photography since the 1970s. Whether it is a singular photographic image or a multimedia installation, her work has always addressed an awareness of how we as individuals are connected to a particular place. She is based both in Santa Fe, New Mexico, and in Singapore, where she teaches part of each year at the Nanyang Technological University. In addition to awards she has received from the Guggenheim Foundation, the National Endowment for the Arts, and the Pollock-Krasner and Rockefeller Foundations, her work has been exhibited at the Louvre in Paris, the Museum of Modern Art in Dublin, the Center for Creative Photography in Arizona, and the Museum of Contemporary Photography in Chicago. The monograph devoted to her projects, *Belonging: Los Alamos to Vietnam—Photoworks and Installations* was published by St. Anne's Press in 2004 and features essays by Terry Tempest Williams, Rebecca Solnit, and Lucy Lippard.

His Story

Sometime around 1900, a young nine- or ten-year-old boy left his small Quechua village of Coaza in Peru and traveled on foot with his father, Félix, to the Santo Domingo mining camp to look for work. Their journey took approximately six days. It was here that young Martín Chambi was introduced to photography, possibly by Carlos Southwell, a professional employed at the camp to document daily activities and mining progress and to make identity portraits of the Indian laborers. This marked the beginning of Chambi's acculturation process and his lifelong affinity for photography. Although he eventually worked within a larger community of photographers, as a Quechua Indian by birth, much of his story is unique.

In 1908 he made his way to the cosmopolitan, commercial city of Arequipa, where he served as an apprentice to Maximiliano T. Vargas (1873?–1959), one of the city's most sophisticated and successful photographers. After nine years of learning both the practice and business of photography, Chambi, a young man of twenty-six, left Arequipa and set out on his own in 1917. He finally settled in Cusco, a city in the throes of twentieth-century modernization and one that was located near many indigenous communities. By then he had become fully acculturated through education, marriage, and his photography profession and was seen by local intellectuals, artists, and politicians as a successful mestizo. Yet, despite the more obvious signs of his acculturation—his Western style of dress, a prosperous business, and his general practice of speaking Spanish rather than his native Quechua language—Chambi always remained committed to his indigenous culture, language, and customs. He successfully negotiated the myriad levels of stratified Cusqueñan society and was as comfortable photographing a campesino and his boss in a rural landscape as he was photographing local politicians or dignitaries in his Cusco studio. Chambi's vast photographic legacy provides an exceptional archive of images of pre-Columbian archaeological sites, Spanish colonial and Incan architecture, indigenous and Catholic festivals, and rites and pilgrimages, along with a comprehensive record of all the citizens—Indians, campesinos, mestizos, Europeans—in and around the Cusco region during Peru's defining decades of the early twentieth century.

I first discovered Martín Chambi in a book of collected essays by Max Kozloff. I lived in New York City at the time and would soon be relocating to Albuquerque to continue my graduate studies under Eugenia Parry. Imagine my surprise when

I learned that not only had Chambi been rediscovered and his work brought to national and international attention by Edward Ranney, a renowned photographer who lived an hour away in Santa Fe, New Mexico, but the UNM Art Museum, thanks to Ranney's efforts and extended work with the Chambi family, owned one hundred images by Chambi. Shortly after I arrived at the University of New Mexico, I made an appointment at the art museum to see the photographs. I was immediately hooked. I went on to complete my dissertation on Martín Chambi in 1997 and today remain as fascinated by his complex life story and his pictures as I was when I first discovered them so long ago.

Michele M. Penhall was the curator of prints and photographs at the University of New Mexico Art Museum in Albuquerque from 2004 to 2014, where she organized both historical and contemporary exhibitions on photography, prints, video works, and book collections. In addition to her research and writing on twentieth-century Latin American photography, she edited and contributed to the monograph *Desire for Magic: Patrick Nagatani, 1978–2008*, which accompanied the thirty-year retrospective of Nagatani's œuvre. Penhall received her PhD in art history from the University of New Mexico in 1997 under Eugenia Parry, Thomas Barrow, and Edward Ranney, writing on the twentieth-century Peruvian photographer Martín Chambi.

Martín Chambi
(Peruvian, 1891–1973)
*Venacio Arce and Campesino with
 Potato Harvest, near Katka,
 Quispicanchis,* 1934
Gelatin silver print, 8½ × 12¾ in., 1981
Gift of Edward Ranney
© Martín Chambi Archive
81.150

Plates

Photographer unknown
(American, early 20th century)
Photographic album containing 25 images, some toned, hand-
 tipped in
Title page inscribed, "Random Shots Compiled for the Edification
 of Eleanor T. Wragg, Waco, Texas, December 25th 1915"
25 gelatin silver prints, each with descriptive text on facing
 page, image size ca. 3½ × 2½ in., album size
 5¼ × 5¼ × ⅝ in.
Gift of the Estate of F. Van Deren Coke and Joan Coke
2012.23.33

A quiet game
with my friend
"William" of
the Baylor Museum

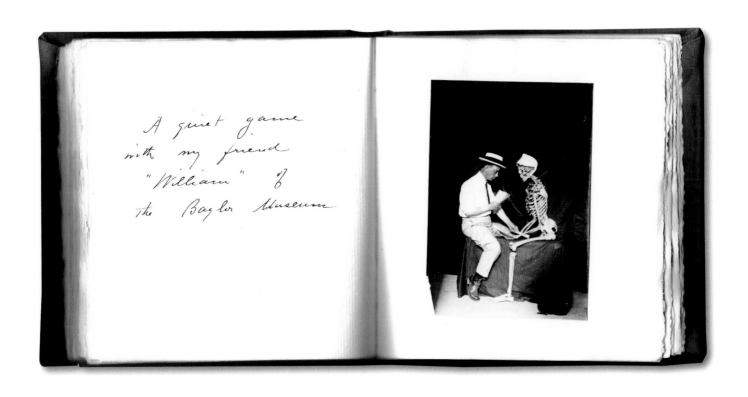

Tamas Dezso
(Hungarian, b. 1978)
Night Watchman (Budapest), 2009
Chromogenic print, 18¹¹/₁₆ × 22¹¹/₁₆ in.
Edition 3/10
Purchased with funds from the Friends of Art
© Tamas Dezso; courtesy of Robert Koch Gallery,
 San Francisco, CA
2012.4.1

Josef Sudek
(Czech, 1896–1976)
The Window, 1954
Gelatin silver print, 4¾ × 6⅝ in.
Gift of Eleanor and Van Deren Coke
© Josef Sudek, courtesy of Isabela and Gabriela Fárová
76.163

S. Gayle Stevens
(American, b. 1955)
Blow, from the portfolio *Calligraphy*, 2011
Wet plate collodion tintype, 5 × 5 in.
Edition 3/3
Gift of *Fraction Magazine* and the Ranney Bram Family
© S. Gayle Stevens, courtesy of the artist
2014.15.2

Betty Hahn
(American, b. 1940)
Greenhouse Portrait (Bea Nettles), 1973
Gum bichromate with colored thread on fabric,
 8¾ × 12¾ in.
Purchased with funds from the Julius L. Rolshoven Memorial Fund
© Betty Hahn
74.58

Robert Heinecken
(American, 1931–2006)
A Is for Asparagus 2, 1971
Gelatin silver print, photogram and chalk, 4 × 7 in.
© The Robert Heinecken Trust
74.64

Anna Atkins
(British, 1799–1871)
Hymenophyllum Wilsoni, ca. 1850
Cyanotype, $7\frac{7}{8} \times 4\frac{13}{16}$ in.
The Beaumont Newhall Collection
Purchased with funds from the John D. and
 Catherine T. MacArthur Foundation
91.29

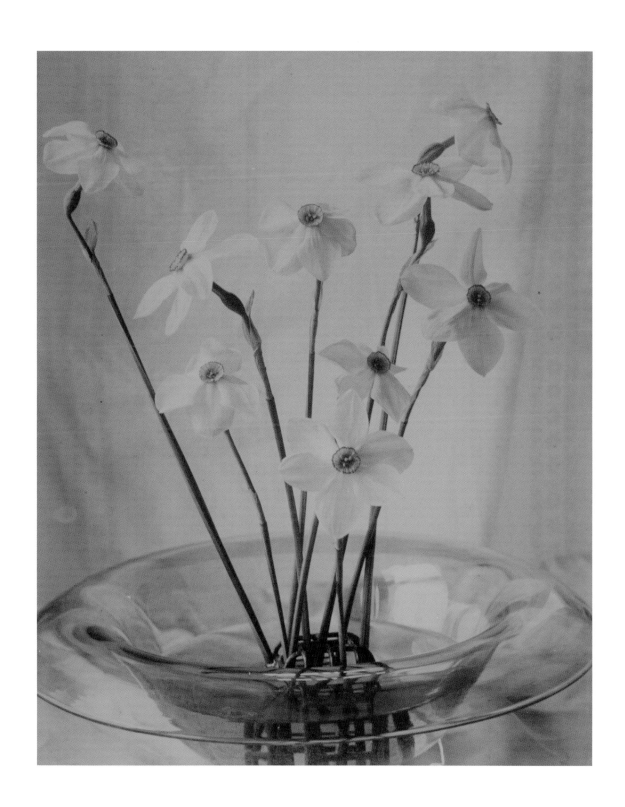

Laura Gilpin
(American, 1891–1979)
Narcissus, 1928
Platinum print, 9½ × 7⅝ in.
Gift of Eleanor and Van Deren Coke
© 1979 Amon Carter Museum of American Art,
 Fort Worth, Texas
73.227

Chas Fritsch
(American, active Pennsylvania, dates unknown)
Untitled, n.d.
Cabinet card, albumen print, 6¼ × 4⅛ in.
Anonymous gift in honor of Thomas Barrow
2013.1

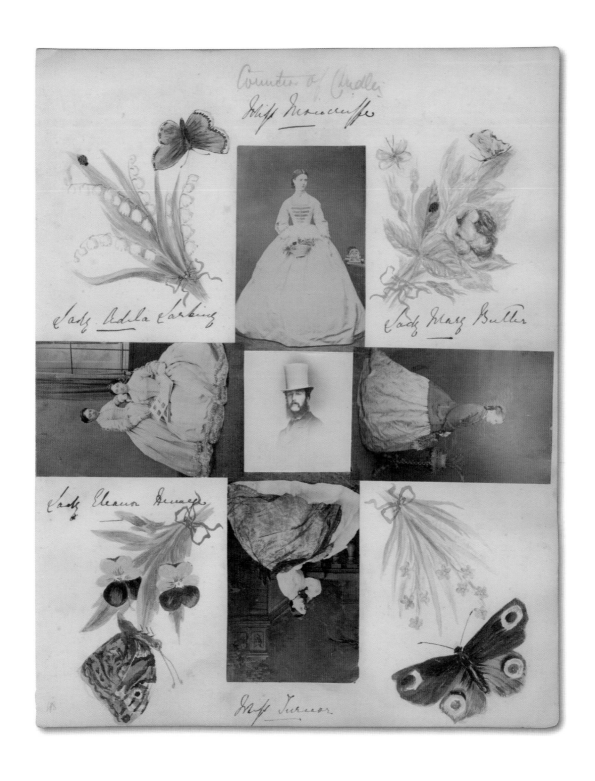

Mary Georgiana Caroline, Lady Filmer (née Cecil)
(British, 1838–1903)
Untitled, from the *Filmer Album*, mid-1860s
Watercolor with albumen prints, 11¼ × 9 in.
77.111

Tsutomu Yamagata
(Japanese, b. 1966)
浅草に店を持って 30 年。客は年々減っている。(Has run a
 bar in Asakusa for 30 years. The number of customers has
 declined every year.)
From the series *Thirteen Orphans*, 2010
Gelatin silver print, 13⅛ × 13⅛ in.
Edition 2/10
Gift of the artist
© Tsutomu Yamagata; courtesy of the artist
2013.22.5

Miguel Gandert
(American, b. 1956)
Frances López, 1994
Polaroid print, 24 × 20 in.
Purchased with funds from Elizabeth Wills, the Contemporary
 Arts Society, Walter and Allene Kleweno, and anonymous
 donors
© Miguel Gandert; courtesy of the artist
97.25.7

Martin Parr
(British, b. 1952)
Lynmouth, England, 1999, from the series *Think of England*
Chromogenic print on Fuji Crystal Archive paper,
19½ × 29½ in.
Edition 5/10
Purchased with funds from the Friends of Art
© Martin Parr/Magnum Photos/ROSEGALLERY
2012.1

Anne Noggle
(American, 1922–2005)
The Gay Divorcée, 1979
Gelatin silver print, 11½ × 16⅛ in.
Gift of Mary N. Pease
© Anne Noggle; courtesy of the Anne Noggle Estate
83.86

August Sander
(German, 1876–1964)
Real Estate Agent, Cologne, 1928
Gelatin silver print, 11½ × 6 in., 1971
©2014 Die Photographische Sammlung/SK Stiftung Kultur—
 August Sander Archive, Cologne/Artists Rights Society (ARS),
 New York
72.392

CHARLES BAUDELAIRE

IL faut admirer en Baudelaire un des plus grands hommes de ce temps, et qui, si nous ne vivions pas sous le règne intellectuel de Victor Hugo, mériterait que nul poëte contemporain fût mis au-dessus de lui. C'est à dessein que je rapproche tout de suite ces deux noms, pour faire une remarque dont l'importance est capitale. De tous les artistes modernes du vers, l'auteur des *Fleurs du mal* est le seul qui n'ait rien dû à l'auteur de *La Légende des Siècles*. Il l'admirait évidemment avec toute l'intensité, et avec toute la subtilité de ses facultés compréhensives, mais il ne procédait ni de lui ni de personne. Non qu'il ait existé comme un produit du hasard et en dehors de la tradition, car en lui, comme en tout vrai chanteur, on retrouve, depuis Homère, toute la race qui l'a précédé. Mais sa pensée, résolument sincère, s'affirme toujours par une forme vraiment originale, aussi Baudelaire fût-il, dans le sens du mot le plus complet et le plus absolu, un poëte nouveau.

Oui, un poëte nouveau! De là les amertumes de sa vie, l'étonnement des sots, le manque de succès fructueux et les mépris dont il fut abreuvé. De là aussi la pure gloire dans laquelle il est entré presque tout de suite après sa mort, et la renommée immense de son œuvre. Pour toute la jeune génération actuelle, Baudelaire est devenu le poëte avec lequel on vit, qu'on ne quitte jamais, à qui, dans toutes les tribulations et les tortures de la vie, on demande consolation et assistance. Après avoir été riche, il avait connu presque la misère; excepté dans le monde intellectuel, il tenait une bien petite place; aujourd'hui l'œuvre de ce maître a étendu partout son influence, qui ne peut plus être arrêtée ni diminuée; elle s'est mêlée à notre vie, à notre sang, à l'air que nous respirons. Tandis que nous avons déjà vu tant de favoris du succès bruyant disparaître, à peine morts, comme des ombres vaines, Baudelaire est vivant, dans la sereine clarté et pour toujours. Il y a dans cette histoire une grande leçon, mais qui ne profitera à personne; car pour la suivre, il faudrait déjà être un humble de cœur et un génie.

On connaît la vieille et symbolique anecdote d'Hercule ayant, au début de sa vie, à choisir entre deux routes, pour nul être humain elle n'est aussi vraie que pour le poëte, pourvu d'une

Étienne Carjat
(French, 1828–1906)
Charles Baudelaire, ca. 1862
Reproduced in the *Album de La Galerie Contemporaine*,
 semester 1, series 1, 1878
Published by Ludovic Baschet (1834–1909)
Woodburytype and text, 9¹⁄₁₆ × 7⅛ in.
Transfer from the UNM Fine Arts and Design Library
2007.31.1.5

126, boul. Magenta. Paris. Phot Goupil & C⁰. Cliché Carjat et C⁰.

CH. BAUDELAIRE

Né à Paris en 1821, mort en 1867

(top)
Photographer unknown
Untitled, ca. 1856
Daguerreotype, 2¾ × 2¼ in.
Purchased through the UNM Alumni Fund
X0.297.1.115

(bottom)
Photographer unknown
Untitled, ca. 1850
Daguerreotype, 2½ × 2 in.
Purchased through the UNM Alumni Fund
X0.297.1.31

Robert Shlaer
(American, b. 1942)
Beaumont Newhall at Home, Santa Fe, New Mexico, 1988
Daguerreotype, 5 × 4 in.
Edition 7/7
Purchased through the Julius L. Rolshoven Memorial Fund
© Robert Shlaer
93.12

Lewis Carroll (Reverend Charles Lutwidge Dodgson)
(British, 1832–1898)
Francis H. Atkinson, 1863
Albumen silver print, 5⅛ × 4½ in.
Gift of Harry H. Lunn Jr.
84.104

Gustave LeGray
(French, 1820–1882)
Lyndheast Sykes, 1857–1859
Albumen silver print, 7 × 6½ in.
Purchased with funds from Michael Mattis and Judy Hochberg,
 Eric Alterman, and Dr. Donald and Alice Lappé
2004.16.28

Photographer unknown
(Japan, 19th century?)
Untitled (geisha), from the photographic album *Japan A*, n.d.
Hand-colored albumen print, 10⅜ × 7¾ in.
Transfer from the UNM Fine Arts and Design Library
2007.31.2.17

Photographer unknown
(Japan, 19th century?)
Untitled (sumo wrestlers), from the photographic album
 Japan A, n.d.
Hand-colored albumen print, 7¾ × 10⅜ in.
Transfer from the UNM Fine Arts and Design Library
2007.31.2.36

David Levinthal
(American, b. 1949)
Untitled, 1999
Cibachrome, 10 × 8 in.
Gift of John and Mary Mulvany in honor of Van Deren Coke
© David Levinthal
2000.19.1

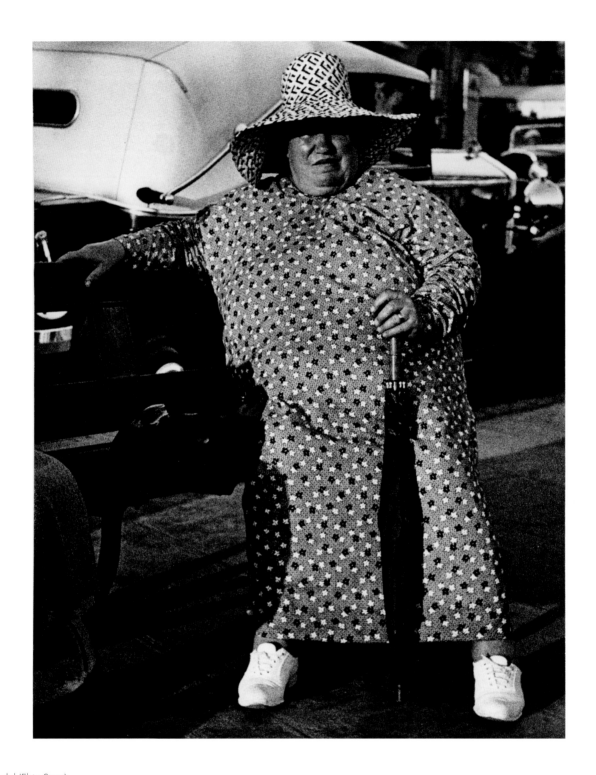

Lisette Model (Elsie Stern)
(American, born Austria, 1906–1983)
Promenade des Anglais, Nice, France, ca. 1934
Gelatin silver print, 19¾ × 15⅜ in., 1977
Gift of Joan and Van Deren Coke
© 2014 Estate of Lisette Model; courtesy of Baudoin Lebon
 Gallery, Paris, and Keitelman Gallery, Brussels
99.62.41

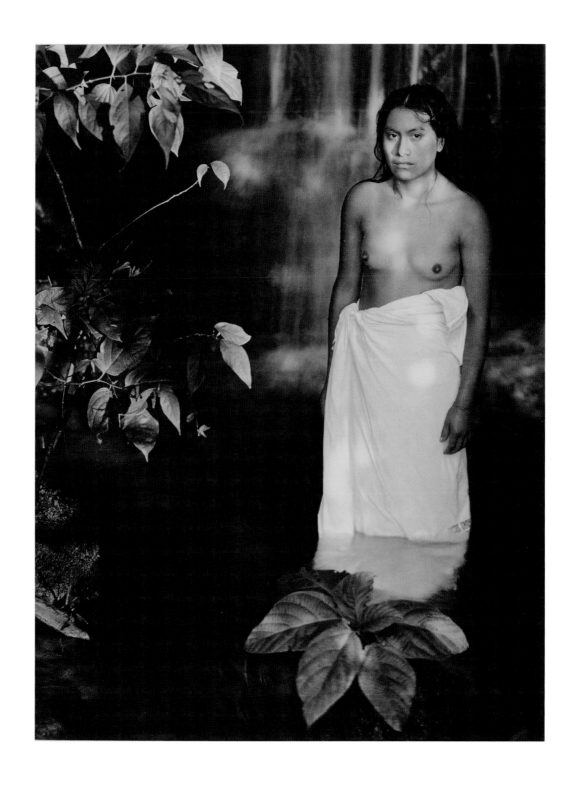

Flor Garduño
(Mexican, b. 1957)
Water, Valle Nacional, Mexico, 1983
Platinum print, 17½ × 13¼ in.
Gift of Joan and Van Deren Coke
© Flor Garduño
2000.44.19

Wayne R. Lazorik
(American, b. 1939)
In collaboration with Ellen Garvens
(American b. 1955)
Before the Chocolate Ones, 1981
Hand-colored gelatin silver print, 36 × 36 in.
Gift of Joel-Peter Witkin in memory of Douglas George
© Wayne Lazorik
99.24

Ruth Bernhard
(American, born Germany, 1905–2006)
In the Box—Horizontal, 1962, print 1992
Edition 43/50
Gelatin silver print, 12¹⁵⁄₁₆ × 23 in.
Gift of The Estate of Ruth Bernhard
© Trustees of Princeton University, reproduced with permission of
 the Ruth Bernhard Archive, Princeton University Art Museum
2007.10

Eikoh Hosoe
(Japanese, b. 1933)
Embrace #47, 1971
Gelatin silver print, 3⅜ × 4⅞ in.
Gift of Eleanor and Van Deren Coke
© Eikoh Hosoe
77.182.4

John Coplans
(British, 1920–2003)
Three-Quarter View, Straight, 1986
Polaroid type 55, 3½ × 4½ in.
Edition A.P.
Purchased with funds from the Friends of Art
© The John Coplans Trust; courtesy of the John Coplans Trust and
 the Carl Solway Gallery, Cincinnati, OH
2012.2.2

Cheryle St. Onge
(American, b. 1961)
Untitled, from the series *Natural Findings 1*, 2008
Archival digital print from 8 × 10 in. negative, 24 × 10 in.
Gift of Fraction Magazine and the Ranney Bram Family
© Cheryle St. Onge; courtesy of the artist
2014.15.6

Mike Disfarmer (née Meyer)
(American, 1884–1959)
Untitled, ca. 1939–1946
Gelatin silver print, 5 × 3½ in.
Gift of George Thomsen
2007.15.1

(left)
Mike Disfarmer (née Meyer)
(American, 1884–1959)
Untitled, ca. 1930
Gelatin silver print, 5 × 3 in.
Gift of Jake and Julia Chatzky
2008.25.16

(right)
Mike Disfarmer (née Meyer)
(American, 1884–1959)
Untitled, ca. 1939–1946
Gelatin silver print, 5½ × 3½ in.
Gift of Anthony James Ellman
2007.7.4

I. Bent
(American, active Boston, MA)
John B. Heywood
(American, active Boston, MA)
C. S. Sanderson
(American, active Bath, ME)
Plumbe National Daguerrian Gallery
(American, active Boston, MA)
Various other photographers unknown
Twenty ⅑th-plate tintypes, ambrotypes, and daguerreotypes,
 overall size 15½ × 15⅞ × 1¾ in., framed
Purchase through the UNM Alumni Fund
X0.297.4.2

André-Adolphe-Eugène Disdéri
(French, 1819–1889)
M. Basilewski, 1867
Carte-de-visite, uncut sheet, albumen silver print,
 7¹³⁄₁₆ × 9⅛ in.
97.41.1

Antoine François Jean Claudet
(French, active Great Britain, 1797–1867)
Untitled, ca. 1850s
Hand-colored stereo daguerreotype, 4 × 7½ in.
Gift from the Estate of F. Van Deren Coke and Joan Coke
2011.23.3 a–b

Peter Henry Emerson
(British, born Cuba, 1856–1936)
Poling the Marsh Hay, 1886
Platinum print, 9³⁄₁₆ × 11¼ in.
The Beaumont Newhall Collection, purchased with funds from
 the John D. and Catherine T. MacArthur Foundation
85.83

Helen Levitt
(American, 1913–2009)
New York, 1942
Gelatin silver print, 7¾ × 9⅝ in.
© Helen Levitt; courtesy of the Estate of Helen Levitt
79.17

Henri Cartier-Bresson
(French, 1908–2004)
Untitled, ca. 1960
Gelatin silver print, 6⁹⁄₁₆ × 10¹⁄₁₆ in.
Gift of Fernando and Gloria Barnuevo Ybarra
© Henri Cartier-Bresson/Magnum Photos
2011.12.1

Robert Fichter
(American, b. 1939)
Daniel Andres with Red Dog, late 1970s
Gelatin silver print, 14⅝ × 15 in.
Gift of the artist
© Robert Fichter; used with permission from the Photography
 Collections, University of Maryland, Baltimore County
92.32.2

Josef Vorisek
(Czech, 1902–1980)
Josef Sudek with His Camera, ca. 1958
Gelatin silver print, 11½ × 11¾ in.
Purchased with funds from Fernando and Gloria Barnuevo,
 Michael Mattis, and Judy Hochberg
© Josef Vorisek
2003.23.1

Joel-Peter Witkin
(American, b. 1939)
The Execution of an Extraterrestrial, Petersburg, VA, 1864, 2013
Unique gelatin silver print with encaustic, 16 × 20 in.
Gift of the artist
© Joel-Peter Witkin
2014.3

Linda Connor
(American, b. 1944)
Untitled (Golden Gate Park), 1972
Gold-toned printing out paper, 8 × 10 in.
© Linda Connor
75.93

Arthur Wesley Dow
(American, 1857–1922)
Untitled, ca. 1895
Cyanotype, 5⅞ × 8 in.
Gift of Joan and Van Deren Coke
91.11.61

Alfred Stieglitz
(American, 1864–1946)
Equivalent, 1927
Gelatin silver print, 3⁹⁄₁₆ × 4⅝ in.
Gift of Doris Bry in honor of Luanne McKinnon
© 2014 Georgia O'Keeffe Museum/Artists Rights Society (ARS),
 New York
2011.9

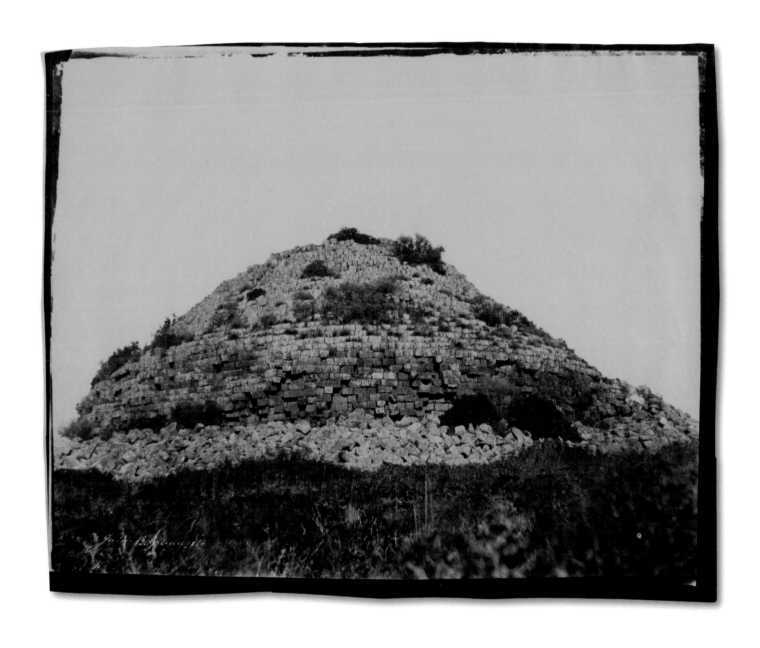

John Beasley Greene
(French, 1832–1856)
Tomb of the Christian, Algeria, 1856
Salt print from paper negative, 9⅛ × 12 in.
Purchased with funds from the Julius L. Rolshoven Memorial Fund
84.95

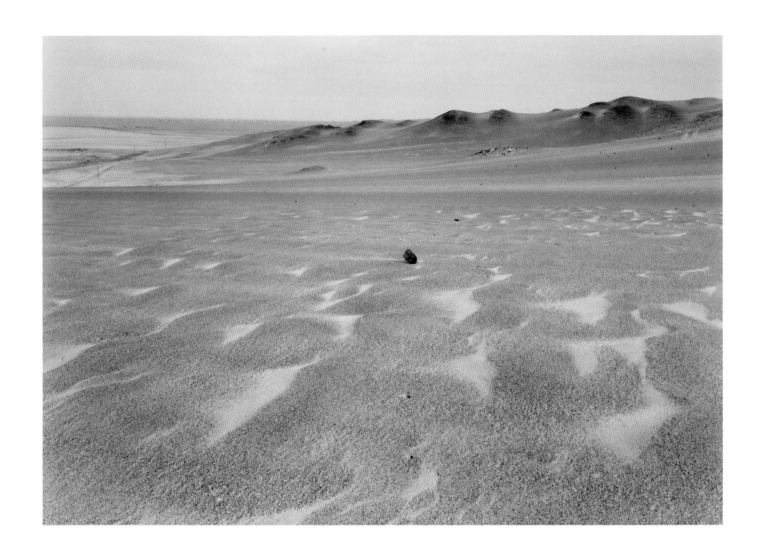

Edward Ranney
(American, b. 1942)
Cerro Colorado, Paracas Península, Peru, 1985
Gelatin silver print, 13 × 18^{11}/$_{16}$ in.
The Eliot Porter Fellowship Collection
Gift of the New Mexico Council on Photography
© Edward Ranney
99.11

Thomas Joshua Cooper
(American, b. 1946)
Clouds over San Jose Canyon—Homage to Alfred Stieglitz,
 1972
Gelatin silver print, 12½ × 17¾ in.
Gift of the artist
© Thomas Joshua Cooper; courtesy of Ingleby Gallery,
 Edinburgh
73.234

Paul Caponigro
(American, b. 1932)
Stonehenge, 1967
Gelatin silver print, 13 × 19 in.
Purchased with funds from the Greater University of
 New Mexico Fund
© Paul Caponigro; courtesy of the artist
78.261

Nicholas Nixon
(American, b. 1949)
View from Medical Arts Square, Albuquerque, 1974
Gelatin silver print, 3¼ × 4¾ in.
Gift of the artist
© Nicholas Nixon; courtesy of Fraenkel Gallery,
 San Francisco, CA
75.158

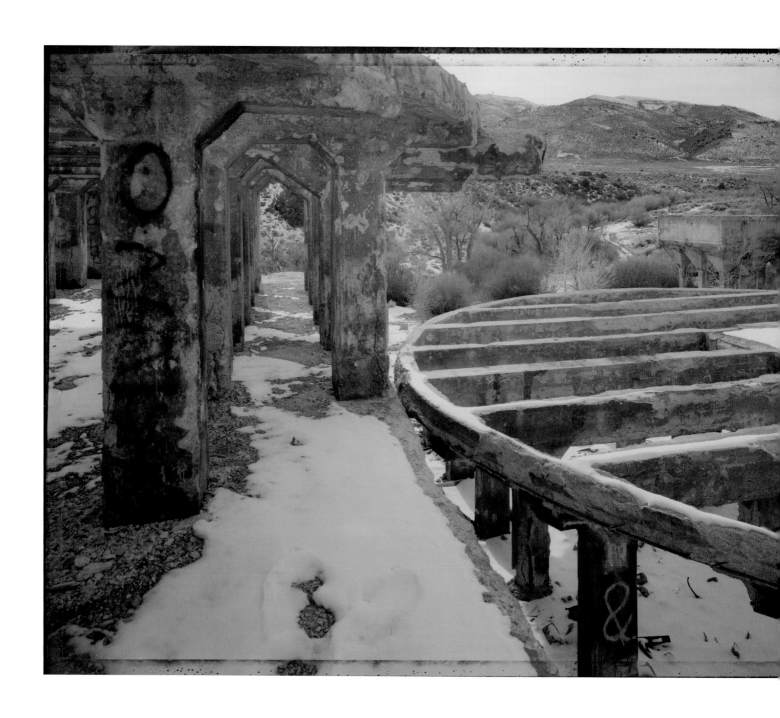

Martin Stupich
(American, b. 1949)
*Cyanide Tank Support Ruins at Abandoned Silver Mill, American
 Flat, Nevada*, 1991
Print made from two 4 × 5 Polaroid 55PN negatives
Gift of David W. Vaughan
© Martin Stupich; courtesy of the artist
2013.20

Louis-Émile Durandelle
(French, 1839–1917)
Le Nouvel Opéra de Paris, ca. 1876
Albumen print, 14 × 10⅛ in.
Gift of Michael Mattis and Judith Hochberg
2000.22.2

Hippolyte Bayard
(French, 1801–1887)
Eglise de St. Pierre à Louviers, ca. 1843
Unnumbered plate from *Souvenirs photographiques*
 (Lille: Blanquart-Evrard, ca. 1850–1854)
Salt print, 7¾ × 10 in.
Gift of Harry Lunn Jr.
84.124

Jean-Eugène-Auguste Atget
(French, 1857–1927)
Untitled, 1895
Gold-toned printing out paper, 7⅛ × 8⅞ in.
Gift of Joan and Van Deren Coke
86.115

William Henry Fox Talbot
(British, 1800–1877)
Gateway to Jesus College, Cambridge, ca. 1855
Photoglyphic engraving, 3 × 2¹⁄₁₆ in.
73.263

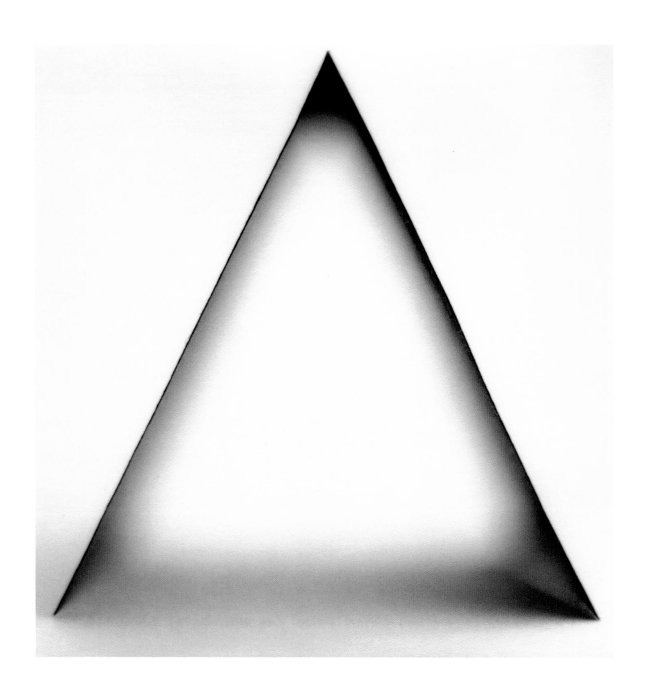

Ion Zupcu
(Romanian, b. 1960)
March 2, 2006, #1, 2006
Gelatin silver print, sepia toned, 14⅝ × 14⅝ in.
Edition 11/30
Gift of the artist
© Ion Zupcu
2008.18.2

Thomas Barrow
(American, b. 1938)
Dart, from the series *Cancellations*, 1974
Toned gelatin silver print, 9¾ × 13⅝ in.
Purchased with funds from the Charles E. Merrill Trust
© Thomas Barrow
74.257

Ellen Garvens
(American, b. 1955)
Scissors: HIB Physical Rehabilitation Centre, Siem Reap,
 Cambodia, 2005
Archival ink-jet print, emulsion mounted on acrylic, 24 × 18 in.
Gift of the artist
© Ellen Garvens
2013.8.1

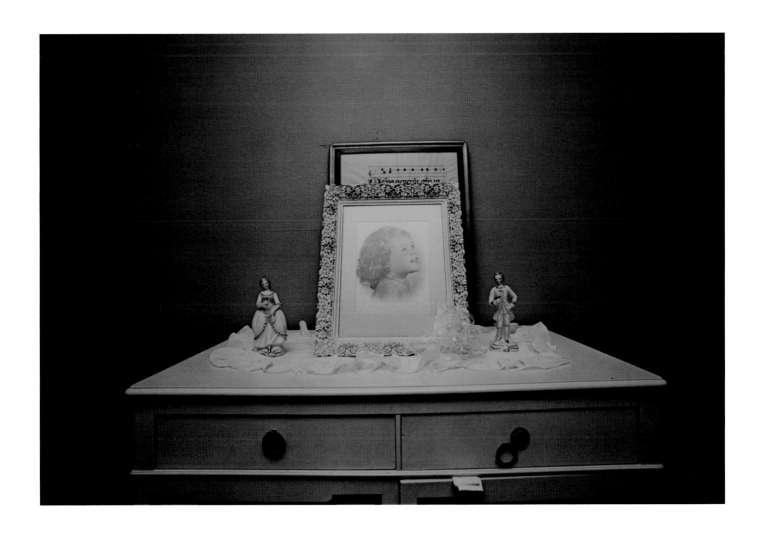

William Eggleston
(American, b. 1939)
Untitled, from *Dust Bells*, vol. 2, ca. 1970s
Dye transfer print, 11⅞ × 17¾ in., 2004
Edition 2/15
Purchased with funds from the Friends of Art
© Eggleston Artistic Trust; courtesy of Cheim & Read, New York
2009.10

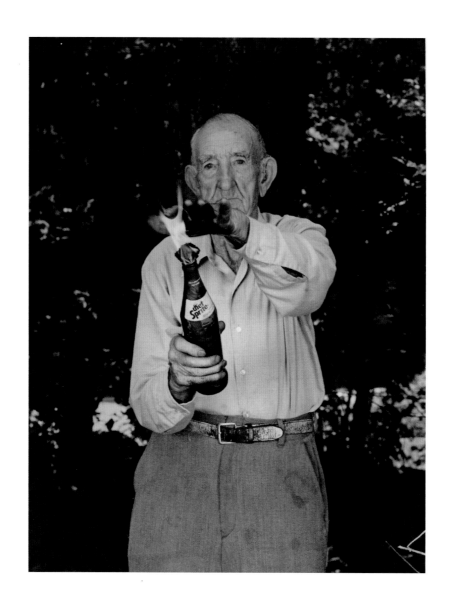

Shelby Lee Adams
(American, b. 1950)
Bradley Shell, Age 86, Fire-handler, 1986
Gelatin silver print, 12¾ × 9⅞ in.
Gift of Ray A. Graham III
© Shelby Lee Adams
2007.34.6

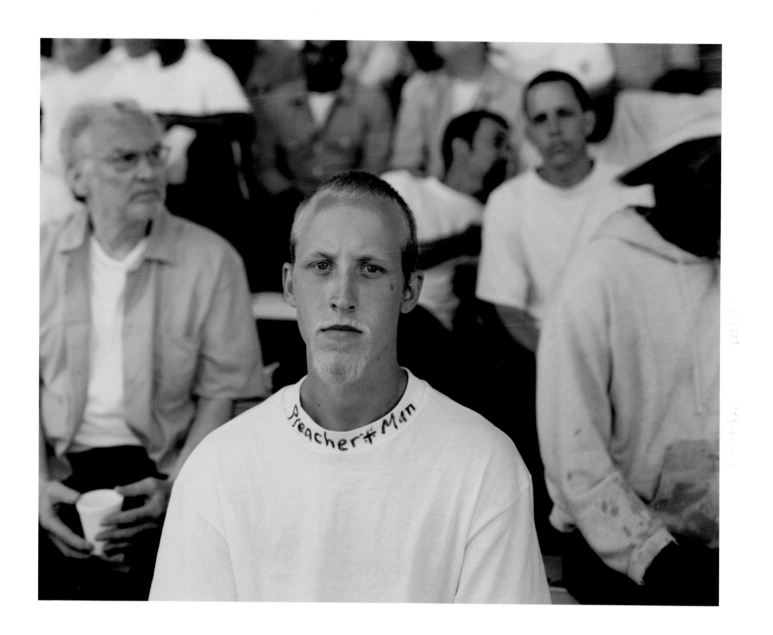

Alec Soth
(American, b. 1969)
Joshua, Angola State Prison, LA, 2002, from the series *Sleeping
 by the Mississippi*, 2002
Digital chromogenic print, 16 × 20 in.
Edition 15/15
Purchased with funds from the Friends of Art
© Alec Soth; courtesy of Sean Kelly, New York
2012.5

Patrick Nagatani
(American, b. 1945)
In collaboration with Andrée Tracey
(American, b. 1948)
Radioactive Rastplatz, 1988
Polaroid diptych, 30 × 42 in.
Gift of Ray Graham III
© Patrick Nagatani
2007.34.8 a–b

Michele M. Penhall
(American, b. 1953)
Untitled
Calotype, March 15, 2003, 11:30 a.m., 3 minutes at f.5.6
Crane's pearl white kid finish paper, 8½ × 11 in.
Collection of the author

Coda

I have been looking at photographs for many, many years, beginning in the late 1970s as an undergraduate in the stacks of Sinclair and Hamilton Libraries at the University of Hawai'i. Poring over monographs by the recognized masters of photography, I always wondered what curiosity drove camera artists, especially the early ones, to choose the subjects they did. Why did Fox Talbot photograph rows of china and ladies' bonnets? What was it like to make your own film, choose a subject, and create an image from that endeavor?

In 1991, at the end of a long stay in Paris, my husband bought me an eighteen-by-twenty-four-centimeter Schrambach view camera, probably made around 1900, from a camera store that was going out of business near the Eiffel Tower. We lugged it back home, and after numerous failed efforts to fit conventional sheet film into antique film holders, I decided to make my own negatives—actually, *calotypes*, the term Fox Talbot used solely for his paper negatives. I settled on Talbot's recipes because they required only a few chemicals and good-quality writing paper. The process was both arduous and exciting. During the course of this adventure, from researching various nineteenth-century techniques to mixing chemicals and preparing the paper, I fretted about what to photograph once I loaded the damp sheets of sensitized paper into the wooden film holders. The variables of time, temperature, and weather were absolutely critical to any success in obtaining a picture. Subjects close to home made the most sense. Talbot probably realized this.

Needless to say, many attempts failed and yielded only blackened sheets of stationery. But when the first successful latent image finally appeared—a view of our tree-lined neighborhood park—it was magical. I have always preferred the negative image, as many early camera artists did, because to me it retains a unique aura. This experience put me, for a brief moment, a bit closer to the mind-set of photography's early scientists, inventors, and artists. And it made me even more acutely aware of the promise of good pictures, and the stories they hold.

MMP

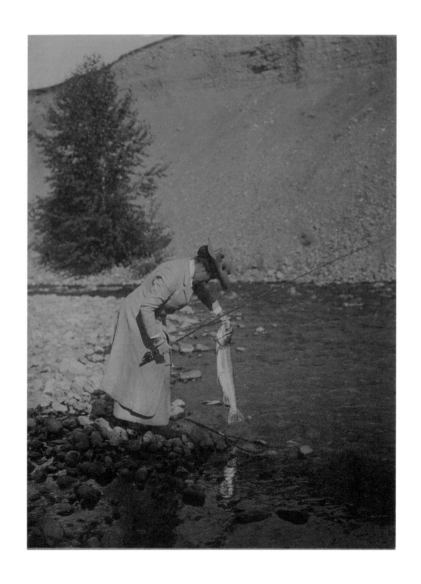

Edward Sheriff Curtis
(American, 1868–1952)
Untitled, ca. 1910
Platinum print, 7⅝ × 3¾ in.
91.31.14

Appendix One
Photographers in the Collection

Aaron, Rich
Aaronson, Bernard
Abbott, Berenice
Abercrombie, Ralph
Abolafia, Oscar
Adams, Ansel
Adams, Bill
Adams, Robert
Adams, Shelby Lee
Adam-Salomon, Antoine Samuel
Adam-Salomon, Antoine Samuel
 (attributed to)
Ahlsted, David
Alenius, Edward K.
Alinari (attributed to)
Alinari, Fratelli
Alinari, Leopoldo,
 Romualdo Alinari,
 and Guiseppe Alinari
Alinder, James
Allen, Harold
Allen, Jesse L.
Allport, M.
Altobelli, Gioacchino
Alvarez Bravo, Manuel
Amateur Photographic
 Association of England
Ambrogi, Patti
Ames, Henry St. Vincent
Anand, Julie
Anderson, David
Anderson, Greg
Anderson, James [née
 Isaac Atkinson]
Anderson, James (attributed to)
Anderson, Marie
Annan, Thomas
Anschütz, Ottomar
Ansco Photo Products, Inc.
Anson, Rufus

Appert, Eugène
Arambourou, Charles
Arbus, Diane
Archivio S. A. T. I. Z.
Army Signal Corps
Aronian, Terrence Scott
Arp, Hans [Jean]
Asbury, Dana
Asch, David
Ascolini, Vasco
Ashburner, Lionel Robert
Ashburner, Lionel Robert
 (attributed to)
Atget, Jean-Eugène-Auguste
Atkins, Anna
Aubert, François
Aubert, François (attributed to)
Audley, R. E.
Avison, David
Aziz and Cucher

Babbitt, Platt D. (attributed to)
Baer, Morley
Bafford, L. Edward
Bailey, James
Baird, Kenneth W.
Baldus, Édouard
Ball, Helen
Ballet, V.
Ballmer, Theo
Baltermants, Dmitri [Dimitri,
 Demitri, Dmetri]
Baltermants, Dmitri
 (attributed to)
Baltz, Lewis
Bankhart, Capt. George
Barendse, Henri Man
Barish, Richard
Barlow, F. P., Jr.
Barnard, George N.

Barnard & Gibson
Barnes, James A.
Barney, Matthew
Barney, Phil
Barnhart, Raymond
Barraud, Herbert
Barrow, Thomas F.
Barsotti, Frank
Barthelmess, Christian
Barton, Chris
Basista, Jody
Bassini
Baucum, Brin A.
Bayard, Hippolyte
Bayer, Herbert
Bayer, William
Bayles, David
Beals, Jessie Tarbox
Beasley, J., Jr.
Beato, Antonio
Beato, Felice A.
Beaton, Cecil
Beaumont, J.
Béchard [Bechard], H.
Becher, Bernd [Bernhard], and
 Hilla Becher
Beckers, Alexander, and
 Victor Piard
Becotte, Michael
Bedford, Francis
Belcher, Ray
Bell, Charles Milton
Bell, George
Bell, William Abraham
Bell, William H.
Bellmer, Hans
Bellocq, E. J.
Bennett, Leonard G.
Bent, I.
Berman, Michael

Berman, Zeke
Bernhard, Ruth
Berscht, Auguste
Bertall, Félicien [Vicomte
 D'Arnoux]
Betts
Bevington, G.
Bidaut, Jayne Hinds
Bidermanas, Izis
Bierstadt, Charles
Biggs, Capt. Thomas
Biggs, Col. R. A.
Billger
Billings and Matthews
Billington, W. C.
Bing, Ilse
Bingham, Robert
Bishop, Michael
Bisson, Frères [Louis Auguste
 Bisson; Auguste-Rosalie
 Bisson]
Bisson, Jeune [Auguste-Rosalie
 Bisson]
Black, James Wallace [J. W.]
Blakeslee, Carl W.
Blanc, Numa
Blanc, Theo, and Antoine Demilly
Blanquart-Evrard, Louis-Désiré
Blaustein, Jonathan
Bloom, John
Blossfeldt, Karl
Blumann, Sigismund
Blume, Anna and Bernhard
Blume, Bernhard
Bodine, A. Aubrey
Boeckstyns, Willy
Boehl and Koenig
Bogardus, Ralph
Bolsey
Bonfils, Félix

Davison, George
Day, J.
Deal, Joe
Dean & Maddox
Deane, Robert
de Beaucorps, Gustave
de Candal, Geri Della Rocca
de Carava, Roy
de Genevieve, Barbara
Delamotte, Philip
Delano, Jack
Delory, Peter
Demachy, Robert
de Mauny, F.
Dennin, William
Desmé, Robert
Detroit Publishing Company
Devine, Jed
Dewey, Anne Pilger
Dewey, R.
DeWitt, Rita
Dezso, Tamas
Diamond, Paul
Di Lapo, Arnolfo
Dingus, Rick
Disdéri, André Adolphe-
 Eugène [A. E.; A. A. E.]
 Disdéri & Cie.
Disfarmer, Mike (née Meyer)
Divola, John Manford
Dixon, Henry Hall
Dobbins, James K.
Dody, Warren Thompson
Doherty, William
Doig, Richard
Doisneau, Robert
Dominguez, Oscar
Dominick, Heather
Donohue, Bonnie
Doodara, Cedrus
Doremus, J. P.
Dorfman, Elsa
Doroshow, Helen
Douglas, J.
Douthat, Anita
Dow, Arthur Wesley
Dow, James
Draho, James
Drtikol, Frantisek
Drucker and Company
Dubreuil, Pierre
Du Camp, Maxime

Duchamp, Marcel
Duclos, Jules
Duggins, Grant E.
Duncan, David Douglas
Dunning, Jeanne
Dunshee, Edward S.
Durandelle, Louis-Émile
Dutton, Allen A.
Duval, A.

Edgerton, Harold
Edlich
Edwards, Fred
Eggleston, William
Ehrhardt, Alfred
Eickemeyer, Rudolf, Jr.
Elliott, James John
Elphinstone, Capt. P. A.
Elrod Brothers
Elter
Eluard, Nusch
Eluard, Paul
Emerick, David
Emerson, Peter Henry
Emery, Charles E.
Endsley, Fred
Engel, Morris
Engel, Walter
England, William
Ensenberger, H. J.
Epstein, Jerome
Erichson and Hanson
Ernst, Max
Erwitt, Elliott
Estrada
Evans, Frederick H.
Evans, Walker
Eyerman, J. R.

Falk, Harvey A.
Famin, Constant Alexandre
Fassbender, Adolph
Faurer, Louis
Feerick, Peggy
Feininger, T. Lux
Fenton, Roger
Ferrez, Marc
Ferrez, Marc (attributed to)
Fichter, Robert
Fiedler, Inge
Fielding, Jed
Fillmore, Francis A.

Filmer, Lady Mary Georgiana
 Caroline
Fink, Larry
Finsler, Hans
Firth, Tom
Fishback, Kent
Fisher, Vernon
Fiske, George
Fitch, Steve
Fitz, W. Grancel
Fleckenstein, Louis
Flick, Robert
Florida State University Arts
 Festival
Folberg, Neil
Fontaine, G.
Fontana, Franco
Foster, Captain
Foster, Giraud, and Norman
 Barker
Foster, Gus
Foster, Steve
Fotvedo
Fox, Robert A.
Franck [François-Louis-Alexander
 Govinet de Villecholle]
Frank, Robert
Franke and Heidecke
Freed, Leonard
Freeman, Sarah Elizabeth
Freke, Rev. James
French, Robert, and W. Morris
Freund, David
Fridrich, Frantisek Josef Arnost
Friedlander, Lee
Frissell, Toni
Frith, Francis
Frith, Francis, and Company
Fruth, Rowena
Fulco, Armand
Furman, Bruce
Futterman, Max J.
Fyman, Vladimir

Gandert, Miguel
Gardner, Alexander
Gardner, James
Garduño, Flor
Garner, Gretchen
Garvens, Ellen
Garzón
Gasparini, Matilde

Gassan, Arnold
Gateley, John
Gates, Jeff
Gazin, Shelley
Geesaman, Lynn
Genthe, Arnold
Genthe, Arnold [Francis
 Bruguière]
G.H.
Giacomelli, Mario
Gibson, H. Lou
Gibson, Ralph
Gifford, Benjamin A.
Gilpin, Laura
Gilula, Stan
Gladwell, T. H.
Goerz, C. P.
Gohlke, Frank
Goldbeck, E. D.
Goldberg, Maurice
Golden, Judith
Golding, William Henry
Goldwater, Barry
González Palma, Luis
Good, Frank Mason
Goodman, C. E.
Goodman, G.
Goodman, Tom
Gordon, Bonnie
Gordon, J. H.
Gossage, John
Gothard, Vince
Goupil et Cie.
Gowin, Emmet
Graham, J. P.
Grant, W. J. A.
Greene, Howard
Greene, John Beasley
Greenfield-Sanders, Timothy
Grenier, François
Grenko, Ronald
Gresley, Major F.
Groover, Jan
Gropius, Walter
Grove, George
Grundy, William Morris
Grundy, William Morris
 (attributed to)
Grundy, William Morris
 (circle of)
Grunowski, Helmut
Guidalevitch, Victor

Guidi, Guido
Gunn and Stuart, London,
 England
Gunnin, Robert
Gunnison, Floyd W.
Gurney, J.
Gurnsey, B. H.
Gutekunst, Frederick
Gutierrez, J.
Guyton, Joseph
Guyton, Joseph (attributed to)
Guzelimian, Vahe [Vahé]
Gwathmey, Rosalie

Hagen, Charles
Hahn, Betty
Haiko, Robert
Hajek-Halke, Heinz
Hajek-Halke, Heinz, and Raoul
 Hausmann
Hajicek, James
Hall, Douglas Kent
Hallman, Gary
Halsman, Philippe
Halus, Siegfried
Hammerschmidt, W.
Hammerschmidt, William
Hammitt, Howard
Hanes, Frank J.
Hanford, Warren
Hanfstaengl, Franz
 (studio of)
Hanka
Hanna, Forman
Hanscom, Adelaide
Hardgrave, Eileen
Harris, O. K.
Harris and Ewing
Harrissiadis, Dimitrios
Hatry, Mildred
Havlicek, Ing. Karel
Hawes, Josiah
Haynes, Frank Jay
Hazard, John Benjamin
Heath, Dave
Heinecken, Robert
Helm
Hemphill, W. D.
Hening
Henkel, Jim
Henle, Fritz

Henri, Florence
Henze, Claire
Hess, Allen
Heuer, Richard
Hilaire, J. B.
Hill, Alexander Wilson
Hill, David Octavius, and
 Robert Adamson
Hill and Adamson
Hillers, John K. [J. K.]
Himelfarb, Harvey
Hine, Lewis W.
Hines, Jay
Hinton, Alfred Horsley
Hintz, Norton M.
Hiser, Cheri
Histed
Hobson, W. S.
Hoffman, Alan
Hoffmann, Heinrich
Hogan, John R.
Holbrook, James R.
Holmes, Burton
Hood, Thomas
Hook, W. E., Wholesale
 View Company
Hooper, W.
Hooper, W. W.
Hoppe, E. O.
Horne, J. Leslie
Horst, Horst P.
Horvat, Frank
Hosoe, Eikoh
Houghton's Ltd.
Howald, Patricia
Howard, W. Dilworth
Howe, Nelson
Howells, Michael
Huffman, L. A.
Huffman, Layton Alton
Hugelmeyer, J.
Hugnet, Georges
Hugo, Leopold
Hume, Richard P.
Hume, Sandy
Hunter, Debora
Hurn, David
Husebye, Terry L.
Hut, Sydney
Hutchins, John
Hutton, Capt. M.

Hyde, J. C.
Hyde, John George

Imler, Tom, Jr.
Impert, Sylvia
Instituto Nazionale
International Research
 Corporation
Irish, Olga Emma
Iturbide, Graciela

Jachna, Joseph
Jackson, J.
Jackson, William Henry
Jackson, Zig
Jacobi, Lotte
Jaconelli, Guy
Jaques, Bertha
Jay, Bill
Jaynes, A. D.
Jean, Marcel
Jeremias, Paul
Jíru, Vaclav
Job, Charles
Jodice, Mimmo
Johnson, Eric
Johnson, Thomas
Jones, Harold
Jones, Jason
Jones, J. C. D.
Jones, Peggy Ann
Jones, Pirkle
Jones, Rev. Calvert Richard
Jones, Ted
Jones & Brother
Jörgensen, Chr.
Josephson, Kenneth

Kahn, Steve
Kanaga, Consuelo
Karsh, Yousuf
Kasebier, Gertrude
Kasten, Barbara
Katcher, Stanley A.
Katscher, Dr. Adolf
Katz, Leandro
Kelly, Angela
Kempe, Fritz
Kenyon, Earl
Kepes, Gyorgy
Kepes, Gyorgy, and

Mary Pratt (modern
 print by)
Keppler, Victor
Kertész, André
Ketchum, Cavalliere
Ketchum, Robert
Khaldei, Yevgeny [Yvgeni]
Kihn, Chae
Kilburn Brothers
Kilikevice, Joe
King, Minor B.
Kinsey, Darius, and Tabith
 Pritts Kinsey
Kirkham, George
Klein, William
Klett, Mark
Klinefelter, Lee M.
Klintworth, C. Verne
Klute, Jeannette
Knaff, Samuel A.
Knaffl & Bro. [Knaffl Brothers]
Knapp, Richard
Knee, Ernest
Koczan, Steve
Koenig, Karl
Konica
Koral, Barry
Korth, Fred G.
Kosicki, Stefhan
Koudelka, Josef
Kowal, Cal
Kraft, James
Kral, W. (attributed to)
Krause, George
Krims, Leslie R.
Kronengold, Eric
Krot, Paul
Krupsaw, Warren
Krzyzanowski, M.
Krzyzanowski [Szulc-
 Krzyzanowski], Michel
Kühn [Kuhn], Carl Christian
 Heinrich
Kurtz, Edmund
Kurtzweil, Darlene
Kusakabe, Kimbei (attributed to)
Küsters, Hans Martin
Kuykendall, Ted

Laboratorio Fotografico
Lalleman, Charles

Lamba [Breton], Jacqueline
Lamont, Elizabeth
Landweber, Ellen
Landweber, Victor
Landy, J.
Lang, Gerald
Lange, Dorothea
Larrabee, Benjamin
Laughlin, Clarence John
Laurent, J.
Laurent, Juan
Laurent, Jules
Laurie, D.
Lauschman, Jan
Lavenson, Alma
Lawrence, William Mervyn
Lawrence, William Mervyn
 (attributed to)
Lawton
LaZar, Arthur
Lazi, Adolf
Lazorik, Wayne R.
Lazorik, Wayne R. (collaboration
 with Ellen Garvens)
Lè Begue, Réne
Lebowitz, Richard
Ledot aîné & Donas
 Photographies
Lee, Kermit N.
Lee, Russell
Le Gray, Gustave
Lehnert, Rudolf, and Ernest
 Landrock
Leighton, J. Harold
Leighton, Ron
Lekegian, G.
LeMarque, L.
Lendvai-Dircksen, Erna
Lensen-Tomasson, Nancy
Leprette, Christian
Lersh, Leo S.
Le Secq, Henri
Levine, Michael
Levinstein, Leon
Levinthal, David
Levitsky, Sergei Luvovich
Levitt, Helen
Levy, Albert (attributed to)
Liebert, A.
Liebling, Jerome
LIFE magazine

Lin, Ihsuan
Lindahl, Axel
Lionel Corporation, New York
Livingston, Jacqueline
L. L. (possibly Léon & Levy)
Llewelyn, John Dillwyn
Llewelyn, Thereza Mary Dillwyn
Lloyd, F. Giesler
Lockwood, Ward
Loeber, C. Stanton
Loew, W. M. Heinz
Lorent, Jakob August
Lotz, Herb
Loubère, P.
Lown, Lynn
Lozoya, Oscar
L. P. (possibly P. Loubère)
Lucas, William
Lukas, Jan
Lumiere Brothers
Lummis, Charles F.
Lynes, George Platt
Lyon, Danny
Lyons, Nathan

Maar, Dora
MacAskill, W. R.
Macijauskas, Aleksandras
Mackenstein
MacKichan, Margaret
MacPherson, Robert
MacPherson, Robert
 (attributed to)
MacWeeney, Alen
Magee, John H.
Magritte, Rene
Mahon, Ralph L.
Maier, Vivian
Malègue, Hippolyte
Mamiya-Sekor
Man, Felix H.
Mandel, Mike
Mann, F. S.
Man Ray [née Emmanuel
 Radnitzky]
Mantz, Werner
MANUAL
Marc, Stephen [née Steve Smith]
Marconi, Gaudenzio
Marey, Jules-Etienne
Mark, Mary Ellen

Markov-Grinberg, Mark
Marquis de Rostaing
Marsh, R. H.
Marshall, Joseph
Martin, Ed
Martin, Ira W.
Martin, Paul Augustus
Marville, Charles (attributed to)
Marville, Charles (published by
 Blanquart-Evrard)
Marville, Charles Bossu
Masayesva, Victor
Mather, Margrethe
Mathews, H. E.
Maull and Polybank
Mauri, Achille
Maurisset, A.
Mautner, Robert
Mayall, John Jabez Edwin
Mayes, Elaine
McCharen, Joe
McCullin, Donald
McDonald, D.
McFerran, Robert L.
McMillan, Jerry
McMurtry, Edward P.
McPheron, Patricia
McWilliams, John
Meatyard, Chris
Meatyard, Ralph Eugene
Melnick, Philip
Memphis Academy of Arts,
 Department of Photography
Menglerova, Libuse
Merrin, Roger
Mertin, Roger
Metz, Garry
Metzker, Ray K.
Meyer, Pedro
Meyerowitz, Joel
Michals, Duane
Mieusement, Médéric
Miller, Edward
Miller, Milton M.
Mills, John
Minolta
Minox
Mirano, Virgil
Miró, Joan
Misonne, Leonard
Misrach, Richard

Model, Lisette
Modotti, Tina
Moers, Denny
Moffat, J.
Moholy-Nagy, Laszlo
Moholy-Nagy, Lucia
Moloy
Montoya, Delilah
Moon, Karl
Moore, Henry P.
Moore, Margaret
Morgan, Barbara
Morris, Wright
Morrison Studio, Chicago
Mortensen, William
Moseni, Arezoo
Moss, J. S. K.
Moulton, Henry DeWitt
Moulton, W. J. (attributed to)
Moulton-Fitchburg
Mucha, Alphonse Marie
Mucher, H. N.
Mulnier, Ferdinand
Mulvany, John
Muniz, Vic
Munn, Major
Muñoz, Jim
Murray, John
Muybridge, Eadweard [née
 Edward James Muggeridge]
Mydans, Carl
Myerowitz, Joel
Myers, Joan

Nadar [née Gaspard Félix
 Tournachon]
Nadel, Vicky
Nagatani, Patrick
Nagatani, Patrick, and Andrée
 Tracey
Nakao, Donna
Napier, Capt. G.
Navara, Frank
Naya, Carlo
N. Brown and Son
N. D., Savone, editeur
Neal, Donald
Negre, Charles
Neimanas, Joyce
Nelson, Kenneth E.
Neree

Nettles, Bea
Neurdein, E.
Neusüss, Floris M.
Newberry, Sandra
Newhall, Beaumont
Newhall, Nancy
Newman, Arnold
Nichols, Tony
Nicosia, Nic
Nixon, Nicholas
Noggle, Anne
Nolan, Justin
North, Kenda
Northrup, Michael
Nunez, Anne Morgan
N. Y. Photo-Gravure Co.

O'Brian, Tony
Oelman, P. H.
O'Hara, Frederick
Olivieri, A.
Ollman, Arthur
Ondrik, David
O'Neil, Elaine
Oorthuys, Cas
Oppenheim, Meret
Orkin, Ruth
Osterman, Willie
O'Sullivan, Timothy H.
Overman, Greg

Paalen, Wolfgang
Paget, Ellen Jane Burnand,
 Marchioness of Anglesea [sic]
Paget, T.
Paird, W. B.
Palfi, Marion
Palscé, Marj
Papageorge, Tod
Papf, Jorge Henrique
ParkeHarrison, Robert
Parker, Bart
Parkhurst, T. Harmon
Parr, Martin
Patterson, Bruce
Patton, Tom [Tommas]
Pawela, Krzysztof [Kryzsztof]
Peabody, H. G.
Peebles, Dan
Peel, Michael
Pelletier, Brian
Penman, Sarah

Penn
Penn, Irving
Pennington, William
Penrose, Roland
Peress, Giles
Pervez, Jules, and A. Guéranne
Peterhans, Walter
Petit, Pierre
Petrillo, Tom
Pfahl, John
Phillips, R.
Philpot, John Brampton
Photo Club de Paris
Picasso, Pablo
Pickands, James, II
Pinkel, Sheila
Pinkerton's National Detective
 Agency
Pinnell, Paige
Pittman, Michael
Pitts, James Ware
Plâté Ltd.
Playfair, Lt. Col. R. L.
Plicka, Karel
Plossu, Bernard
Plumbe, John, Jr. (or studio)
Pokorny, Cestmir
Polaroid Land Corporation
Polk, Martin
Ponti, Carlo
Porter, Eliot
Post, William B.
Pottinger, Robert
Prather, Winter
Pratt, Charles
Prince, Douglas
Prince, Richard
Pritikin, Max
Prout, Victor
Pudumgee, Dorabgee [Dorabjee
 Pudumjee]
Purin, Leonard
Purrington, F. L.
Purvines, Wayne

Rankaitis, Susan
Rankin, Allen
Ranney, Edward
Rau, William
Rauschenberg, Christopher
Rauschenberg, Robert
Ravenshaw, J. H.

Raynolds, E. F.
Reep, Richard
Rees, C. R. (attributed to)
Reeves, Ian
Reid, Giorgina
Reifman, Marsha
Rejlander, Oscar G.
Renger-Patzsch, Albert
Ress, Murray
Ressler, Susan
Reutlinger
Revesz-Biro, Emory P.
Reynolds, Charles
Riboud, Marc
Rice, Leland
Richardson, I. W.
Rickett, Sophy
Rimmington, J. W.
Ringle and Pit
Riss, Marryhard
Ritger, M.
Roberts, Holly
Robertson, James
Robinson, Henry Peach
Robinson, Herbert F.
Robinson, James
Robson, F. S.
Robuchon, Jules
Rochester Optical Company
Rodero, Cristina García
Rodger, George
Rodger, Thomas
Rogers, Ron
Rogers, Thomas
Rogerson, C. W. (as official
 US Navy photographer)
Roitz, Charles
Rolf, W. E.
Romoser, R. E.
Root's Gallery
Rops, Félicien
Rosen, Linda
Rosenblum, Walter
Rosling, Alfred
Ross, Alan
Ross, Donald
Ross, Elliot
Ross, Horatio
Rosse, Countess of
Roszak, Theodore
Roth, Sanford
Rothstein, Arthur

Rotkin, Charles
Rowan, John S.
Rowbotham Brothers
Royky, Edith M.
Rubenstein, Elliot
Rubenstein, Eva
Rubenstein, Meridel
Rubincam, Harry
Rubinstein, Eileen
Rumpf, Ellen Steel
Rush, Kent
Rusk, Grant
Russomagno, Gabrielle
Rust, Thomas [?]

Sahlstrand, Jim
Salbitani, Roberto
Salinger, Adrienne
Salomon, Erich
Salviati, Paolo
Salzmann, August
Sammis, J. H.
Sanchez, Robert
Sander, August
Sanders, Charles
Sanderson, C. S.
Sarason, Henry
Sarony, Napoleon
Sarony and Company
Satizabal, Maria
Saudek, Jan
Sauer, Damon
Savage, Naomi
Sawyer, Joan
Sawyer, Lyddell
Sawyer Co.
Schaeffer, Richard
Scharf, Aaron
Scheinbaum, David
Schilling, Alphonse
Schmidt, Henry A.
Schmidt, I. W.
Schneider, Gary
Schoenfeld, Diana
School of the Art Institute of
 Chicago, graduate students
Schott, John
Schranz, Anton
Schulke, Flip
Schutzer, Paul
Schwabe, F. S.
Schwenke, Dorothee

Wagner, Dorothy Delain
Wainio, Andrew
Wakefield, Rex L.
Wakely, G. D.
Walker, Todd
Wall, Paul
Waller, Frank
Waltman, Jack
Ward, John
Warhol, Andy
Warren, George K.
Warren, George Kendell
Watkins, Carleton E.
Watling, J. W. H.
Watson, Glenn
Watson, Thomas
Watson-Schutze, Eva
Web, Alex
Webb, Todd
Weber, Doris Martha
Weegee [Arthur Fellig]
Weeks, Dennis
Weems, Carrie Mae
Weir, John Spence
Weiss, Jeff
Wellman, Charles

Wells, Alice
Wells, George B.
Wells, Lynton
Wells-Witteman, Alisa
Welpott, Jack
Wenderoth, Frederick A.
Wessel, Henry, Jr.
West, Andrea
West, Ed
Weston, Brett
Weston, Edward
Weston, Edward, and
 Cole Weston
Weston Company
Whaley, Jo
Wherli, Gebr. [Wherli Brothers]
Whipple, John Adams
White, Capt. H. E.
White, Clarence H.
White, E. Kenly
White, George H.
White, Ken
White, Minor [née Martin]
White, Tho. E. M., and C. F. White
Whitlock, Terri
Widdicombe, Robert

Wigger, Paul
Wilding, Dorothy
Wilgus, Jack
Williams, Carla
Williams, James Leon
Wilson, D.
Wilson, Dr.
Wilson, George Washington
Wilson, Helena Chappelin
Wilson, W. H.
Wilson, W. H. (attributed to)
Wilson, W. I.
Wilson, W. Wallace
Winogrand, Garry
Witkin, Joel-Peter
Wittick, Ben
Wittick and Russell
Wolcott, Marion Post
Woller, Ellen E.
Wood, Myron
Wood and Gibson
Woodhouse, Mitchell
Woodson, James
Woodward, Stephen
Woolf, Paul J.
Worms and Company

Worth, Don
Wrigley, Kevin
Wulff, Ann E.
Wyman, E. & H., and Company
Wynfield, David Wilkes
Wynroth, Via

Yamagata, Tsutomu
Yates, Steve
Yavno, Max

Zaleski, Paula
Zangaki, P.
Zichy, Count
Zola, Émile
Zwart, Piet

Note
This list was originally organized and developed by Christopher Jones in 2005, when he was assistant curator at the UNM Art Museum. It continues to be updated and remains a valuable resource for the collection.

Appendix Two
University of New Mexico Art Museum Directors and Curators

Directors

1962–1966	Van Deren Coke
1966–1967	Clinton Adams, acting director
1967–1968	Robert O. Parks
1968–1971	Robert Ellis
1971–1972	Louise M. Lewis, acting director
1972–1980	Van Deren Coke
1980–1982	Edward A. Bryant
1982–1985	Emily Kass, interim director
1985	Thomas F. Barrow, acting director
1985–2001	Peter Walch
2001–2003	Linda W. Bahm, interim director
2009–2007	Linda W. Bahm
2007–2008	John Mulvany, interim director
2008–2012	E. Luanne McKinnon
2011	Sara Otto-Diniz, acting director
2012–2013	Sara Otto-Diniz, interim director
2013–2014	Lisa Becker
2014	Kymberly Pinder, interim director

Assistant and Associate Directors

1964–1968	Robert M. Ellis
1971	Louise M. Lewis
1973–1976	Thomas F. Barrow
1978–1981	Elizabeth Anne McCauley
1981–1982	Emily Kass
1990–2000	Linda W. Bahm
2010–2011	Sara Otto-Diniz
2012–2013	Michele M. Penhall

Curators

1984–1988	Kevin Donovan
1989–1993	Diana C. Gaston
1994–2004	Kathleen S. Howe
2004–2014	Michele M. Penhall

Notes

As mentioned in the introduction, the name change from University Art Gallery to University Art Museum occurred in the fiscal year 1965–1966. This list acknowledges all former gallery and museum directors. The information here comes from UNM annual reports and records activities during the

university's fiscal years that run from July 1 to June 30. The reports do not always provide precise dates for appointments within each year. When dates overlap, it typically indicates that an individual held the position for less than a year. Director E. Luanne McKinnon was, for a time, on leave for health reasons; thus the overlap of her tenure and that of Sara Otto-Diniz.

Over the course of the museum's fifty-year history, there have been assistant and associate directors from time to time. This listing of such positions is as complete as possible, based on UNM annual reports. The 2003–2004 UNM annual report, volume 1, noted in the table of contents that the University Art Museum did not submit a report for that fiscal year.

Especially in the museum's early years, the director often served as the principle curator. This was particularly true during Van Deren Coke's tenure at the museum; he curated the inaugural exhibition and many more during the twelve years he was director. The same applies to some of the associate and assistant directors. A dedicated curatorial position first appears in the 1966–1967 annual report, which names Louise M. Lewis as curator, although her duties were related to collection management. According to the 1970–1971 annual report, Cleta Downey was appointed to the "new position of Assistant Curator of Prints. In that capacity Mrs. Downey is in charge of the accessioning and storage of the sizable Tamarind collection" (944). A full-time staff position, curator of prints, was first established in 1979–1980, though it was not immediately filled (1613). The curators in the above list were primarily responsible for organizing and curating exhibitions—from the collection and outside sources—and for the overall stewardship of the photography and print collection.

Bibliography of Related Works

All entries are authored by the contributors they are listed under except where otherwise indicated.

Thomas Barrow

"The Camera Fiend." *Image* 14.4 (September 1971): 7–8.

Introduction to *The Photography of Van Deren Coke*, by Van Deren Coke, 1–4. Albuquerque: University of New Mexico Art Museum, 1982.

"Learning From the Past." In *9 Critics, 9 Photographs/Untitled 23*, edited by James Alinder, 32–36. Carmel, CA: Friends of Photography, 1980.

"Looking Down." *Image* 15.2 (July 1972): 6–7.

"On Betty Hahn." *Working Papers* 1 (November 1980).

Photography and Postmodernism. Edited by Thomas Barrow and Peter Walch. Vol. 8 of *New Mexico Studies in the Fine Arts*. Albuquerque: College of Fine Arts of the University of New Mexico, 1983.

Reading into Photography: Selected Writings, 1959–1981. Edited by Thomas Barrow, Shelly Armitage, and William Tydeman. Albuquerque: University of New Mexico Press, 1982.

"Roger Mertin." In *Contemporary Photographers*, edited by George Walsh, Michael Held, and Colin Naylor, 507–8. New York: St. Martin's Press, 1982.

"Talent." *Image* 14.5–6 (December 1971): 29–31.

"Three Photographers and Their Books." In *One Hundred Years of Photographic History: Essays in Honor of Beaumont Newhall*, edited by Van Deren Coke, 8–11. Albuquerque: University of New Mexico Press, 1975.

Geoffrey Batchen

"A arte de arquivar" [The art of archiving]. In *Fotografia na arte: De ferramenta a paradigma* [Art and photography], edited by Ricardo Nicolau, 138–41. Porto, Portugal: Serralves Museum of Contemporary Art/Público, 2006.

"An Almost Unlimited Variety: Photography and Sculpture in the Nineteenth Century." In *The Original Copy: Photography of Sculpture, 1839 to Today*, edited by Roxana Marcoci, 20–26. New York: Museum of Modern Art, 2010.

"The Art of Business." In *America and the Tintype*, edited by Steven Kasher, 17–24. New York: International Center of Photography and Steidl, 2008.

Burning with Desire: The Conception of Photography. Cambridge: MIT Press, 1997.

"Camera Lucida: Another Little History of Photography." In *The Meaning of Photography*, edited by Robin Kelsey and Blake Stimson, 76–91. Clark Studies in the Visual Arts. Williamstown, MA: Sterling and Francine Clark Art Institute, 2008.

"Camera Lucida: Another Little History of Photography." In *The Weight of Photography*, edited by Johann Swinnen, 191–210. Brussels: Academic and Scientific Publishers, 2010.

"Cancellation" and "Cancelación." In *The Last Picture Show: Artists Using Photography, 1960–1982*, edited by Douglas Fogle, 62–67. Minneapolis, MN: Walker Art Center, 2004.

"Dreams of Ordinary Life: Cartes-de-Visite and the Bourgeois Imagination." In *Photography: Theoretical Snapshots*, edited by J. J. Long, Andrea Noble, and Edward Welch, 80–97. London: Routledge, 2009.

Each Wild Idea: Writing, Photography, History. Cambridge: MIT Press, 2001.

"Ektoplazma: Dijital cagda fotograf" [Ectoplasm: Photography in the digital age]. *IFSAK: Fotograf ve Sinema Dergisi* (Istanbul) 32.2 (2012): 98–103.

"Electricity Made Visible." In *New Media, Old Media: A History and Theory Reader*, edited by Wendy Hui Kyong Chun and Thomas Keenan, 27–44. New York: Routledge, 2006.

"Endurance: The Photographs of Harold Cazneaux." In *Harold Cazneaux: Artist in Photography*, edited by Natasha Bullock, 122–31. Sydney: Art Gallery of NSW, 2008.

"Ere the Substance Fade: Photography and Hair Jewellery." In *Museum Objects: Experiencing the Properties of Things*, edited by Sandra Dudley, 72–89. London: Routledge, 2012.

"Evocations: The Art of Anne Ferran." In *Anne Ferran: The Ground, the Air*, edited by Craig Judd, 7–16. Hobart: Tasmanian Museum and Art Gallery, 2008.

"For an Impossible Realism: An Interview with Victor Burgin." In *Parallel Texts: Interviews and Interventions about Art*, edited by Victor Burgin, 84–95. London: Reaktion Books, 2011.

"Forever Dark." In *Dark Sky*, 4–39. Wellington: Adam Art Gallery, 2012.

Forget Me Not: Photography and Remembrance. Amsterdam: Van Gogh Museum; New York: Princeton Architectural Press, 2004.

"Forstaelsens former" and "Modes of Apprehension." *Filter* (Denmark) 3 (Summer 2009): 56–64, 80–83, 97–99.

"From Elsewhere" and interview. In *Love It and Leave It: Australia's Creative Diaspora*, edited by Nathalie Latham, 10–11, 150–51. Canberra: T & G Publishing and National Portrait Gallery, 2007.

"From Infinity to Zero." In *Now Is Then: Snapshots from the Maresca Collection*, edited by Marvin Heiferman, 120–30. New York: Princeton Architectural Press in cooperation with the Newark Museum, 2008.

"Fuuro anterior: La historia del arte y la instantánea / Previous Future: Art History and the Snapshot." In *Soñarán los androides con cámaras fotográficas? / Do Androids Dream of Cameras?*, edited by Joan Fontcuberta, 184–207. Madrid: Secretaría General Técnica, 2008.

"Geoffrey Batchen, repères biographiques et introduction," by Patrick Talbot; "Les éternels retours de la photographie," by Arnaud Claass; "Epitaphe," by Geoffrey Batchen, translated by Patrick Talbot; "La photographie vernaculaire: 'Ne m'oubliez pas,' une interview de Geoffrey Batchen," by Brian Dillon, translated by Patrick Talbot; "Paysages de paysages ou l'art en tant en tant que carte," by Joan Fontcuberta, edited and translated by Patrick Talbot; "La photographie par les nombres," by Geoffrey Batchen, translated by Patrick Talbot. Special issue on the work of Geoffrey Batchen. *Infra-Mince: Revue de Photographie* (Arles, France) 7 (June 2012): 25–91.

"Individualism and Conformity: Photographic Portraiture in the Nineteenth Century." *New York Journal of American History* (Spring/Summer 2006): 10–27.

"Interview, with Yoshiaki Kai" (2008); "A Philosophical Window" (2002); "Snapshots: Art History and the Ethnographic Turn" (2007), translated into Japanese by Osamu Maekawa and Yoshiaki Kai; "Annotated Bibliography," by Yoshiaki Kai; "Genealogy of Photography: Batchen's Theory of Photography," by Osamu Maekawa. *Photographers' Gallery Press* (Tokyo) 7 (2008): 68–140.

Introduction to *Shadowgraphs: Photographic Portraits by Len Lye*, 4–5. Wellington: Adam Art Gallery, 2011.

"Judging a Book by Its Cover." *Cabinet* 36 (Winter 2009–2010): 36–41.

"The Labor of Photography." *Victorian Literature and Culture* 37.1 (2009): 292–96.

"A Latticed Window." In *Singular Images: Essays on Remarkable Photographs*, edited by Sophie Howarth, 15–21. London: Tate Modern, 2005.

"Les snapshots: L'histoire de l'arte et le tournant ethnographie." *Etudes Photographique* (Paris) 22 (2008): 4–37.

"Life and Death." In *Suspending Time: Life, Photography, Death*, edited by Geoffrey Batchen, 28–129. Japan: Izu PhotoMuseum, 2010.

"Looking Askance." In *Picturing Atrocity: Photography in Crisis*, edited by Geoffrey Batchen, Mick Gidley, Nancy K. Miller, and Jay Prosser, 227–40. London: Reaktion Press, 2012.

"Nadenken over kritiek." In *Kunstkritiek: Standputen rond beeldende kusten uit België en Nederland in een international perspectief (1985–2010)*, edited by Hilde Van Gelder and Laurens Dhaenens, 261–68. Lauven: Amsterdam University Press and Lannoo Campus, 2010.

"Phantasm: Digital Imaging and the Death of Photography." In *Art and Electronic Media*, edited by Edward A Shanken, 209–11. London: Phaidon, 2009.

"Phantasm: Digital Imaging and the Death of Photography." In *Reading Photography: A Sourcebook of Critical Texts, 1921–2000*, edited by Sri-Kartini Leet, 350–52. Farnham, UK: Lund Humphry, 2011.

"Photography by the Numbers." In *Joan Fontcuberta: Orogenesis*, 9–13. New York: Aperture Books, 2005.

Photography Degree Zero: Reflections on Roland Barthes's "Camera Lucida." Edited by Geoffrey Batchen. Cambridge: MIT Press, 2009.

Picturing Atrocity: Photography in Crisis. Edited by Geoffrey Batchen, Mick Gidley, Nancy K. Miller, and Jay Prosser. London: Reaktion Books, 2012.

"Revenant." *Foam* (Amsterdam) 27 (Summer 2011): 111–14.

"Revenant." In *Taryn Simon: A Living Man Declared Dead and Other Chapters, I–XVIII*, 739–53. London: Tate Modern and Mack, 2011.

"Serious Amateur" and "Un amateur éclairé." In *The Joy of Photography*, edited by Piotr Uklansky, 34–43, 60–71. Strasbourg: Musée d'Art Contemporain and Hatje Cantz Verlag, 2007.

"Snapshots: Art History and the Ethnographic Turn." *Photographies* (London) 1.2 (September 2008): 121–42.

"Surreptitious Pictures." *Artlink* (Adelaide) 31.3 (2011): 32–34.

Suspending Time: Life, Photography, Death. Japan: Izu PhotoMuseum, 2010.

"This Haunting." In *Photography Theory*, edited by James Elkins, 284–86. New York: Routledge, 2007.

"Thomas Wedgwood," "Vernacular Photography," and "Antecedents." In *Encyclopedia of Nineteenth-Century Photography*, edited by John Hannavy, 668–74, 1443–46, 1482–83. New York: Routledge, 2007.

What of Shoes? Van Gogh and Art History. Cologne: Seemann Henschel, 2009.

William Henry Fox Talbot. London: Phaidon, 2008.

"Zviditelnei elektrini" [Electricity made visible]. *Teorie Vedy/Theory of Science* 15.2 (2006): 51–76.

Christopher Kaltenbach

"The Currency of Tradition, Restaurant Tanga." *(Inside) Australian Design Review*, no. 36 (2005).

"Expo 05 Aichi: Pass the Hundreds and Thousands Coated Tofu." *Architecture Review, Australia*, no. 92 (2005): 28–32.

"Fetishising Hope for a Hydro-Centric Life." *(Inside) Australian Design Review* (2008).

"hhstyle.com." *(Inside) Interior Design Review*, no. 36 (2005).

"The Inherent State of the Kigumi Lattice." *Architectural Review Asia Pacific (AR)*, no. 135 (2014): 52–57.

"Keitai City." *(Inside) Interior Design Review*, no. 39 (2005).

"Looping Décosterd and Rahm's Feedback Interiority." In *Décosterd and Rahm—Distortions: Architecture 200–2005*. Orleans, France: FRAC CENTRE, Éditions HYX, 2005.

"Louis Vuitton, Roppongi Hills (Jun Aoki)." *(Inside) Australian Design Review*, no. 30 (2004): 118–25.

"Marukan: The Japan Industrial Design Association Exhibition on Eco Design." *(Inside) Australian Design Review*, no. 29 (2003): 154–56.

"Mitaka Lofts: Arakawa and Gins." *Architecture Review Australia*, no. 97 (2006): 39–40.

"The Modality of a Crystalline Intelligence." *(Inside) Australian Design Review*, no. 57 (2009): 72–75.

"Naoto Fukasawa: Looking for the Imperceptible." *(Inside) Australian Design Review*, no. 31 (2004): 136–39.

"Natural Sticks II." *MARK*, no. 43 (2013): 44–45.

"The Nature of Geometry: An Exercise in Reverse Engineering a Methodology." *(Inside) Australian Design Review*, no. 61 (2010): 32–37.

"A New Formula for the Accommodation of Codes: The 9h Capsule Hotel." *(Inside) Australian Design Review*, no. 60 (2010): 86–91.

"OMOHARA Forest." *MARK*, no. 39 (2012): 34–35.

"On Design." *MARK*, no. 27 (2010): 150.

"Pining for a New Landscape Paradigm." *(Inside) Australian Design Review*, no. 39 (2005).

"Reading into the New 'Real' of Toyo Ito's Tama Art University Library." *Architectural Review Australia*, no. 105 (2008): 34–37.

"Regerminating the City." *Architectural Review Asia Pacific (AR)*, no. 128 (2012): 72–77.

"A Retreat from Tokyo: Mastering the French Ruse au Japon." *Architectural Review Asia Pacific (AR)*, no. 130 (2013): 76–83.

"Ross Lovegrove: Where Does Love Grow When the User Is Absent?" *(Inside) Australian Design Review*, no. 33 (2004): 68–69.

"The Shape of Things to . . . Be Put on Hold: Preparing a Trend for Recession." *Architectural Review Australia*, no. 109 (2009): 22–24.

"Shaping the Raw Material of Faith." *MARK*, no. 22 (2009): 44–45.

"Taken for a Ride on BP's Greencurve." *Architectural Review Australia*, no. 104 (2008): 32–36.

"Waiting for the Revolution to Surface." *Architectural Review Australia*, no. 103 (2007): 32–36.

"Where Butterflies Rest." *MARK*, no. 33 (2011): 148.

Beaumont Newhall

Afterword to *Voyage of the Eye*, by Brett Weston, 79–87. New York: Aperture Foundation, 1992.

Airborne Camera: The World from the Air and Outer Space. New York: Hastings House, 1969.

"Antaeus, or the Photographer of the World." *Contemporary Photographer* 5.4 (Spring 1965).

The Art and Science of Photography. Watkins Glen, NY: Century House, ca. 1956.

"Cartier-Bresson's Photographic Technique." In *The Photographs of Henri Cartier-Bresson*, edited by Beaumont Newhall and Lincoln Kirstein, 12–14. New York: Museum of Modern Art, 1947.

A Catalogue of the Epstean Collection on the History and Science of Photography: And Its Applications Especially to the Graphic Arts; With an Appreciation and Bibliography of Edward Epstean. By Beaumont Newhall and Edward Epstean. 1937. Reprint, Pawlet, VT: Helios, 1972.

A Chronicle of the Birth of Photography. Cambridge, MA: Harvard Library Bulletin, 1953.

The Daguerreotype in America. New York: Dover, 1976.

Die Vater der Fotografie: Anatomie einer Erfindung. Seebruck am Chiemsee: Heering, 1978.

Edward Weston Omnibus: A Critical Anthology. By Edward Weston. Edited and with introductions by Beaumont Newhall and Amy Conger. Salt Lake City, UT: G. M. Smith / Peregrine Smith Books, 1984.

Eliot Porter Retrospective. Santa Fe, NM: 1973. Museum brochure for an exhibition at the University of New Mexico Art Museum.

Focus: Memoirs of a Life in Photography. Boston, MA: Little, Brown, 1993.

Foreword to *One Mind's Eye: The Portraits and Other Photographs of Arnold Newman*, by Arnold Newman, v. Boston, MA: D. R. Godine, 1974.

Foreword to *Photographen der 20er Jahre*, by Karl Steinorth, 7–19. Munich: Laterna Magica, 1976.

Foreword to *Seeing Straight: The f.64 Revolution in Photography*, edited by Therese ThauHeyman, viii–ix. Oakland, CA: Oakland Museum, 1992.

Frederick H. Evans. Rochester, NY: George Eastman House, 1964.

An Historical and Descriptive Account of the Various Processes of the Daguerreotype and the Diorama. By Louis Jacques Mandé Daguerre. Illustrated and with an introduction by Beaumont Newhall. New York: Winter House, 1971.

The History of Photography: From 1839 to the Present. New York: Museum of Modern Art, 1982.

In Plain Sight: The Photographs of Beaumont Newhall. Foreword by Ansel Adams. Salt Lake City, UT: G. M. Smith, 1983.

Introduction to *The Pencil of Nature*, by William Henry Fox Talbot. New York: Da Capo Press, 1969.

Latent Image: The Discovery of Photography. Garden City, NY: Anchor, 1967.

Masters of Photography. Edited and with an introduction by Beaumont Newhall and Nancy Wynne Newhall. 1958. Reprint, New York: Park Lane, 1981.

Nancy Newhall, 1908/1974. Edited by Beaumont Newhall, Nancy Wynne Newhall, and Peter Hunt Thompson. Carmel, CA: Friends of Photography, 1976.

One Hundred Years of Photographic History: Essays in Honor of Beaumont Newhall. Edited by Van Deren Coke. Albuquerque: University of New Mexico Press, 1975.

On Photography: A Source Book of Photo History in Facsimile. Watkins Glen, NY: Century House, 1956.

Perspectives on Photography: Essays in Honor of Beaumont Newhall. Edited by Peter Walch and Thomas F. Barrow. Albuquerque: University of New Mexico Press, 1986.

Photo Eye of the 20s: An Exhibition Prepared in Collaboration with the Museum of Modern Art. Rochester, NY: George Eastman House, 1971.

Photography: A Short Critical History. New York: Museum of Modern Art, 1938.

Photography, Essays, and Images: Illustrated Readings in the History of Photography. Edited by Beaumont Newhall. New York: Museum of Modern Art, 1980.

Proto Modern Photography. Santa Fe: Museum of Fine Arts, Museum of New Mexico, 1992.

Supreme Instants: The Photography of Edward Weston. Boston, MA: Little, Brown, in association with the Center for Creative Photography, University of Arizona, 1986.

T. H. O'Sullivan: Photographer. By Beaumont Newhall and Nancy Newhall. Rochester, NY: George Eastman House, 1966.

Transfixed by Light: Photographs from the Menil Foundation Collection. Exhibition at the Rice Museum, Institute for the Arts, Rice University, March 21–May 24, 1981. Catalog by Kathryn Davidson and Elizabeth Glassman. Houston, TX: Menil Foundation, 1980.

William H. Jackson. By Beaumont Newhall and Diana E. Edkins. Dobbs Ferry, NY: Morgan and Morgan; Fort Worth, TX: Amon Carter Museum, 1974.

Robert ParkeHarrison

The Architect's Brother. Santa Fe, NM: Twin Palms, 2000.

Counterpoint. By Robert ParkeHarrison and Shana ParkeHarrison. Santa Fe, NM: Twin Palms, 2008.

Everyman: Environmental Performances. By Robert ParkeHarrison and Shana ParkeHarrison. Santa Fe, NM: Atrium Gallery, 2005.

Gautier's Dream. By Robert ParkeHarrison and Shana ParkeHarrison. Chicago, IL: Catherine Edelman Gallery, 2014.

Eugenia Parry

"Animal Magnetism." In *Meinrad Craighead: Crow Mother and the Dog God, A Retrospective*, 265–91. San Francisco, CA: Pomegranate, 2003.

The Art of French Calotype: With a Critical Dictionary of Photographers, 1845–1870. By Eugenia Parry Janis and Andre Jammes. Princeton, NJ: Princeton University Press, 1983.

At the Still Point: Photographs from the Manfred Heiting Collection. Vol. 1, *1840–1916*. By Eugenia Parry and Manfred Heiting. Los Angeles, CA: Cinubia, 1995.

"Beyond *Is* and *Is Not*." In *Linda J. Ging: Paintings*, 7–25. Albuquerque, NM: Fresco Fine Art, 2006.

"Broken Arcs of One Curve: Notes on a Woman's Life—Jane Reese Williams." In *To Collect the Art of Women: The Jane Reese Williams Photography Collection*, 7–28. Santa Fe: Museum of Fine Arts, Museum of New Mexico, 1991.

"The Bug in Amber and the Dance of Life." In *Vanishing Presence*. Minneapolis, MN: Walker Art Center; New York: Rizzoli, 1989.

"Convalescent . . . Incorruptible." In *The Bone House*, by Joel-Peter Witkin, 175–89. Santa Fe, NM: Twin Palms, 1998.

Crime Album Stories: Paris 1886–1902. Zurich: Scalo, 2000.

Daughter/Father. Essay and exhibition catalog. Boston, MA: Photographic Resource Center, 1988.

Degas Monotypes. Essay, catalog, and checklist. Cambridge, MA: Fogg Art Museum, Harvard University, 1968.

"Demolition Picturesque: Photographs of Paris in 1852 and 1853 by Henri Le Secq." In *Perspectives on Photography: Essays in Honor of Beaumont Newhall*, edited by Peter Walch and Thomas Barrow, 33–66. Albuquerque: University of New Mexico Press, 1986.

"Edgar Degas' Photographic Theater." In *Edgar Degas, Photographer*, by Malcolm Daniel, 52–73. New York: Metropolitan Museum of Art, 1998.

"Fabled Bodies: Some Observations on the Photography of Sculpture." In *The Kiss of Apollo: Photography and Sculpture, 1845 to the Present*, edited by Jeffrey Fraenkel, 9–23. San Francisco, CA: Fraenkel Gallery / Bedford Arts, 1991.

"Fool for Christ." In *Joel-Peter Witkin*, 227–67. Paris: Delpire, 2012.

"Forager." In *Ralph Eugene Meatyard: Dolls and Masks*, 9–21. Santa Fe, NM: Radius Books, 2011.

"Ghost Lands." In *Jungjin Lee Wind*, 99–102. New York: Sepia International / Aperture Foundation, 2009.

"Great Pretender." In *Modern Romance: David Levinthal*. Los Angeles, CA: St. Anne's Press.

"Her Geometry." In *Women Photographers*, edited by Constance Sullivan, 9–27. New York: Abrams, 1990.

"His Geometry." Translated as "Il geometria del sognatore" in *Normanno Soscia: Geometria del sognatore*, 3–19. Itri, Italy: d'Arco Edizioni, 2003.

"A Hot Iron Ball He Can Neither Swallow Nor Spit Out: Patrick Nagatani, Nuclear Fear, and the Uses of Enchantment." In *Nuclear Enchantment*, 1–47. Albuquerque: University of New Mexico Press, 1991.

"How Still the Riddle Lies!" In *Jayne Hinds Bidaut: Tintypes*, edited by Nicole Ray, 9–21. New York: Graphis, 1999.

"A Hundred Different Stories: The Art of Photography." In *Photography's Multiple Roles: Art, Document, Market, Science*, edited by Terry Ann R. Neff, 52–81. Chicago, IL: Museum of Contemporary Photography, Columbia College; New York: D.A.P., 1998.

"Hungry." In *Bertha Alyce: Mother exPosed*, by Gay Block, 258–85. Albuquerque: University of New Mexcio Press, 2003.

"I've Got You Now." Foreword to *The Short Story and Photography, 1880's–1980's*, edited by Jane M. Rabb, xiii–xviii. Albuquerque: University of New Mexico Press, 1998.

Joel-Peter Witkin. London: Phaidon, 2007.

"L'art d'un collectionneur: Henri Le Secq photographe." In *Henri Le Secq, photographe de 1850 à 1860: Catalogue raisonné de la collection de la Bibliothèque des Arts Décoratifs, Paris*, by Eugenia Parry Janis and Josiane Sartre, 5–35. Paris: Musée des Arts Décoratifs / Flammarion, 1986.

"Less of a Test Than Earth: The Art of Adam Fuss." In *Adam Fuss*, by Adam Fuss, 1–28. Santa Fe, NM: Arena Editions, 1997.

"Let Us Crown Ourselves with Rosebuds." In *For My Best Beloved Sister Mia: An Album of Photographs by Julia Margaret Cameron*, by Therese Mulligan et al., 9–12. Albuquerque: University of New Mexico Art Museum, 1994.

Louis De Clercq. Stuttgart: Mayer & Mayer, 1989.

"The Man on the Tower of Notre Dame: New Light on Henri LeSecq." In *Image* (International Museum of Photography at the George Eastman House, Rochester, NY) 19.4 (1976): 13–25.

"999 Degrees of Will." In *The Photography of Alfred Stieglitz: Georgia O'Keeffe's Enduring Legacy*, edited by Therese Mulligan, 17–43. Rochester, NY: George Eastman House, 2000.

"No One I Know: The Mystery of Marjorie Content, Photographer." In *Marjorie Content: Photographs*, edited by Jill Quasha, 38–61. New York: W. W. Norton, 1994.

Out Takes. Catalog for exhibition on Wendy Snyder MacNeil. Toronto: Ryerson Image Centre, Ryerson University, forthcoming.

"Penitent." In *The Thrill of the Chase*. Catalog for exhibition on Sam Wagstaff. Los Angeles, CA: Getty Center, forthcoming.

"Photography." In *The Second Empire: Art Under Napoleon III*, 401–33. Philadelphia, PA: Philadelphia Museum of Art; Paris: Museés Nationale, 1978.

"Photography and the Spirit: Hippolyte Bayard." In *Hippolyte Bayard: Photography and the Spirit: A Collection of Photographs from 1839 to 1848*, 1–4. Munich: Daniel Blau Photography, 2010.

The Photography of Gustav Le Grey. Chicago, IL: Art Institute of Chicago and the University of Chicago Press, 1987.

Photography Within the Humanities. Edited by Eugenia Parry Janis. Danbury, NH: Addison House, 1977.

"Prisoner of the Lake." In *Robert Stivers: Sanctum*. Santa Fe, NM: Twin Palms, 2006.

"Setting the Tone: The Revival of Etching, the Importance of Ink." In *The Painterly Print: Monotypes from the Seventeenth to the Twentieth Century*, 9–28. New York: Metropolitan Museum of Art, 1980.

Shooting Off My Mouth, Spitting Into the Mirror: Lisette Model, a Narrative Autobiography. Göttingen: Steidl, 2009.

"A Still Life Instinct: The Color Photographer as Epicurean." In *One of a Kind: Recent Polaroid Color Photography*, 9–21. Boston, MA: D. R. Godine, 1979.

"That Memory or Dream Thing I Do." In *Georgia O'Keeffe: Visions of the Sublime*. Memphis, TN: International Arts, 2004.

"They say *I* and *I* and Mean: Anybody." In *Harm's Way: Lust and Madness, Murder and Mayhem; A Book of Photographs*, by Joel-Peter Witkin. Santa Fe, NM: Twin Palms, 1994.

"Tracks in the Snow." In *Paolo Ventura: Winter Stories*. New York: Aperture Foundation, 2009.

Michele M. Penhall

"Adolph de Meyer: L'apres-midi d'un faune." In *British Photography in the 19th Century*, edited by Mike Weaver, 273–79. New York: Cambridge University Press, 1989.

"Almost Indian." *Earthwatch Institute Journal* 20.2 (2001): 16–19.

"Between Snapshot and Document." In *Big Eyes: The Southwestern Photographs of Simon Schwemberger, 1902–1908*, 149–88. Albuquerque: University of New Mexico Press, 1992.

"Dispersal/Return" and "Bill Gilbert: Physiocartography." In *Land/Art New Mexico*, 162–63. Santa Fe, NM: Radius Books, 2010.

"El pictorialismo en los Andes." In *La recuperación de la memoria: El primer siglo de la fotografía, Perú, 1842–1942*, 156–61. Lima: Museo de Arte and Fundación Telefónica, 2001.

Introduction and "Heal Thyself." In *Desire for Magic: Patrick Nagatani 1978–2008*, edited by Michele M. Penhall, 4–5, 146–48. Albuquerque: University of New Mexico Art Museum, 2010.

Introduction and "The Invention and Reinvention of Martín Chambi." "Aspects of South America," edited by Michele M. Penhall, special issue, *History of Photography* 24.2 (2000): i, 106–12.

"The Photographic Works of Betty Hahn, 1964–94." In *Betty Hahn: Photography or Maybe Not*, by Steve Yates, 172–98. Albuquerque: University of New Mexico Press; Santa Fe: Museum of Fine Arts, Museum of New Mexico, 1995.

"Staging Ambiguity." In *Sam McFarlane*. Albuquerque: University of New Mexico, Department of Art and Art History, 2008.

Meridel Rubenstein

Belonging: Los Alamos to Vietnam. Los Angeles, CA: St. Ann's Press, 2004.

Critical Mass. By Meridel Rubenstein and Ellen Zweig with Woody Vasulka and Steina Vasulka. Santa Fe: Museum of Fine Arts, Museum of New Mexico, 1993.

La Gente de la Luz: Portraits from New Mexico. Santa Fe: Museum of New Mexico, 1977.

Richard Rudisill

"Bibliography of Directories of Photographers." Pts. 1 and 2. *Repeat Photography Newsletter* 2.1 (Spring 1985): 13–20; 2.2 (Winter 1985): 10–31.

Biographical foreword to *The P. E. Harroun Collection*. Santa Fe: Museum of New Mexico, 1975.

The Burro. Compiled by Richard Rudisill and Marcus Zafarano. Santa Fe: Museum of New Mexico, 1979.

"The Camera and the Plow." *El Palacio* 89.1 (1983): 18–24.

"Curator's Choice—Favorites from the Collections: History." *El Palacio* 91.1 (Spring 1985): 58; 91.2 (Fall 1985): 41.

"Daguerreotype," "Lumière Brothers," and "Joseph Nicéphore Niépce." In *World Book Encyclopedia*. Chicago, IL: World Book, 1984.

"Directories of Photographers: An Annotated Bibliography." Compiled by Richard Rudisill and Steven Joseph. In *Photographers: A Source Book for Historical Research*, edited by Peter E. Palmquist, 41–139. Brownsville, CA: Carl Mautz, 1991.

"Early Processes" and "The Land." In *Approaches to Photography: A Historical Survey*. Amarillo: Amarillo Art Center, 1979.

Foreword, selected bibliography, and biographical note. In *Frederick Monsen at Hopi*, v–vii. Reprint series no. 2. Santa Fe: Museum of New Mexico, 1979.

Foreword to *The Early Pacific Coast Photographs of Carleton E. Watkins*, by J. W. Johnson, pages. Santa Fe: Museum of New Mexico, 1976.

"A Guide to Research." *Northlight: Journal of the Photographic Historical Society of America* 3.1 (Winter 1975–76): 12–13.

"Historical Society of New Mexico Donation to the Museum of New Mexico." *El Palacio* 90.3 (Fall/Winter 1984): 7–13.

An Introduction to Directory Research. Santa Fe: Museum of New Mexico Photo Collections, 1975.

"An Introduction to Directory Research." *Picturescope: The Quarterly Bulletin of the Picture Division of the Special Libraries Association* 29.4 (Winter 1981): 138–44.

Introduction to *Photography: The Selected Image*, by James Baker and Gerald Lang. University Park: Pennsylvania State University, 1978.

"Letter from Minneapolis." *Contemporary Photographer* (Summer 1965).

Mirror Image: The Influence of the Daguerreotype on American Society. Albuquerque: University of New Mexico Press, 1971.

"On Reading Photographs." *Journal of American Culture* 5.3 (Fall 1982): 1–14.

"Photograph Collections Milestone: The 100,000 Catalogued Image." *El Palacio* 88.3 (Fall 1982): 40–41.

Photographers of the New Mexico Territory, 1854–1912. Compiled by Richard Rudisill. Santa Fe: Museum of New Mexico, 1973.

The Portrait. Compiled by Richard Rudisill, Arthur Olivas, and Marcus Zafarano. Santa Fe: Museum of New Mexico, 1980.

A Problem in Attribution. Santa Fe: Museum of New Mexico Photo Collections, 1975.

Review of *Crying for a Vision: A Rosebud Sioux Trilogy, 1886–1976*, edited by Don Doll, Jim Alinder, and Eugene Buechel. *Exposure: Journal of the Society for Photographic Education* 15.2 (May 1977): 43–44.

Review of *Mother Earth, Father Sky: Navajo and Pueblo Indians of the Southwest*, by Marcia Keegan. *El Palacio* 81.4 (Winter 1975): 51.

Review of *The Spirit of Fact: The Daguerreotypes of Southworth and Hawes, 1843–1862*, by Richard Sobieszek. *Afterimage* 4.3 (September 1976): 19.

Santa Fe: Past and Present, 1860–1979—An Exhibition of Photographs. By Richard Rudisill and Mary Peck. Santa Fe, NM: Santa Fe Gallery of Photography, 1979.

"Santa Fe Museum Compiles Photographers' Bibliography." Pt. 1, "Published Works." *Photographica* 13.4 (April 1981): 11–12.

"Santa Fe Museum Compiles Photographers' Bibliography." Pt. 2, "Works in Progress." *Photographica* 13.5 (May 1981): 11–12.

"Some Introductory Thoughts (on the Uses of Photographs)." *Santa Fe Center for Photography Newsletter* 2.1 (Winter 1983): 1–2.

"Watkins and the Historical Record." *California History: The Magazine of the California Historical Society* 57.3 (Fall 1978): 216–19.

April M. Watson

The Art of Frederick Sommer: Photography, Drawing, Collage. By Keith F. Davis and April M. Watson. Prescott, AZ: Frederick and Frances Sommer Foundation, 2005.

"Barry Anderson." In *Contact Sheet 142: Light Work Annual*, 10. Syracuse, NY: Light Work, 2007.

Bibliography. In *Alfred Stieglitz: The Key Set; The Alfred Stieglitz Collection of Photographs at the National Gallery of Art*, by Sarah Greenough, 972–90. Washington, DC: National Gallery of Art, 2002.

Heartland: The Photographs of Terry Evans. By Keith F. Davis, Jane L. Aspinwall, and April M. Watson. Kansas City: Hall Family Foundation in association with the Nelson-Atkins Museum of Art, 2012.

"A History from the Heart." In *For My Best Beloved Sister Mia: An Album of Photographs by Julia Margaret Cameron*, by Therese Mulligan et al., 14–25. Albuquerque: University of New Mexico Art Museum, 1995.

Impressionist France: Visions of Nation from Le Gray to Monet. By Simon Kelly and April M. Watson. Saint Louis, MO: Saint Louis Art Museum; Kansas City, MO: Nelson-Atkins Museum of Art, 2014.

"It Is the Heart Which Makes Us." In *Family Photographs, 2001–2015*, by Bjørn Sterri. Oslo: Pilver Press, forthcoming.

"The Promise of Water." In *Surf Site Tin Type*, by Joni Sternbach. Bologna: Damiani, 2015.

"William Christenberry." In *Original Sources: Art and Archives at the Center for Creative Photography*, 72–75. Tucson, AZ: Center for Creative Photography, 2002.

BIBLIOGRAPHY OF
RELATED WORKS

Carla Williams

The Black Female Body: A Photographic History. By Carla Williams and Deborah Willis. Philadelphia, PA: Temple University Press, 2002.

1000 Photo Icons: George Eastman House. By Carla Williams, William S. Johnson, and Mark Rice. Edited by Therese Mulligan and David Wooters. Cologne: Taschen, 2002.

Passage on the Underground Railroad: Photographs by Stephen Marc. By Carla Williams, Keith Griffler, and Diane Miller. Jackson: University Press of Mississippi, 2008.

"Sell It or Sit Down on It: The Black Female Body in French Photography, 1850–1890." MFA thesis, University of New Mexico, 1996.

Joel-Peter Witkin

The Bone House. Santa Fe, NM: Twin Palms, 1998.

Disciple and Master. New York: Fotofolio, 2000.

Forty Photographs. San Francisco, CA: Museum of Modern Art, 1985.

Gods of Earth and Heaven. Altadena, CA: Twelvetrees Press, 1991.

Harm's Way: Lust & Madness, Murder & Mayhem; A Book of Photographs. Santa Fe, NM: Twin Palms, 1994.

Joel-Peter Witkin. Pasadena, CA: Twelvetrees Press, 1985.

Masterpieces of Medical Photography: Selections from the Burns Archive. Edited by Joel-Peter Witkin. Santa Fe, NM: Twelvetrees Press, 1987.

The Maxims of Men Disclose Their Hearts: Photographs by Joel-Peter Witkin. Edited by John Wood. South Dennis, MA: Steve Albahari, 21st Editions, 2009.

"Revolt Against the Mystical." MFA thesis, University of New Mexico, 1976.

Songs of Innocence and Experience. Edited by John Wood. Brewster, MA: Leo and Wolfe Photography, 2004.

Witkin. Zurich: Scalo; New York: D.A.P., 1995.

Jonathan Blaustein
(American, b. 1974)
One Dollar's Worth of Double Cheeseburger from McDonald's,
 from *The Value of a Dollar Project,* 2008
Digital archival pigment print, 14 × 18⅝ in., 2011
Edition 2/10
Gift of Jonathan Blaustein and Jessie Kaufman
© Jonathan Blaustein; courtesy of the artist
2011.5.2

Index